TAKING PLACE

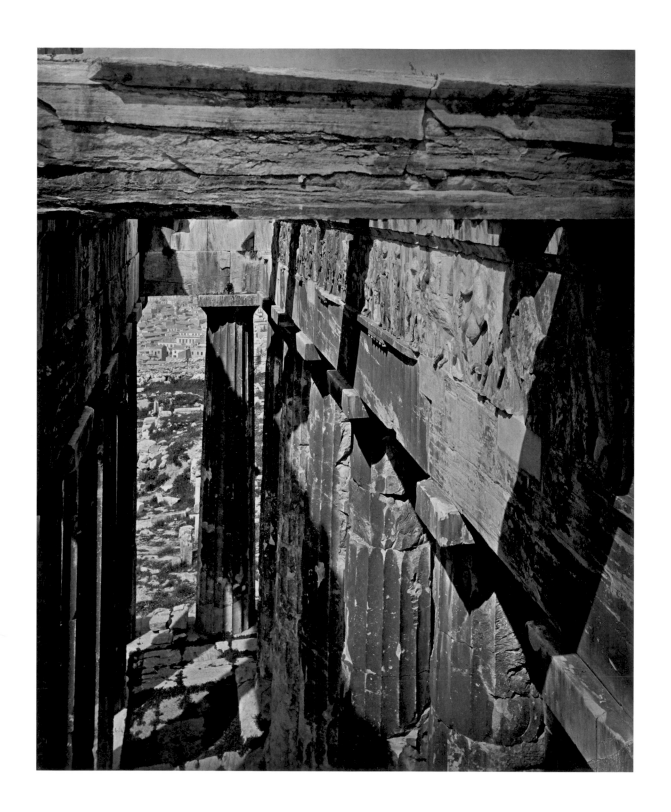

2. **William James Stillman**
Untitled [Part of the Frieze of the Parthenon], ca. 1868–69
Carbon print
17 3/8 x 14 3/8 in. (44.1 x 36.5 cm)

3. **Louis-Adolphe Humbert de Molard**
Untitled [Two Men Sitting under a Pergola], ca. 1847
Paper negative
9 1/2 x 7 1/8 in. (24.1 x 18.1 cm)

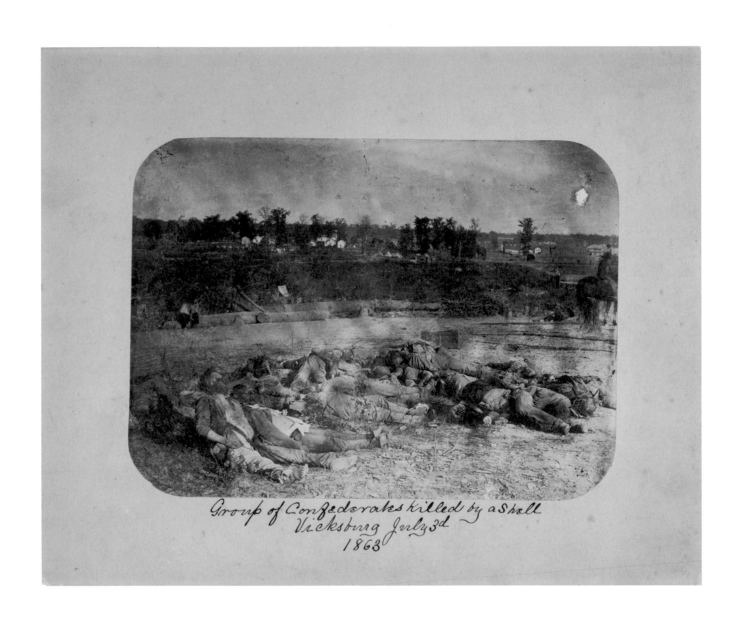

Group of Confederates killed by a Shell
Vicksburg July 3d
1863

4. **George Armistead and Henry White**
Group of Confederates Killed by a Shell, Vicksburg, July 3, 1863, 1863
Salt print from a glass negative
5 15/16 x 8 in. (15.1 x 20.3 cm)

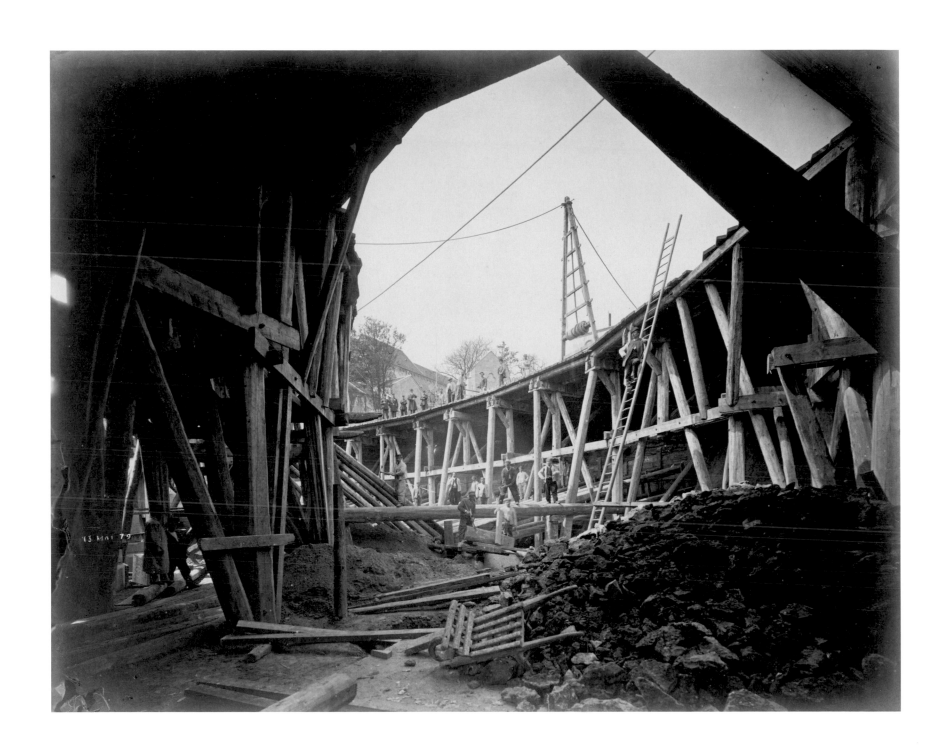

5. **Louis-Emile Durandelle**
Construction of Sacré-Coeur, 1879
Albumen print from a glass negative
13 1/2 x 17 1/8 in. (34.3 x 43.5 cm)

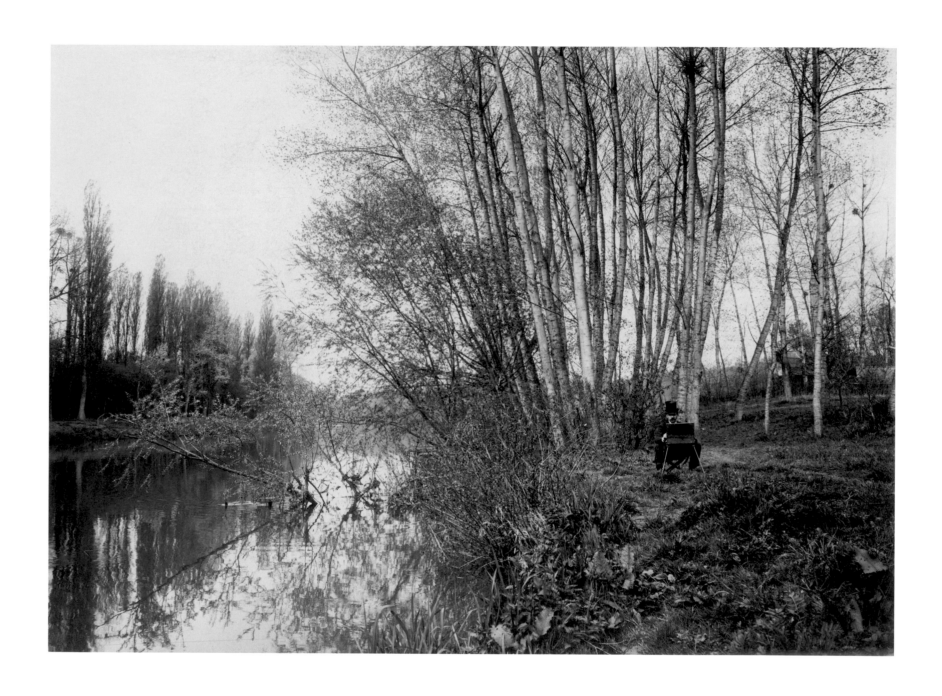

6. **Félix Thiollier**
Untitled [Emile Noiret, Painting by a Stream], 1880s
Gelatin silver print
11½ x 15¾ in. (29.2 x 40 cm)

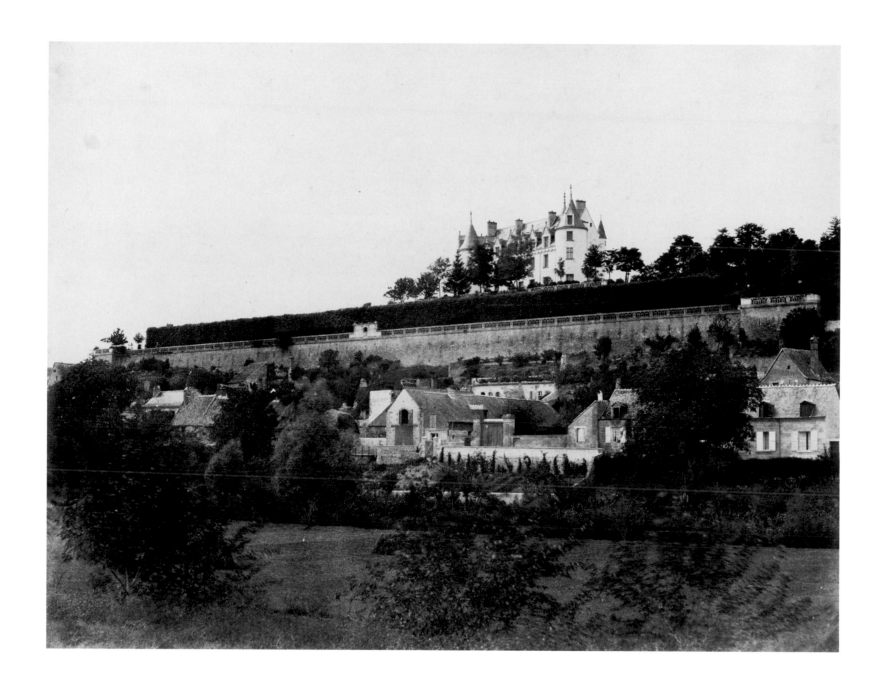

7. **André Philippe Alfred Regnier**
Château de Moncontour, ca. 1858
Albumen print from a paper negative
14 3/8 x 18 7/8 in. (36.5 x 47.9 cm)

Overleaf:

8. **Albert Renger-Patzsch**
Vorstadt von Essen (Suburb of Essen), 1931
Gelatin silver print
8 7/8 x 6 5/8 in. (22.5 x 16.8 cm)

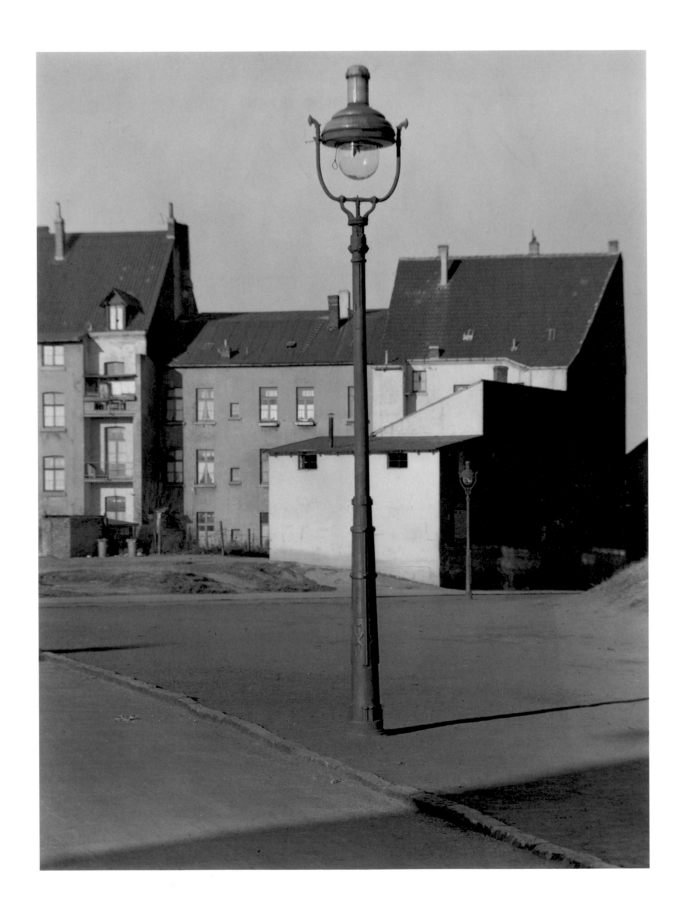

TAKING PLACE

PHOTOGRAPHS from the
Prentice & Paul Sack Collection

Sandra S. Phillips

Alan Trachtenberg

Douglas R. Nickel

Corey Keller

SAN FRANCISCO MUSEUM OF MODERN ART

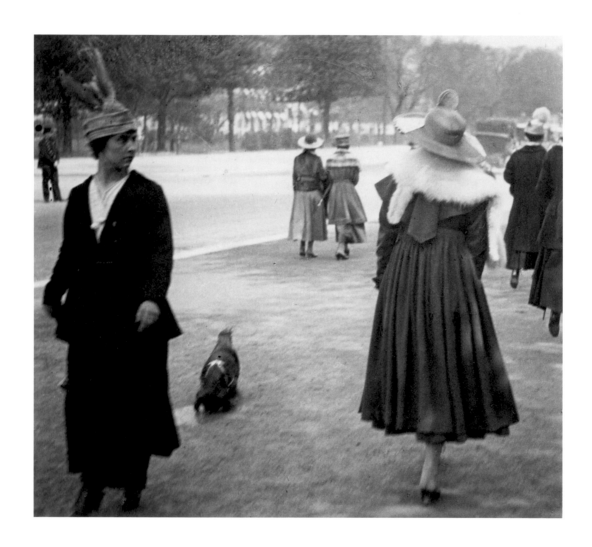

9. **Jacques Henri Lartigue**
La mode—avenue du Bois (Fashion—avenue du Bois), 1915
Gelatin silver print
4 1/2 x 4 15/16 in. (11.4 x 12.5 cm)

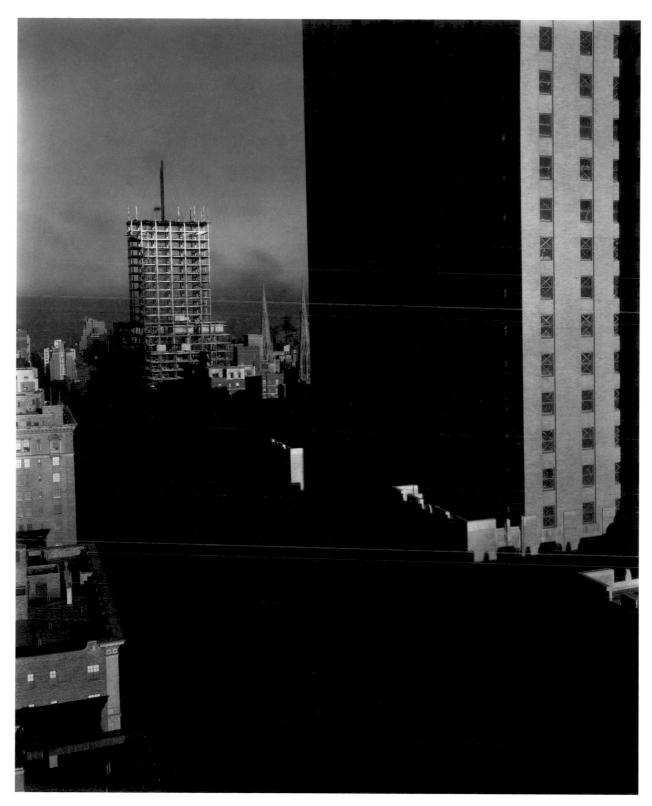

10. **Alfred Stieglitz**
From My Window at the Shelton, West, 1931
Gelatin silver print
9 7/8 x 7 3/4 in. (25.1 x 19.7 cm)

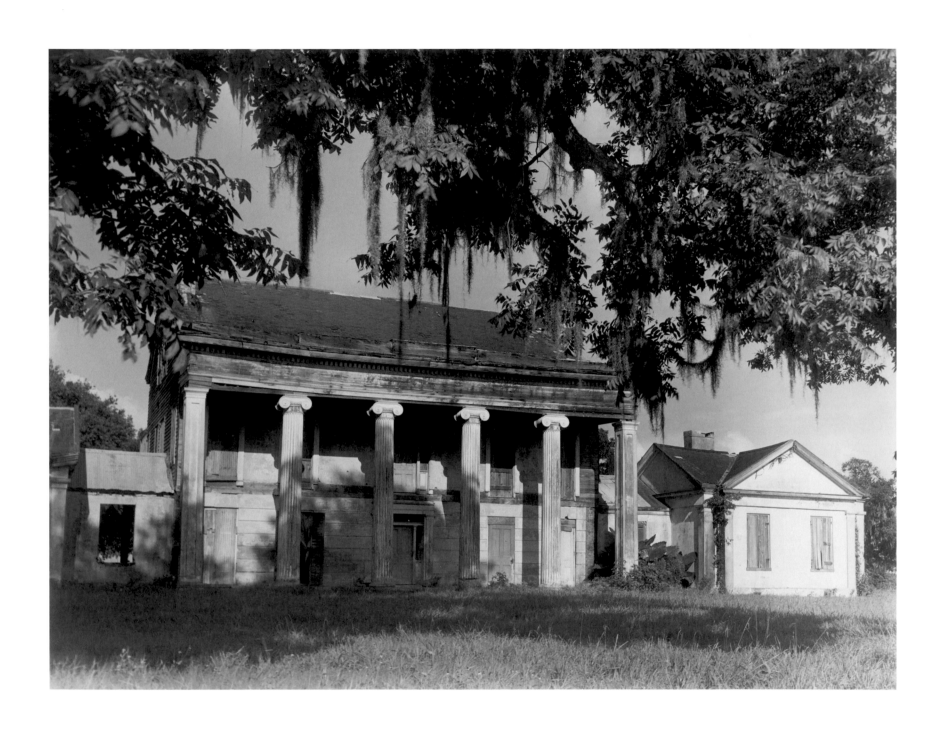

11. Clarence John Laughlin
The Oak Arch, Woodlawn Plantation, 1945
Gelatin silver print
14 5/16 x 18 7/8 in. (36.4 x 47.9 cm)

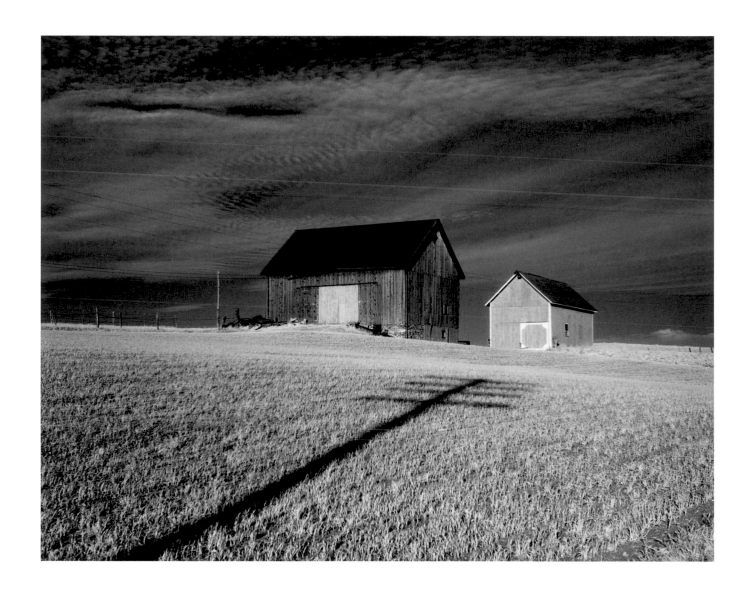

12. Minor White
Vicinity of Dansville, New York, 1955
Gelatin silver print
7 3/8 x 9 3/8 in. (18.7 x 23.8 cm)

This catalogue is published by the San Francisco Museum of Modern Art on the occasion of the exhibition *Taking Place: Photographs from the Prentice and Paul Sack Collection,* organized by Sandra S. Phillips and Corey Keller for the San Francisco Museum of Modern Art and on view from June 2 through September 6, 2005.

This exhibition is sponsored by Deutsche Bank and RREEF.

Additional support is provided by Elaine McKeon, Nancy and Steven Oliver, Jane and Jack Bogart, and the George Frederick Jewett Foundation.

Director of Publications: Chad Coerver
Managing Editor: Karen A. Levine
Designer: Jody Hanson
Editor: Janet Wilson
Production Manager: Nicole DuCharme
Publications Assistant: Lindsey Westbrook
Scans by Robert J. Hennessey and Ben Blackwell
Separations by Robert J. Hennessey Photography
Printed and bound in Germany by Dr. Cantz'sche Druckerei

Library of Congress Cataloging-in-Publication Data

San Francisco Museum of Modern Art.

 Taking place : photographs from the Prentice and Paul Sack collection / Sandra S. Phillips . . . [et al.].

 p. cm.

 Includes bibliographical references.

 ISBN 0-918471-78-8 (hardcover : alk. paper)—

ISBN 0-918471-76-1 (pbk. : alk. paper)

 1. Photography, Artistic—Exhibitions.

 2. Architectural photography—Exhibitions.

 3. Sack, Prentice—Photograph collections—Catalogs. 4. Sack, Paul—Photograph collections—Catalogs. 5. San Francisco Museum of Modern Art—Photograph collections—Exhibitions. I. Phillips, Sandra S., 1945– II. Title.

 TR655.S26 2005

 779′.074′79461—dc22

 2005000127

Photography credits appear on page 242.

CONTENTS

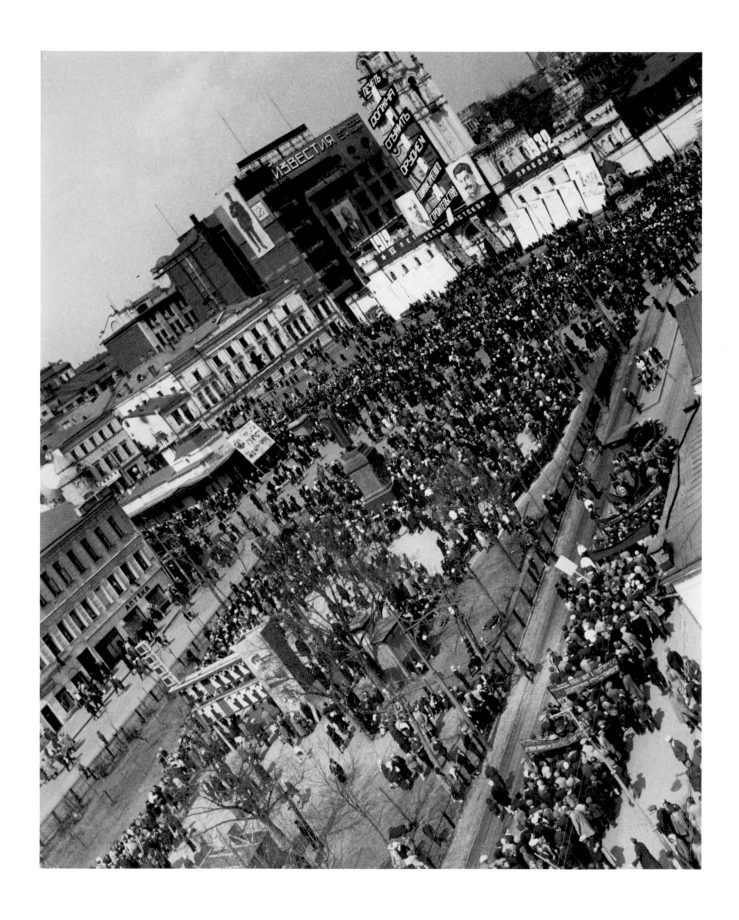

DIRECTOR'S FOREWORD

Since its founding in 1935, the San Francisco Museum of Modern Art has been committed to building a photography collection of international stature, a fact that distinguishes the institution as one of the first American museums to recognize photography as a legitimate art form. With the advice and support of the renowned Bay Area photographer Ansel Adams and a host of local practitioners and patrons, the Museum's commitment to the medium strengthened steadily over the decades, gaining momentum with the appointment of the first dedicated curator of photography in 1958 and the establishment of a distinct Department of Photography in 1980. Since then, SFMOMA's collection has grown to include nearly fourteen thousand photographs spanning the entire history of the medium, from its invention in the mid-nineteenth century to the present day.

In 1998, however, the Museum's holdings were dramatically transformed by a single remarkable gift. The formation of a supporting organization known as the Prentice and Paul Sack Photographic Trust granted us a unique position of access to more than one thousand of the finest photographs then in private hands, enabling the institution to exhibit, study, publish, and lend the pictures as we do the works in our own collection. With this exceedingly creative and generous gesture, the Sacks added a significant new level of breadth and depth to the Museum's holdings. They also single-handedly revived a rich Bay Area legacy of photography patronage that dates back to one of our institution's founding trustees, Albert M. Bender, and to Ansel Adams himself.

It is difficult to overstate the Sacks' importance to this institution. Prior to making this gift, Paul had been an active member of Foto Forum, a Museum auxiliary that supports the Photography Department's acquisitions efforts. In 1992 he and Sandra S. Phillips, then curator of photography, spearheaded a successful effort to establish an accessions committee devoted to the medium of photography, an extremely important development that reflects the institution's long-term commitment to this art form. Upon the formation of the trust, Paul became a member of SFMOMA's board of trustees, where he has played a major role as an advocate for

Neal Benezra

13. **Alexander Rodchenko**
Pushkin Square, 1932
Gelatin silver print
11 3/4 x 9 1/2 in. (29.8 x 24.1 cm)

photography within the institution. The Sacks have also supported the larger photographic community through their connections with the San Francisco Art Institute (where Paul studied painting); with the Friends of Photography, the venerable, now-defunct nonprofit founded in 1967 by Ansel Adams, Brett Weston, and Nancy and Beaumont Newhall; and through other patronage activities.

Though it is a relatively small community, the San Francisco Bay Area has long been noteworthy in terms of its strength and influence in photography circles. In recent years this has largely been due to the enthusiasm and generosity of the Sacks and other prominent benefactors who have fostered a fertile environment for practitioners, curators, critics, and collectors. Paul's fascination with pictures of the built environment may be very different from the concerns of figures such as Bender and Adams, but his passion has helped to sustain the importance of photography in the community at large. Indeed, one of his primary motivations in forming the trust was to make it possible for the pictures to be seen by as many people as possible. The trust ensures that a rotating selection of the Sacks' photographs remain on public view at all times as part of the permanent-collection display *Picturing Modernity,* and key works have been loaned to photography exhibitions worldwide. *Taking Place,* however, is a truly momentous project. Presenting nearly three hundred of the Sacks' most significant pictures, from

nineteenth-century daguerreotypes to more contemporary gelatin silver prints, it is among the largest photography exhibitions in our institution's history and offers an unmatched perspective on the evolution of the medium.

This ambitious presentation is the fruit of the longtime friendship between Paul and Sandra Phillips, now SFMOMA's senior curator of photography. Their close collaboration over the years has greatly elevated the Museum's international stature as a center for the exhibition and study of photography. (For more on their partnership and accomplishments, see Sandra's essay in this volume, which traces their relationship from their first meeting to the present day.) The exhibition was co-organized by Sandra Phillips and Corey Keller, assistant curator of photography, whose deep knowledge of the medium and powers of diplomacy have been crucial to shaping this presentation and publication. Before Corey joined the Museum, Douglas R. Nickel, former curator of photography (now director of the Center for Creative Photography), offered the Sacks his expertise on nineteenth-century photography and generously assisted in the preparation of the exhibition. Curatorial associate Erin Garcia has also been central to the project, which has benefited immeasurably from her keen eye and careful orchestration of details.

Taking Place was organized by an extraordinarily talented team of SFMOMA staff members under the supervision of Ruth

Berson, deputy director for exhibitions and collections. Marcelene Trujillo, assistant exhibitions director, expertly managed the complexities of the gallery presentation with grace and good humor. Deserving special recognition for their dedication to the collection and their long friendship with the Sacks, Jill Sterrett, director of collections and head of conservation, and Theresa Andrews, conservator of photographs, have given Paul much encouragement and wise counsel concerning the care of his pictures. Associate registrar Cassandra Smith has ensured the safety of the trust's holdings on their many journeys between Paul's office and SFMOMA, and she has also devised innovative new procedures for documenting the prints as they enter and leave the Museum. Veteran exhibitions design manager Kent Roberts oversaw all aspects of the complex installation, assisted by senior museum preparators Rico Solinas, who supervised work in the galleries, and Greg Wilson, who matted and framed hundreds of prints for the presentation. Administrative assistant Jillian Slane provided invaluable help with exhibition maquettes, while Photography Department curatorial associates Suzanne Feld and Terri Whitlock contributed thoughtful writing for the gallery didactics. For their significant efforts on behalf of the project, thanks are also due to Susan Backman, imaging coordinator; Jennifer Bartle, intellectual property assistant; Elizabeth Epley, assistant director of development, donor services;

James Gouldthorpe, senior museum preparator; Marla Misunas, collections information manager; Terril Neely, senior graphic designer; Don Ross, in his dual role as imaging specialist for both the Museum and the Sack Collection; Gregory Sandoval, manager of adult interpretive programs; and Sandra Farish Sloan, senior public relations associate.

The members of the SFMOMA Publications Department, under the guidance of its director, Chad Coerver, deserve particular recognition for their work on this handsome catalogue. Managing editor Karen Levine oversaw the project from its inception, working closely with the curators to hone the volume's rich image selection and overall content. Jody Hanson is responsible for the elegant and sensitive graphic design, and Janet Wilson made important contributions to the book through her meticulous editing. The volume's superior reproductions were scanned and separated by Robert J. Hennessey, with additional scans by Ben Blackwell. Production manager Nicole DuCharme served as the crucial liaison between Hennessey, the printer, and the publications team. Publications assistant Lindsey Westbrook took on the formidable task of clearing reproduction rights for more than two hundred photographs, while Jennifer Sonderby, head of graphic design, provided valuable suggestions at key stages of the project. Everyone involved in creating the book extends warm gratitude to the distinguished historian Alan Trachtenberg, whose catalogue essay is an elegant meditation on the notion of place in photography, and to his fellow contributors Sandra Phillips, Corey Keller, and Doug Nickel.

In addition to the individuals named above, the curators wish to thank Cindy Herron, the Sacks' expert and learned collections manager, for her prompt and helpful cooperation; the members of the photography accessions committee for their dedication and support; and Jennifer Sime and Miriam Paeslack for their enthusiastic and thorough research.

These acknowledgments would not be complete without a nod to the Museum's board of trustees, with particular thanks to Elaine McKeon, board chair from 1995 through 2004, and current chair Steven Oliver. Elaine and Steve's gifts in support of this exhibition offer a substantial measure of the great importance of these photographs, of the trust, and of Paul himself to this institution. Board president Richard L. Greene has been intimately involved in the details of the trust, and we owe him a great deal of gratitude for his tireless efforts on behalf of the collection. Working closely with the entire board, J Mullineaux, the Museum's director of development, and associate directors of development Andrea Morgan, Lynda Sanjurjo-Rutter, and Stacey Silver helped to secure the necessary funding for this historic presentation.

The exhibition would not have been possible without the underwriting of our corporate sponsors, Deutsche Bank and RREEF. Additional support was provided by Elaine McKeon, Nancy and Steven Oliver, Jane and Jack Bogart, and the George Frederick Jewett Foundation. On behalf of Prentice and Paul Sack and the Museum, I extend our deep appreciation to these benefactors for their vital, ongoing support.

Taking Place is a celebration not only of an unparalleled collection, but also of a remarkable couple. Since 1998, the Sacks have continued to collect actively, and I am thrilled to announce that, in conjunction with this exhibition, they have promised to transfer all photographs in their private collection acquired after the initial gift — some eight hundred additional pictures — to the trust. To commemorate this extraordinary gesture, the Museum has agreed to grant the Fine Arts Museums of San Francisco equal access to the trust's holdings for exhibition and study. Beginning this fall, our sister institution expects to mount a changing display of pictures from the trust in the photography galleries of the new de Young Museum. Through this innovative arrangement — unprecedented in American museum practice — more people than ever before will have the opportunity to encounter the photographic masterpieces so passionately selected by these imaginative collectors.

PREFACE

Paul Sack

In building my collection, I have focused on presenting the history of photography through vintage photographs, each of which has somewhere within it a building that could be owned or leased. The building in question might be a tiny spot in a large landscape or even an interior, so a picture of someone inside a room could qualify for the collection. The theme is an obvious reference to my career as a real estate investor.

I am a collector. I have—over the course of my lifetime—collected stamps, baseball cards, drawings, and daggers, but none of these on the same scale or with the same passion with which I have collected photographs.

Why do people become collectors? One Freudian psychiatrist, Werner Muensterberger, has suggested that it is because as a child one learns that possessing things can relieve anxiety. Think of a small child and his precious blanket.

I prefer the alternative theory that a major pleasure of collecting is that it is virtually the only activity in one's life in which one has to satisfy no one but one's self. For the most part, this collection represents no one's taste or decisions but my own. There has been no professional curator finding and selecting pictures; however, I have—when I needed it—asked the San Francisco Museum of Modern Art's senior curator of photography, Sandra S. Phillips, for advice on my selections. On those occasions, she has been enormously helpful.

The abovementioned psychiatrist wrote that there is a moment of bliss when the decision is made to acquire something, and I have found this to be true. In order to avoid buying something just to achieve that bliss, I have made it a practice, whenever possible, to ask for prints to be shipped to me on approval, so that I can look at them alongside similar works in my collection before making a final, presumably more informed, acquisition decision. I send back to the dealers at least half of the prints that I take on approval, and the process makes me feel more confident about what I buy.

While the prints are in my possession, I generally try to do a little research, which can include looking in books at other images by the same photographer to evaluate how a

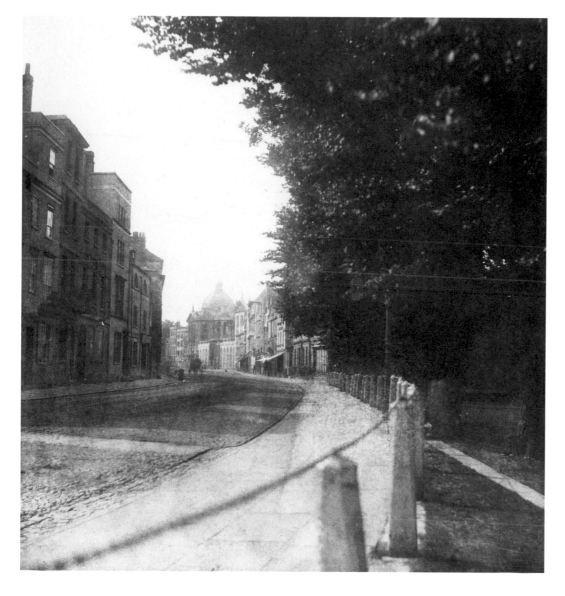

14. **William Henry Fox Talbot**
Oxford, High Street, 1843
Salt print from a paper negative
7 3/8 x 6 13/16 in. (18.7 x 17.3 cm)

that I had not observed or tell me things that I had not known.

Because the collection is about the history of photography, I have tried to represent as many as possible of the important photographers and to have eight to twelve prints by the most significant of them. Almost all of the prints are vintage—in other words, they were printed by the photographer within two or three years of the date that he or she made the negative.

Although the decisions have been my own, no one can work on a collection of this size without owing a debt to others for their help. I want to thank Cindy Herron, my collections manager, for being such a pleasant perfectionist in cataloging, appraising, and storing prints and for being an artist in arranging displays from the collection. I am particularly grateful to Sandra Phillips for her intellectual support and for pointing me in so many right directions. I would like to thank Weston Naef and Leonard Vernon for suggesting valuable criteria for making acquisitions decisions. And I would also like to thank my wife, Prentice, for her consistent encouragement of the project.

print under consideration fits into the photographer's body of work in terms of theme and quality; reading up on the photographer's life and artistic reputation, determining his or her importance to the history of photography; learning more about any movements in which the photographer may have participated; and confirming through an appraiser that the asking price is reasonable.

This research takes time and thought, and I find it to be one of the pleasures of collecting. Another important and enjoyable activity related to collecting is looking frequently at photography in museums and commercial galleries and sometimes visiting a museum's print room to learn more about its collection or to undertake research on a specific artist. I have also enjoyed showing my collection to knowledgeable visitors, as they will often see things in photographs

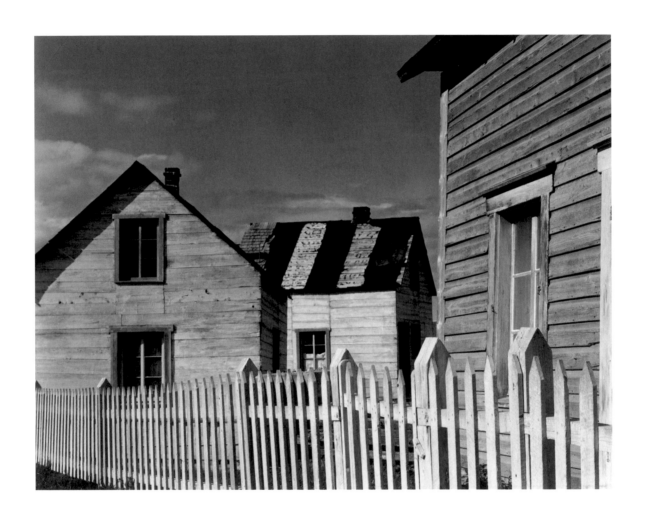

PAUL SACK and the Development of a Collection

It must be about sixteen years ago, in early 1989, that I met Paul Sack for the first time. I had come to the San Francisco Museum of Modern Art the year before, and Mary Zlot, an art adviser and a mutual friend, told me that he had recently developed an interest in photography and that she was assisting him. She wanted us to meet, and so we did, at the office of his company, RREEF (Rosenberg Real Estate Equity Fund), on California Street.

Although there was a room of paintings near the entryway, mainly the work of California artists (I remember a Wayne Thiebaud cityscape), my chief memory is that there were black-and-white photographs everywhere, particularly in the hallways, as Paul was already very careful about protecting his prints from excessive light. They were all pictures of buildings. Because his business was real estate, he had decided that seeking out photographs of built structures would offer a more personal and meaningful, even a more adventurous, theme around which to assemble a collection, since photographs of this subject are nicely diverse.

This was not a man new to art. As I got to know Paul, I learned that he had been a painting student at the San Francisco Art Institute, where he had counted among his teachers Richard Diebenkorn and James Weeks. (I later learned that Jay DeFeo had been a model for the Diebenkorn class.) Paul was so committed to studying painting that he had deliberately chosen the real estate business so he could earn enough and have free time for what he most wanted to do: paint, travel, and live abroad. He kept to his aspirations—he studied painting in the fall and spring and drawing in the summer—and maintained a studio in an old garage building not far from where SFMOMA now stands. Thus it was hardly surprising that he had formed a collection of paintings by well-known contemporaries, including local artists such as Thiebaud and Diebenkorn and some of their East Coast counterparts. These were displayed

Sandra S. Phillips

15. **Paul Strand**
Village, Gaspé, 1936
Gelatin silver print
4 11/16 x 5 15/16 in. (11.9 x 15.1 cm)

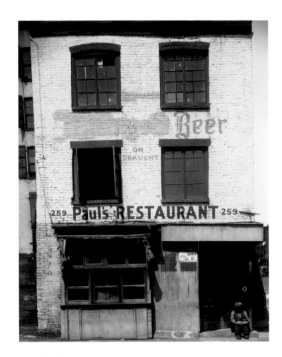

16. Walker Evans
South Street, New York City, 1934
Gelatin silver print
7 3/16 x 5 1/2 in. (18.3 x 14 cm)

in his home, much like the room in his office space. But when we first met, those paintings (at least the ones I saw in his office) did not seem to have the hold on him that his newfound interest in photography did. What was evident in our first meeting was that he was absolutely fascinated with this medium, still relatively new to him. It was a challenge in a way he could not yet fully explain. I believe he identified with those small black-and-white pictures in a manner that he had not done with his paintings.

I remember one picture in particular because of its significance for him then: a picture he still returns to, a kind of keystone of the collection. It was located in a far hall, not near his office. "I was lucky that the Walker Evans was the first picture I bought," Paul has said. "I learned a lot from it." This 1934 picture of a storefront in lower Manhattan, showing a loafer at the door of a diner, includes a sign that reads "Paul's Restaurant" (*pl. 16*). Clearly the name of the restaurant is what originally attracted him to the picture, but its location, on South Street in New York City, also appealed to this transplanted New Yorker. What is remarkable about the photograph beyond its subject is its apparent modesty: it is not an obviously commanding picture, but a subtle, even a gentle one, probably made looking down from the window across the street. It demonstrates what photography does best: it is about the act of looking, a picture about what the world looks like, and it was made in the spirit of inquiry, not critique. Moreover, it perfectly exemplifies what Evans believed photography should be, what distinguishes it from painting or the other visual arts. Photography, he said, should be "nowhere seen but everywhere felt." In other words, the presence of the photographer should be invisible, or at least not obvious—hidden, so to speak, in the apparent transparency of the picture itself. Photographs are still mostly pictures of things as much as formal inventions. Or, as the curator of photography John Szarkowski has written of William Eggleston, "In this peculiar art, form and subject are defined simultaneously."

The first time I saw the collection, most of the photographs were what we now call "modern prints." There were a few vintage pictures, mainly by Walker Evans, and others by some contemporaries. There were also color photographs—by Kenneth Snelson, Harry Callahan, Joel Meyerowitz, and Richard Misrach—which I regret are no longer in the collection, as Paul gradually discovered that he wanted only black-and-white pictures. Other photographs related to that first one by Evans, as in a family tree: pictures by Berenice Abbott (*pl. 33*), for instance, taken when she had just returned to New York after years in Paris, like Evans himself, and was able to see the city under the tutelage of Eugène Atget; the strange and marvelous street pictures by the transplanted German photographer in San Francisco, John Gutmann (*pl. 17*); and Peter Stackpole's elegant photographs of the construction of the Golden Gate Bridge (*pl. 147*). Paul was also very drawn to Robert Frank's early,

almost romantic pictures of black-suited bankers on London streets (*pl. 193*). All of these described what was out there in the world, and many of them, like the Evans picture, were originally made in the 1930s. However, most of the prints in the collection, including the Abbotts, Gutmanns, and Stackpoles, were made later.

Rather soon my new friend, for such Paul certainly became, began to look at original prints seriously and attentively, and within a few years the later prints were either traded or donated. I believe that early in those years he also articulated more precisely the range of his collecting, saying that he wanted to own pictures that not only depict buildings but that also, somewhere within the bounds of their four sides, show a property he could own or lease. That was a limitation he welcomed, and I admit that at first I tried to encourage him to consider pictures of all kinds of architecture. But he was very clear that a more expansive approach was not of real interest to him.

I still find this a wonderfully individual and revealing, if sometimes baffling, way to define a collection. I respect it because it somehow fits, even reflects, Paul's personality, his interests, and, if one dare enter this ambiguous terrain, it is psychologically true. My friend is an accomplished businessman and has done some very adventurous things in his life. I believe it is fair to say that he has been very conscious and appreciative of, and nourished by, the idea of home, as well as curious and interested in a nonjudgmental way in places where people live, work, or go to enjoy themselves. Today we refer to this as the "built environ-ment," but I believe that he is an old fashioned idealist, and what really interests him is the idea of community. He believes in progress, in the ability of people to do better, to make their lives richer or more meaningful and purposeful. In 1965 he and his wife, Prentice, learned Swahili and took their four small children to Tanzania for two years, where he directed the efforts of the Peace Corps.

To define a collection as Paul has done may thus be natural for someone whose busi-ness interest is residential real estate, but I believe it is also an indication of how resonant the sense of place is to him, both the intimate space of home and the external space of the larger environment. In this volume Alan Trachtenberg writes of the complex theoretical and histor-ical associations place can have, and of the special relationship of photographs to the particu-larity of place, but the pictures in the Sack Collection refer personally to their owner. I do not believe he is sentimental. In some instances he has stretched his criteria for the collec-tion to include tents, caves, and the interiors of houses, especially if he is interested in a particular picture. I would not say that he necessarily considers all these kinds of houses ideal spaces, but he certainly finds pictures of them compelling enough to want to own. Sometimes he may claim as some kind of human dwelling what to the uninitiated eye more

17. John Gutmann
The Monkey, San Francisco, 1938
Gelatin silver print
9 5/16 x 6 15/16 in. (23.7 x 17.6 cm)

18. **Helen Levitt**
New York, 1939
Gelatin silver print
9 x 5 15/16 in. (22.9 x 15.1 cm)

closely resembles a rock or a bush or an unidentifiable speck, and that is enough to allow himself the pleasure of owning the picture. Like many collectors, Paul requires a sense of personal relevance to make the picture—beyond its quality—matter enough to him to feel right about owning it.

I think it took a couple of years for Paul to feel comfortable collecting pictures that were beyond the kind of photography he knew from Evans and pictures of cities. In 1989 he saw and soon purchased a wonderful Paul Strand, a cubist-inflected picture of sheds and picket fences on the Gaspé Peninsula (*pl. 15*). I asked him if SFMOMA could borrow it for the exhibition *A History of Photography from California Collections,* which the Museum was planning to celebrate the 150th anniversary of photography. When we organized a retrospective show of Helen Levitt's pictures, I was able to locate some remarkable vintage prints (*see pls. 18, 157–59*), which he admired and purchased. I also recall a Lewis Wickes Hine picture, another original print, small in scale but grand in the spirit it conveys, of a woman in the street carrying a pile of shirts on her head as she hurried, as majestic as a Greek caryatid, through lower Manhattan in the first decade of the last century (*pl. 107*). At the time the Museum's Department of Photography had little money to spend on acquisitions, and rather than give up on this picture, I showed it to Paul, suggesting that sometime in the future he might consider giving it to the institution. He began to value SFMOMA as a resource and would visit the collection and learn from it. In his unobtrusive way, he came to understand the strengths of our collection as well as its weaknesses. He understood that what he was buying for himself, essentially documentary photography, was not a strength of the Museum's collection, though it was one of the aspects of photography that I, a recently arrived curator, thought it appropriate to develop.

I do remember a moment when Paul asked if he should be looking at nineteenth-century photography, if that was an area of importance. As I recall, I said that some of those pictures were as modern and adventurous as the photographs he had already purchased, and that he would be eminently suited to explore such new territory. One of his favorites, and one of his earliest purchases in this new arena, is the remarkably protomodernist *Oxford, High Street,* made in 1843 by William Henry Fox Talbot (*pl. 14*). As the collection grew, it was fun to visit Paul and see what new pictures he was considering or what had been acquired. I cannot say I guided him, only that I was around if he needed me to look at something, and to make suggestions if they were wanted and needed. The rest he did by himself.

Not too long after his leap into the nineteenth century, which began in 1989, Paul decided to make use of a long room in his office suite that was not only quiet but also allowed light levels to be controlled. It was here that he chose to hang these newly acquired older

19. **Charles Marville**
Parc Monceau. Rivière et pont (Monceau Park:
River and Bridge), ca. 1862
Albumen print from a glass negative
9 3/4 x 14 1/4 in. (24.8 x 36.2 cm)

pictures—by Charles Marville (*pl. 19*), Louis De Clercq, and Bisson Frères as well as a
beautiful picture by an anonymous photographer of a building perched precipitously in
a rocky landscape in India (*pl. 78*).

About that time, perhaps a little more than ten years ago, the objective of the Sack
Collection was given a further refinement. Paul had hired Cynthia Herron to manage the
collection, and when she asked what he really wanted to do, he said immediately, "I want to
show the history of photography from the beginning to about 1975 in pictures that include,
somewhere within them, buildings I could own or lease." He understood instinctively the
continuity of the medium—that unlike painting there is no separate "modern" photography,
that in fact the whole medium, a child of the technological revolution of the nineteenth
century, is itself modern.

He also recognized that there are other kinds of modern photographs beyond the tradi-
tion of documentary work that would be worth exploring. The Museum's important collec-
tion of f.64 work and experimental European photography of the 1920s and 1930s provided
him with examples of high-quality pictures, and he discovered that some of the material still
available was extremely interesting to him and fit neatly within his declared scope. Thus he
purchased a rare and beautiful Laura Gilpin print, a still life of Indian ovens in Taos, New
Mexico (*pl. 140*); an enigmatic Ansel Adams print, also of Taos (*pl. 145*); and a photograph by
Tina Modotti, the first Modotti picture to enter the Museum's collection (*pl. 141*). He found a

surrealist picture by Ilse Bing of a crumbling, half-destroyed poster of Greta Garbo in a street in Paris (*pl. 174*) and a constructivist photograph of a grain elevator by Martin Bruehl (*pl. 154*). Paul did set a limitation: color was not to be admitted into the scope of his collecting. By the time color photography was introduced (William Eggleston's exhibition at the Museum of Modern Art, New York, was held in 1976 and stimulated a new generation of practitioners), he felt that the medium had changed in some essential way, that in general much of the more contemporary photography was not personally congruent with his interests, and, moreover, that color was then (and still is, to some extent) far less stable a process than the gelatin silver print.

Paul retired in 1992 and four years later moved the business from the California Street office to a space in the 49 Geary Street building, where many of the art galleries in San Francisco are located. He shared the space with his daughter, Kirby Sack, who now runs his company, and devoted his principal energies to his collection. He joked that the move would make his collecting more "convenient," but this may have been only partly true, as it also signaled, at least for me, a new adventurousness, a willingness to go to auctions in New York, Paris, and London or to visit those cities and see dealers and meet other collectors. He would often say he had retired from business to take up collecting full time, to read about photography and see as much as he could, and to collect the very best and most meaningful pictures that he could find.

This move to Geary Street roughly coincided with the opening of SFMOMA's new building in January 1995. As arguably the second-oldest museum of modern art in the country, SFMOMA had, since its inception, been located in San Francisco's Civic Center neighborhood. Its spacious Beaux-Arts building, constructed to house the Museum and the city's major veterans' organizations, opened in 1935. SFMOMA had long outgrown the building, where its displays were installed on the top floor and in the corridors of the floor below. Much of its great photography collection was displayed in those hallways, and much of its substantial permanent collection was seen irregularly. The new building inspired the staff to rethink the Museum's mission, and the Photography Department, with one of the largest and oldest collections (and one of the most esteemed) in the country, was given more space for temporary shows as well as a gallery devoted to the photography collection. The department decided that this was an opportunity to rethink the scope of the collection: rather than defining photographic modernism as having an equivalent in movements in modern painting, the entire history of the medium could justifiably be considered modern. Thus the staff determined that the permanent-collection gallery should display the entire history of photography, from daguerreotypes and salt prints to present-day efforts. This decision was based not only on the

abstract belief that such a display would be more historically relevant and true, but also in great part on the fact that we had come to realize how much we depended upon Paul's enthusiasm for earlier photography and his understanding of its relevance to the larger history.

As the Sack Collection was moving to its new space on Geary Street, we had the welcome opportunity to see him even more often — and to help avert an unforeseen danger to the collection. Paul had become very interested in the conservation of his photographs; he has always been very concerned about print quality, insisting that the pictures he buys be in the very best condition. (We soon learned that his sister-in-law, Susanne P. Sack, had been the chief conservator at the Brooklyn Museum of Art.) Before the move to his new office space, he consulted with Jill Sterrett, then SFMOMA's paper conservator and now head of conservation, about the best way to store and preserve his prints. One afternoon she came to visit as he was installing the collection in its new space. The rooms had been painted the day before, and the racks and file cases were already in place, but instead of helping him install the pictures, she told him it was essential to move them offsite immediately to protect them from the ill effects of gases released into the air by chemicals in the enamel-based paint. There were a couple of anxious hours that day as Jill and Paul worked together to save the collection from certain damage.

The new SFMOMA building and our commitment to show photography as a modern medium in its entirety demonstrated to our friend how important his collection had become to the community and how closely it fit into and expanded the Museum's holdings. Paul had played an enormously important role when the Museum's accessions committee determined to exclude the Photography and the Architecture and Design Departments from the presentations and discussions of proposed acquisitions, restricting the committee's focus to objects coming into the Department of Painting and Sculpture. Rather than complain when we had lunch soon afterward, Paul said, with his usual pragmatism and sense of adventure, "You should have your own accessions committee," and he was the first to lead it.

He also had come to understand, even before the new building opened, how lively and important photography is to the San Francisco community. He recognized it as an important heritage of the Bay Area, perhaps its most important artistic contribution since the nineteenth century. One day in 1998, with absolutely no warning that I can recall, I came back from a trip to the surprise of my life. Paul had given the Museum some pictures and saw that they were promptly shown in our galleries. He clearly enjoyed sharing his pictures with us and with the community, later confiding that he had been inspired by the example set by Albert M. Bender, a founding trustee of the Museum and an enthusiastic benefactor. In 1998 Paul originated a trust arrangement with the Museum, the very first of its kind anywhere, so

that his pictures would be held jointly by him and the Museum, that he and I and SFMOMA's director would be its trustees, that we would have the collection at our disposal to show in the Museum, and that he would have the pleasure of keeping them safe in his carefully arranged space nearby. True to his background in real estate, he asked that we give thirty running feet to his collection each time we changed the permanent-collection display, but where we chose to focus the pictures in the historical stream was to be our decision. Since the pictures are so good, and so necessary to fulfill the Museum's ambition to show the entire history of the medium, such perspicacious generosity on the part of Paul, who established the trust at SFMOMA with the full understanding of what the Museum owns and how these pictures could benefit the institution, has ensured the high quality and range of what can be presented to the public.

I should mention that Paul has taken very seriously, and with characteristic enthusiasm, his new role as ambassador for photography. For many years he was actively engaged with the Friends of Photography, an organization that Ansel Adams helped initiate in Carmel, and which moved to San Francisco in 1989. At the San Francisco Art Institute, he gave an annual cash award to the best young photographer working in black and white. And he became a trustee of SFMOMA, giving his support for the quality and importance of the department to the Museum as a whole. He has never ceased to be an advocate for this medium, which he embraced, relatively late in his career, with passion and intelligence.

His collection bears the marks of the original enthusiasm that motivated it, but I believe it is fair to say that the attention he has given to studying the history of photography has resulted in a more complex and richer collection. While retaining his love of the "sport," as he calls it, of discovering and purchasing photographs, he has developed a discerning and original eye. He has challenged himself to see the bigger picture, to look at all kinds of photography, from the most obscure photographs of the nineteenth century to contemporary work to vernacular pictures of special poignancy. He has some very daring pictures—including relatively recent acquisitions by Henri Cartier-Bresson (*pl. 179*), Diane Arbus (*pl. 204*), and Francesca Woodman (*pl. 20*). He is not afraid to make mistakes, and he does his homework. There have been occasions when I have brought him pictures that took him a longer time to understand, and he has been patient with me, as, for example, when the Museum was given the opportunity to acquire some remarkable early pictures by Charles Sheeler. It was not entirely clear to him why these pictures are so remarkable (and so expensive). The picture he chose, *Side of White Barn* (1917; *pl. 143*), is certainly one of the very great photographs in American history and one of the treasures of his collection.

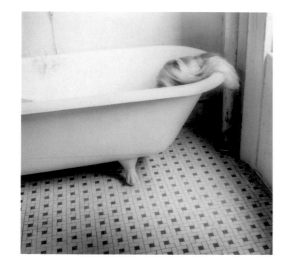

20. Francesca Woodman
New York, 1979–80
Gelatin silver print
6 x 6 ⅛ in. (15.2 x 15.6 cm)

He has maintained his original affinity with documentary photography, which is reflected in the large proportion of Walker Evans pictures in the collection, as well as in the work of those for whom Evans was an important guide: Lee Friedlander, Garry Winogrand, even early William Eggleston (in black and white). He has continued to explore photographs of the West; his collection extends from nineteenth-century pictures of western development by Timothy H. O'Sullivan, William Henry Jackson, Andrew Joseph Russell, and others to the modern westerners Robert Adams and Lewis Baltz. He has included Pictorialism in his purview, another fortunate move, as the Museum's collection is sadly deficient in this area. And although SFMOMA has some strength in European photography between the wars, we had scarcely any good vintage work by André Kertész, for instance. Through the Sack Collection, we now have important examples of work from Kertész's period in Hungary (*pl. 21*), Paris, and New York. The same can be said of the Man Ray pictures in his collection (*pl. 173*): they expand, in marvelous and unexpected ways, the representation of a photographer we thought we knew.

21. André Kertész
Wine Cellars at Budafok, Hungary, 1919
Gelatin silver print
1¹/₂ x 2¹/₈ in. (3.8 x 5.4 cm)

One of the Sack Collection's more recently acquired strengths is a suite of Atget prints (*pls. 124–29*) we both spent many hours looking over. Paul's contemporary pictures include work by Bernd and Hilla Becher, Cindy Sherman (again in black and white), Gordon Matta-Clark (*pl. 217*), and Thomas Struth, representing an adventurous expansion of his interest into the arena of Conceptual art. The most recent addition has been in the field of daguerreotypes, and, here again, Paul has found pictures that are remarkable and original (*see pls. 34–36*). His objective, to represent the history of the medium within his particular purview, has been undeniably and most ably accomplished. In the meantime, he has begun to form two related collections, one of Japanese photography and the other of pictures of the wives of photographers (*see pl. 22*). Both collections contain remarkable pictures.

Such a partnership has rewards that go beyond the professional. Paul Sack has had a very good life and has achieved what he most wanted to do. He is one of those generous and enlightened people who give back to their community more than they have profited from it, and he has the respect and friendship of those he met along the way. I think it is mostly his optimism that is so cherished and inspiring. It is a rare person indeed who can be a friend, partner, and benefactor, and we in the community and at the Museum are graced by his presence.

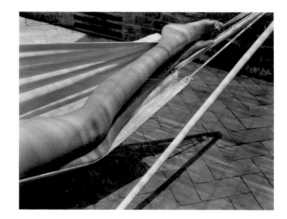

22. Edward Weston
Legs in Hammock, Laguna, 1937
Gelatin silver print
7⁵/₈ x 9⁵/₈ in. (19.4 x 24.4 cm)

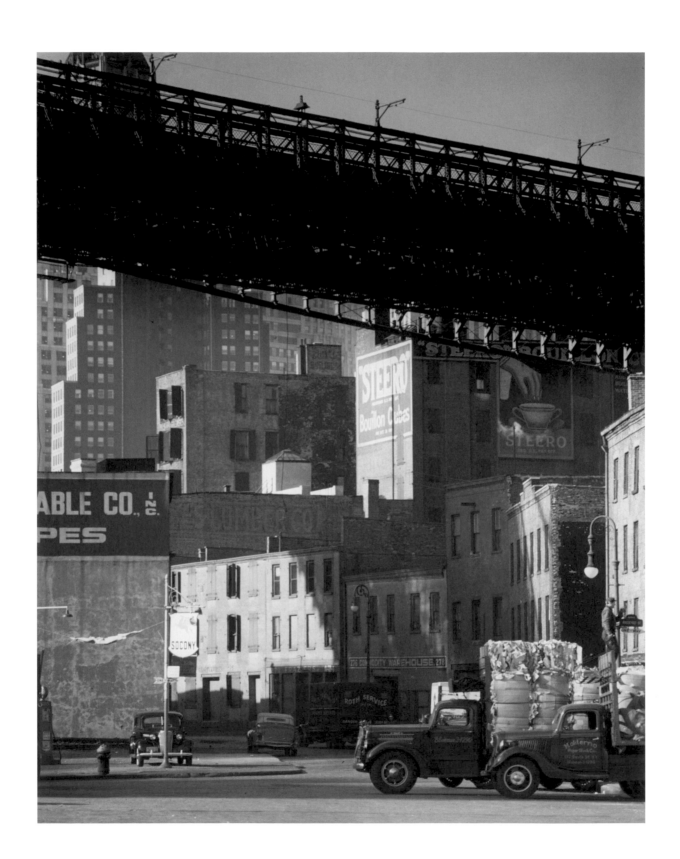

TAKING PLACE

Motifs of Space and Time in Photography

*A place that ever was lived in is like a fire that never goes out. It flares up,
it smolders for a time, it is fanned or smothered by circumstance, but its being is
intact, forever fluttering within it, the result of some original ignition. Sometimes
it gives out glory, sometimes its little light must be sought out to be seen, small
and tender as a candle flame, but as certain.*

——EUDORA WELTY, "Some Notes on River Country"[1]

Alan Trachtenberg

To talk about "place" in photography, a subject vast and boundless, we ourselves need a place, a solid footing somewhere. Drawn from a remarkable collection of pictures assembled by Paul Sack with a keen eye and a questioning mind, this exhibition gives us ample ground on which to stand. The title, *Taking Place*, is a shrewd provocation. The photographs invite us to stand before an image and let our imaginations roam in search of clues to what gives that place its particularity. Each picture discloses a point in space inhabited by objects and memories, intentions and desires that we catch as intimations, not certainties but possibilities of meaning. The images ground us in elusive particularities. As an ensemble, they comprise an extended meditation on place, on history, and on photography.

A forlorn dress hangs from a cart jammed against a blank wall in Miroslav Hak's haunting wartime picture of 1942, *Ve dvore* (In the Courtyard; *pl. 186*). That fugitive figure of a dress makes a *place*, not merely a location, of that grim, shabby corner of a broken city or village. The dress spells mystery, something once filled with throbbing life now limp and lifeless, the corpse of a dress still suggesting the contours of a living woman's flesh; it evokes anxiety about the fate of the woman, of the city or village, of the place itself.

23. **Andreas Feininger**
*New York, South Street, Corner of Roosevelt Street
and Brooklyn Bridge,* 1940
Gelatin silver print
9 3/4 x 7 5/8 in. (24.8 x 19.4 cm)

The dress is a human artifact, like the cobbled courtyard and clobbered walls, like the photograph itself, which is also a place, not just a picture of a somewhere but a place in its own right where human activity occurred and continues: the making and the viewing of the picture. Just as the emptiness of the dress stirs us to imagine its fullness, the warm body it once covered and expressed, so the emptiness of the courtyard moves us to wonder what secrets the cobblestones bear on their worn surfaces, what unspeakable things the dress might utter. The photographer found this scene, brought its elements together, and discovered or invented a place where experience has happened and can continue to happen in successive viewings of the picture.

The Hak photograph typifies the pleasures and provocations of this unique exhibition. Place is the overriding theme, but these are not pictures of an abstraction floating in a void. We see locations that have been made into places by human activity, activity embodied in buildings, monuments, roads, bridges, signs of human presence even if people are not visible in the scene. In some of the pictures we see human figures as bodies clad or naked, or as shadows, silhouettes, reflections, or empty dresses. The scenes represented in this diverse and bountiful exhibition earn the name of "place" by virtue of the human markings they reveal, marks of labor, marks of love, marks of pleasure and of woe. There are also marks of conflict, of private property and public access, questions of what belongs where and to whom.

As an exhibition of photographs, photographic *pictures, Taking Place* reveals that to take is also to *make* place in a specifically photographic way. Paintings and drawings portray places, too, but the photograph endows its image with something of its own character, something elusive that might be called *specificity*. Although critics and theorists have not settled questions about the unique character of media, we can say that photographs as a rule do not portray or depict but rather *present* their subjects. Of course, presentation can legitimately be called portrayal or depiction, but the methods employed by artists in different media take on a life of their own. About a photograph we can say (we must say) that we are given this particular view of the visible world because a camera was placed there and its shutter released. It is difficult to imagine a truly placeless photograph; even abstractions produced by extreme close-ups of skin or rocks or the surface of the moon, images you have to pore over to make out, tell us that we are looking at a point or position in space. And also in time. Photographs give us a view of a specific somewhere made at a specific time. They "take place" as events in both space and time; they have a *when* as well as a *where*; they collapse one into the other to produce the illusion of a fixed, unmoving event that is the still photograph.[2]

In its historical sweep, *Taking Place* represents the world in flux. We see ruins of the ancient past, as in Calvert Richard Jones's classic rendering of a canonical classical ruin,

Colosseum, Rome, Second View (1846; *pl. 24*), displayed on the same gallery walls as images of fresh destruction by modern warfare; we gaze on new buildings under construction, crowded cities, cramped streets, modern highways, decaying buildings, country estates alongside scenes of poverty, the lavish alongside the abject: the collection presents a visual history of change. It asks us to think about the era of the photograph as a time of complex forces reshaping the look of the man-made world, changing the face and the meaning of "place." It also invites us to think about the work of photography and the conditions of seeing and knowing that the medium has enabled.

As a rule, most photographs barely hold our attention. Conditioned by overload, we take a quick glance, no more. As one historian put it recently, "The photograph has become almost invisible."[3] When we pay close attention and photographs do become visible *as photographs,* we are often so dazzled by the illusion of some remnant of the world that we tend to pass over the questions "How does this sense of presence happen? What gives photography such power to bring past places and objects into present experience?" The camera seems a disembodied eye, and we trust its report without blinking. Here is a street, a vista, a room. We see certain particulars.

Yet we also see an act of seeing: someone's embodiment of the abstract powers of the camera, a creative act in the sense that something that had not existed before—just this picture—came into being. The photograph seems so much a reflex of what it shows that we typically fail to realize how much of an artifact it is, something crafted by technique, desire, skill, intent. Seeming to show the world effortlessly, photographs appear to embody two sides at once, their own cause—the self-delineating scene in the world—and the effect of that cause, the picture itself. Too often we leave the photographer out of the equation; too often we forget the fact of the camera.

Garry Winogrand was fond of saying that he makes pictures in order to see what things look like photographed. To say of photographs that they do no more than show the world photographed may seem willfully redundant and obvious. But such self-evident comments can startle the mind and open the eyes. Photographs do show at least this: the world in the state of *having been* photographed. Yes, but it's not as easy a proposition as it may seem. We stand before a picture made with a camera. What exactly does this mean, in all senses of the words? The philosopher Stanley Cavell offers one deceptively simple answer. "When we see a photograph," he writes, "we see things that are not present." Things photographed are (or were) *elsewhere,* in another place, another time. In a photograph we see things that we know are absent from us just as we are absent from them. They were already absent from the photographer the instant after the picture was taken.[4]

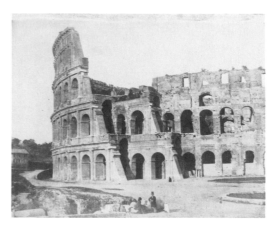

24. Calvert Richard Jones
Colosseum, Rome, Second View, 1846
Salt print
7 3/4 x 9 3/4 in. (19.7 x 24.8 cm)

We can say about every photograph, figuratively and a bit fancifully, that it shows some part of the visible world already in the process of becoming a ruin, going down into earth, dust to dust. Hence the air of melancholy that hangs over many photographs, as Roland Barthes explains in his *Camera Lucida*.[5] Making past places and faces seem present to us (as they once were present to someone), the photograph inevitably registers a loss, something gone forever, the evaporation of a once-substantial thing; they seem present to us only insofar as we know they are not. Photographs make absence into presence. Melancholy and sadness define the climate in which we learn to love and fear photographs. We know in our bones that this is true and important.

How did the camera get to be in that place at that time, and why? We know that it had to be somewhere in the presence of what it shows, that it had to *take a place* before it could show a place. Where are we in Lewis Wickes Hine's *Empire State Building Construction* (1931; *pl. 148*)? We are looking down from a great height, at a slight angle, over the city of New York, as we can tell from the silvery tower of the Chrysler Building just off the center of the picture. But all the visual interest in this grand vista in the sky falls on the worker precariously perched on a steel beam, head tilted, left arm extended and thumb pointing downward, presumably signaling to someone below. Something is going up, the steel frame of a building, yet all the tension of the picture, its lines of force, point *downward,* dangerously.

The beam above and the one on the left to which the worker clings for support, for his life, frame the figure. The right-angled beams create the effect of a picture within a picture, the effect of a frame (a window frame?) within the larger frame of the photograph's four edges. It's the location of the camera that creates this window effect. We can surmise the exact place where Hine stands at eye level with the worker, both hanging on high above the city. The city below, with its solid ground and floors, overlaps to dizzying effect this scene of treacherous footing. The picture induces in us all the fears aroused by great heights.

Photographer and worker virtually mirror each other. Like the worker, the photographer not only balances himself on a beam or platform nearby but is also pointing. He aims his camera for the sake of a photograph that in turn points to things in the world. The picture makes the scene of pointing into a *place,* not only a "where" but a location where something happens, something the picture makes memorable. The "where" is a workplace, a twin workplace, that of the skyjack and of the photographer. They belong together in a mutual act of labor. The finished building will "belong" to a corporation, but for the time registered in the photograph it belongs to those who labor there in construction and in representation. Skyjack and photographer perform similar acts of pointing to an elsewhere, the work of the camera

analogous to the worker's thumb. The finished picture represents a view (what we see) and also an *act,* an event, something *taking place*—two symbiotic events, what's recorded (the perched worker, the pointing thumb) and the making of a photograph. It is not only a picture *of* something or somebody, as if taken through an open window, but a picture of something that includes *itself* mirrored invisibly, its own singular act of photographic picturing.

There's also a history embedded in the image. It shows a worker helping to build what was then the world's tallest building. By showing (invisibly) that the photographer is also a worker, Lewis Hine confirms an identity he had already established with his pictures of child labor in the early twentieth century. The Empire State Building pictures extend that identity to include strenuous and heroic feats of physical labor. There is also a historical context to which the pictures speak. Hine's aim was to celebrate labor, to show that it is workers operating machines who make "machine-made" things. The Empire State Building was hailed as celebrating something else: empire, power, and wealth. It was designed and publicized to represent the capitalist economy in which what transpires in corporate offices in tall build-ings (like this one) produces the city's and the nation's wealth and thereby controls the destiny of laboring people and the life of cities. Hine wanted to show labor at the base of wealth. The building opened just after the crash of 1929 and the onset of the Great Depression. Hine published his pictures of "Men at Work," including the Empire State Building pictures, just as unemployment began to soar. *Empire State Building Construction* is ringed with historical and ideological ironies that become inseparable from our understand-ing of its work, once the picture is reconnected to its place in space and time, its historical as well as physical place. Hine's image delineates a curious kind of place, transient and fragile, soon to be obliterated by the completion of the very work that gives the location a tempo-rary character of place, where something worth remembering occurs. It's a place about which we can say that without Hine's camera it would not exist—a paradoxical place constructed by photography.

Photographs are place-specific in particular ways. A camera had to be put down and held still for the duration of the exposure. If it's a photograph on paper, most likely there was a negative before there was a positive image; the picture we see was made not at the original site but at another place, a darkroom. Negatives can be as arresting as positive prints, as the stunning examples in the Sack Collection reveal. They give physical evidence that the process of making a photograph includes a moment of reversal, a phase when the world of "normal" vision seems to be canceled, regions of light and shadow inverted, and, as in a mirror, space switched right to left.

25. Benjamin Brecknell Turner
Ludlow, ca. 1852–54
Paper negative
11 3/4 x 15 3/4 in. (29.8 x 40 cm)

Taking Place helps restore the negative, such as the stunning *Ludlow* (ca. 1852–54; *pl. 25*) by Benjamin Brecknell Turner, as worthy of both aesthetic and theoretical consideration. One implication of the invisible presence of a negative within a positive image is that every photograph holds within itself a hidden trace of its opposite. The relation of negative to positive corresponds roughly to the idea, stimulated by the vast changes in the nineteenth century, that the present is always passing away, always becoming something else. The existence of negatives may very well account for some part of the extraordinary appeal of photography in its early years.

It is not surprising that an era undergoing deep, turbulent change, as did the long nineteenth century (from the French Revolution at the end of the previous century to the Great War early in the next), should be gripped with thoughts of negation and change, the long, slow sequences of geological change and the sudden, eruptive changes of modern times. A product of the first third of the nineteenth century, photography entered a culture tense with anxiety about new technologies and social relations, changes in the experience of space and time and in the meaning of place. Photography appeared alongside other instruments of change such as the steam engine, the railroad, the telegraph, the factory system,

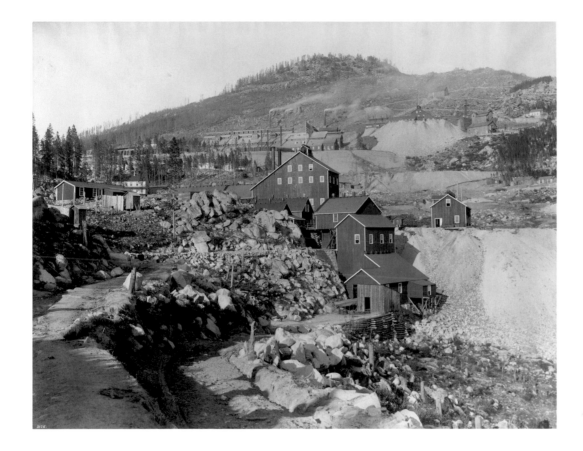

26. **Frank Jay Haynes**
Granite Silver Mine, Montana Territory, 1887
Albumen print from a glass negative
16 7/8 x 21 1/2 in. (42.9 x 54.6 cm)

and, as we see in Frank Jay Haynes's *Granite Silver Mine, Montana Territory* (1887; *pl. 26*), the application of modern machinery to the extraction of profitable minerals from deep below the surface of earth. Perception of upheaval in traditional modes of life, social forms, and cultural practices made the first era of the photograph seem a time of frenzied activity with uncertain ends.

In the first important novel with a photographer as a protagonist, *The House of the Seven Gables* (1851), Nathaniel Hawthorne describes two elderly people in New England on their first railroad journey:

> *Looking from the window, they could see the world racing past them. At one moment, they were rattling through a solitude;—the next, a village had grown up around them;—a few breaths more, and it had vanished, as if swallowed by an earthquake. The spires of meeting-houses seemed set adrift from their foundations, the broad-based hills glided away. Everything was unfixed from its age-long rest, and moving at whirlwind speed in a direction opposite from their own.*[6]

The passage echoes observations throughout the era, the sense of a world rushing ahead, unsettling all traditional ideas and experiences of time and of place. The classic expression of

a rupture with the past appeared in the words of Karl Marx and Friedrich Engels in 1847: "Constant revolutionizing of production, uninterrupted disturbance of all social conditions, everlasting uncertainty and agitation distinguish the bourgeois epoch from all earlier ones. All fixed, fast-frozen relations, with their train of ancient and venerable prejudices and opinions are swept away, all new-formed ones become antiquated before they can ossify."[7] With its own seeming power to unfix images from actual things—in Oliver Wendell Holmes's fanciful trope, removing skins from substances—photography was taken as partner to all the new forces of upheaval.[8] But if a symptom, photography also offered an anodyne. What it unfixed it was also capable of refixing, in the form of a still (or stilled) image. If space and time seemed sundered by the new forces—the railroad, for example, changed old ideas of how long it takes to get from here to there—the photograph seemed to reunite them, to recover a stillness in which contemplation is possible, contemplation of the world in the form of an image of what is absent yet seemingly, and strangely, present: an imaginary place made visible as image.

Is there, then, a special affinity between the medium and the concept of place? Looking more closely at the concept, we can learn from anthropologists, geographers, philosophers, and poets that it takes more than a locus to make a place. Place in the most meaningful sense of the word is not a gratuitous gift of nature. Places are sites of memory, association, and habitation. They are where life has been lived and shared; they are communal artifacts of consciousness, though there are entirely personal places as well. A culture of superhighways and jet airplanes, e-mail and virtual reality has tended to obliterate the sense of difference between here and there; to be somewhere has come to seem like being anywhere or nowhere.

But to qualify as a place in the traditional sense, whether for an individual or a group, a locus must be the site of a significant occurrence, an event (like a battle) remembered and memorialized, perhaps with a physical marker. It can be identified with particular activities, like the workplace or the home. It has a name and has stories that explain why it stands apart from other places. Place is seatedness and rootedness, a relation to earth and sky: a place-world that gives focus and meaning to those who dwell there, at the site itself or in the imagination of the site. Places are imagined to give back of themselves to those who inhabit their aura of memory and meaning. One anthropologist writes, "Place-making is a universal tool of the historical imagination."[9] For persons or whole societies, to be deprived of place by the destruction of war, the erosion of time, the expropriation of communal property, is akin to loss of an essential component of being.[10] It is to become alien everywhere, in a state of perpetual estrangement.

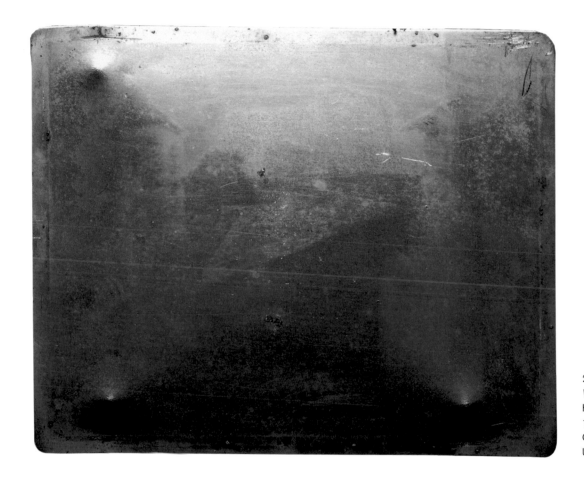

27. **Joseph Nicéphore Niépce**
View from the Window at Gras, ca. 1826
Heliograph
10 1/8 x 11 3/8 in. (25.7 x 28.9 cm)
Gernsheim Collection, Harry Ransom Center,
University of Texas at Austin

What difference has photography made in the experience of place? Seeming to overcome distance, making the distant and the past seem present here and now, photography can appear to be a solution to the displacements of the "constant revolutionizing" that grips modern societies. It seems to offer a recovery of the past from the ravages of time and forgetfulness. Early photographers were drawn to old things in cities and in the countryside, to ruins in distant lands (especially regions such as India, North Africa, and Asia Minor coming under imperial domination by Europe). Could it be that the erosion of place by the new technologies of transportation and communication, that loss of connectedness to the tangible world, gave photographers a motive, conscious or not, to experiment with the place-making capacities of their new instruments of seeing?

The first known photograph was made from a window, a noteworthy fact of place making by looking out. The picture, made by Joseph Nicéphore Niépce and known as *View from the Window at Gras* (ca. 1826; *pl. 27*), seems no more than a smudge of light and shade.[11] But clearly enough, this is a picture of one place taken from another. Its fragmented shapes and

diagonal lines might suggest a cubist painting, as if a protomodernist image stands at the threshold of photography. In their account of what the picture shows, Helmut and Alison Gernsheim rely on markers of spatial relation: "On the left is . . . the pigeon-house (an upper loft in the Niépce family house); to the right of it is a pear-tree with a patch of sky showing through an opening in the branches; in the centre, the slanting roof of the barn. The long building behind it is the bakehouse, with chimney, and on the right is another wing of the house (as it was at the time)."[12] The description gives a spatial account of the scene, as if place is defined primarily by geometry. The camera obscura seems to bring one place into another in the form of an exact image projected upon its own translucent window of ground glass, an image that seems a perfect apodictic replica of something real: the illusion of an elsewhere brought inside.[13]

Overlooked by the Gernsheims, and by other commentators on this historic picture, is the outline of a window mullion visible on the left side of the image. This faint hint of additional frames within the frame of the picture points ahead to modernism in yet another way: the inclusion of the subjective position of the observer within the image of what is observed. By including evidence of the window within the picture, however unconsciously, Niépce raises an implicit challenge to the assumption that the camera obscura delivers a demonstrably objective view of the world. From the beginning, then, windows emerged as complicating elements in photographs, points of mediation between inside and outside, between inner vision and outer sensory experience.

Convenience probably explains why Niépce chose to position his camera out of the window of his work space. He may well have been aware, too, that views from windows had the sanction of fine art. A view from a window through which the light of the outside world pours into an interior space was a familiar thematic in pictorial conventions, especially in seventeenth-century Dutch paintings. Early photographers understandably took bearings and inspiration from existing pictorial practices. Available conventions and genres such as portraiture, landscape, interior views, still life, conversation pieces, and genre paintings gave opportunities for practitioners of the new medium to discover new ways of making pictures in the old manner. The view through a window, often a latticed or mullioned sheet of glass, often opening onto a landscape or a view of buildings, was one such painterly trope early photographers found particularly appealing, a way of testing the powers of the new medium while demonstrating its ability to compete with fine art.[14]

If Niépce's first picture was from a window, William Henry Fox Talbot's was *of* a window. Windows appear throughout Talbot's pictures, enough to suggest that this inventor of the negative-positive process was possessed by a tropism for light-porous openings in walls.

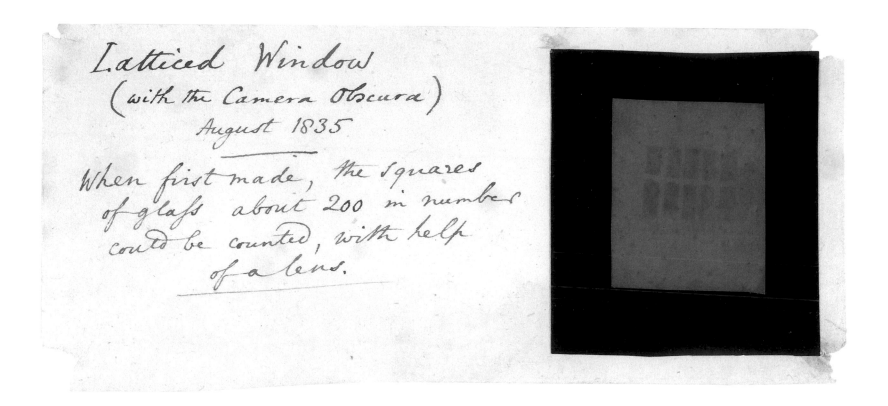

The suggestion is intriguing, for windows lend themselves easily to serving as an analogy or symbol of the camera lens looking out (like an actual eye) from an interior space. Talbot's earliest surviving negative (*pl. 28*), dated August 1835, shows a latticed window from inside a room. He explained: "When first made, the squares of glass about 200 in number could be counted, with help of a lens."[15] Discussing another inside view of a window, a picture Talbot made in Rouen in 1843, Anne McCauley speculates that his interior perspective shows that "subjectivity itself" is the subject of the picture. His windows suggest that Talbot wished to think himself inside the camera in order to grasp better the constructive role of subjectivity in the making of the view.[16]

Was Talbot drawn to the 1835 view because such a window looks like an array of individual lenses, a multitude of viewing points, each offering a slightly different perspective on the world? We might read in his first negative a kind of allegory or parable of photography as a subjective act of seeing through a lens from a fixed position within a specific space, as if through the mediation of a window. The brief essays accompanying each image in his *Pencil of Nature* (1844–46), the first printed book with tipped-in photographs, while they ruminate about the uses and the good of what he called "photogenic drawing," show Talbot's heightened awareness that photography *always* takes place in a place. His attraction to windows can be taken as Talbot's realization that photography is the most contingent of media. Everything

28. **William Henry Fox Talbot**
Latticed Window in Lacock Abbey, 1835
Paper negative
1 1/8 x 1 3/8 in. (2.9 x 3.6 cm)
National Museum of Photography, Film, and Television, Bradford, England

depends on where the photographer places the camera. *How* the photographer sees matters as much as *what* he or she sees. Once the camera is put somewhere, Talbot notes with pleasure, the lens-eye can be turned upon anything in the physical world; it gazes with the same disinterested stare everywhere and at anything and everything. With the freedom of air and light, it sublimely ignores property rights or political borders and mocks the prerogatives of private ownership.

The Pencil of Nature gives "place" for each picture, and often time as well. About the opening image in the book, *Part of Queen's College, Oxford,* he writes: "The view is taken from the other side of High Street—looking North. The time is morning." Time past is rendered by photography as time *now* and so can be spoken of in the present tense: "The time is morning." For Talbot, place and pencil open the door to the future for photography. Pencil implies that each image has an unconscious story embedded in its overt content, a story of an occurrence in a certain place at a certain time.

The Gernsheims observe that the exposure for the Niépce photograph must have been about eight hours, for the sun seems to be "shining on both sides of the courtyard!"[17] In *The Pencil of Nature,* Talbot writes about a picture of the gateway to Queen's College, Oxford, noting that when examined with the aid of a magnifying glass, "a distant dial-plate is seen, and upon it—unconsciously recorded—the hour of the day at which the view was taken."[18] Niépce's picture and Talbot's remark about the dial-plate both express the self-evident but nonetheless profound truth that every photograph of a space is also a picture of a slice of time in that space, the site where what exists ineluctably passes away.

There's another implication in the habit of pointing cameras out of windows. Niépce photographed a place intimately familiar to him, continuous (as part of his estate) with the private realm of his workroom, his private property. Though the window was probably of no more significance than a convenient place to prop the camera, there may well have been a certain proprietorial pleasure in looking down from that height on the courtyard of his rural château. A traveler away from home, Talbot writes about his *View of the Boulevards at Paris* that it was "taken from one of the upper windows of the Hôtel de Douvres."[19] Pointing his camera out the window of a guest room could be how the tourist made himself feel at home.

Besides appropriating a convention from other graphic arts, there's a historical process at work in the use of the window as the site of photographic seeing and observing. When the lens is pointed out from an enclosed room in a city, the image flashing on the ground glass of the camera obscura allows the viewer to enjoy the outside scene, to possess it as an imaginary good from within a private (even if rented) space. With rapid urbanization throughout the nineteenth and twentieth centuries and the spread of the typical

middle-class nuclear family, the number of private homes and rented flats in city buildings increased dramatically. A gap both spatial and social opened between private and public space, between the domestic and the civic realms. That distance corresponded to an emerging social reality: privacy as a middle-class goal, the segregation and seclusion of individuals in increasingly segmented private dwellings.

Especially as the camera became more portable and mobile in the later nineteenth century, it encouraged the use of windows, through which light comes in, as viewing points for looking out. It encouraged the passive mode of spectatorship toward the life flowing in the streets below. By looking through cameras pointed out of windows, one might remove oneself to an elsewhere, the intervening space (a social space) between oneself and the outside seemingly overcome by the mere downward cast of the eyes. Cameras pointed out of windows can be seen as an early initiation into the modernity and the culture of spectacle that the invention of photography inaugurated and heralded. Niépce's gesture at his estate and Talbot's in Paris foretold a future use of photographs: looking out from segmented private spaces into increasingly distant, detached, and fragmented public places.[20]

If any object seemed to designate a distinctive place, it was the ancient ruin: pyramids, temples, fallen columns, decayed parapets—the kinds of traces of past glories in deteriorated stones as seen in James Anderson's *Tombeau de Cécilia Metella, via Appia Antica, Rome* (Tomb of Cecilia Metella, via Appia Antica, Rome, ca. 1857; *pl. 29*). Apart from capitalizing on the popularity enjoyed by such imagery in paintings and engravings, photographers perhaps found something cognate to their own work in the motif of the ruin. Georg Simmel remarks in his essay "The Ruin" that all things built by man represent at once a "striving upward" and a "sinking downward," that the ruin represents the battle between human will and natural process. The ruin "is the site of life from which life has departed," and for this reason "the ruin creates the present form of a past life."[21]

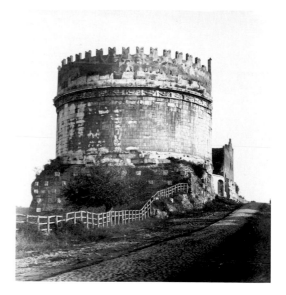

29. James Anderson
Tombeau de Cécilia Metella, via Appia Antica, Rome (Tomb of Cecilia Metella, via Appia Antica, Rome), ca. 1857
Albumen print from a glass negative
13 9/16 x 12 7/16 in. (34.4 x 31.6 cm)

The past surviving into the present as a trace of its former fullness: cannot the same be said of the photograph? Like actual ruins, photographs of ruins declare the futility of monuments built as gestures toward eternity. But photographs are also ruins in their own right; we might say they make their subjects into ruins by fixing the image into an illusion of stillness, the illusion that time has been stopped. The release of a shutter resembles the tick of a clock, a notice that what is present is already past, that the resulting picture presumes the inevitable passing away of the subject, its return to earth. We can say that photographs consign their subjects to a forestalled decay in the very act of preserving their images against the ruination of time. Pictures like Robert Eaton's *Roman Forum* (1853; *pl. 75*) and Timothy H.

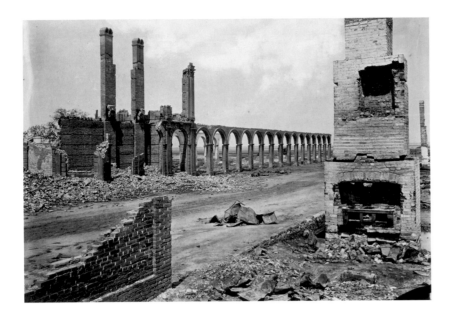

30. **George N. Barnard**
Ruins of the Railroad Depot, Charleston, South Carolina, 1865
Albumen print
10 1/8 x 14 1/4 in. (25.7 x 36.2 cm)

31. **Ilse Bing**
Champ-de-Mars, vue de la Tour Eiffel
(Champ-de-Mars, View from the Eiffel Tower), 1931
Gelatin silver print
8 3/4 x 11 1/8 in. (22.2 x 28.3 cm)

O'Sullivan's *Ruins in Ancient Pueblo of San Juan, Colorado* (1874; *pl. 101*) might be taken, then, as reflections on photography itself, on the memento mori—"remember that you must die"—every photograph whispers to its viewers. "The photograph, like the souvenir, is the corpse of an experience."[22]

Wars such as the American Civil War presented another challenge: how to make a place-world of the site of the destruction of place and of human bodies. What gives the power of astonishment to George N. Barnard's *Ruins of the Railroad Depot, Charleston, South Carolina* (1865; *pl. 30*) is the sad receding line of Roman arches, as if they were the remains of an aqueduct in the French countryside rather than the wrecked side of a railroad depot (the epitome of modernity) at the heart of the Confederacy in the United States. The Roman arches call up southern plantations, the classical facades (in wood) of American slavery, the self-deceiving aspiration toward eternal empire. The initial discordance of Rome in South Carolina, of aqueduct and railroad, becomes both bathetic and injurious in the setting of this photograph of General William T. Sherman's willful military destruction. The bathos and the tragedy fuse into the making of a place that seems entirely photographic, a moment of stillness seized from a history of devastation. The place will be rebuilt, and the image will survive as the only record that this scene of wreckage once cohered in someone's eyes into the significance of a place. Something cataclysmic happened here, a "here" rich with ironic association, now fixed into memory of a specific historical past.

In a different register, Helen Levitt's quiet masterpiece, *New York* (1939; *pl. 18*), reveals a group of free-flying children at play, clambering over another misplaced example of

classicism, a faux-Greek portal in a New York slum. Debasement of the sacred in these shabby, incongruous gestures toward something ancient and monumental suggests that the work of photography, with its unappeasable appetite for all visible facts, includes the stripping away of the sacred on behalf of the profane, the secular, the worldly. Roland Barthes observes that by making photography "the somehow natural witness of 'what has been,' modern society has renounced the Monument."[23] Yet in the wonderful fluidity of the children's bodies, the hint of heroic combat at the very place it would have been depicted on ancient friezes, Levitt's photograph shows that a certain way of seeing can restore the spirit of the sacred and the monumental in the most profane of city spaces. Place emerges from the mutual play of the boys and the photographer as together they take down the pretense of the facade.

From the beginning, photographers have been self-conscious about their medium, a way of picturing that defies the time-honored association of visual art with skills of the hand. Place making in photography has often entailed commentaries, deliberate or unconscious, by photographers on their medium and their own practices. For this reason, the difference photographs have made to the experience and the meaning of "place" begins with the making of the photograph; in its act of showing, the photograph becomes a place: visible yet ephemeral, double-sided, a fusion of the photographer's place of work and the viewer's place of interpretation.

Fascination with windows has persisted, as if looking out from them or looking at them from the outside (as in Harry Callahan's *Chicago* [ca. 1948; *pl. 185*]) models the photographic act itself. In *From My Window at the Shelton, West* (1931; *pl. 10*), Alfred Stieglitz, "looking west" *from* the Shelton toward two towers of windows, gazes upon a scene sketched in tones from deep black to bright white, as if already a photograph. In *Champ-de-Mars, vue de la Tour Eiffel* (Champs-de-Mars, View from the Eiffel Tower, 1931; *pl. 31*), Ilse Bing aims her camera down and through the diamond-shaped openings formed by the trusses of the Eiffel Tower, meanwhile catching the giant mechanism as both a thing and a shadow of itself (a negative?) falling upon the boulevard and pedestrians below.

Morris Huberland's ca. 1950 photograph of Bonwit Teller display windows on Fifth Avenue in New York (*pl. 160*) makes a multilayered joke out of the association of windows with eyes. In this case, windows become pictured eyes looking out toward the street but actually blocking vision from the street of what lies behind the window. It is a gimmick to whet the consumer's appetite. The pictures of eyes interfere with the transparency of the windows, both frustrating and arousing the shopper to wonder and to wish. The photograph makes a wry comment on shopping, especially with the image of a hand superimposed on

the eye in the window on the left, suggesting that to see with a consumer's eye is also to grasp with the desire to possess.

In Lisette Model's *Fifth Avenue* (1950s; *pl. 162*), window and mirror fuse, erasing each other's distinctive mode of viewing, the window serving as a surface both transparent and reflective. The resulting picture captures with charm and power the confusion of spaces and perspective that reveals how place has lost its meaning on the city's paramount shopping street. Framing the confusion of surface and depth reflected on the outer surface of this store window, the picture redeems the vertiginous effects of the city by showing them captured and confined, yet preserved as fortuitous, ephemeral, and random—those features of city life with which, in Siegfried Kracauer's words, photography enjoys an affinity.[24] In Umbo's *Ob's reicht?* (Will It Be Enough?, 1940s; *pl. 32*) we find a similar play of surface and depth, transparency and shadowed silhouette; the young female window-shopper, caught suspended between this and that, yes or no, dissolves into shadow, becoming another example of vertiginous effects caught by a passerby with a quick eye and a speedy camera.

Wry commentary on the mirroring and shadowing effects of window reflections on downtown city streets became a kind of mental and visual habit among modern urban photographers. Prowling lower Manhattan in search of the curious and the anomalous, Berenice Abbott in the 1930s scored countless hits, none more cool, low-key, and hilarious than her intimation of flimflam (Abbott, like her friend Walker Evans, could not resist ironic pieces of lettering) in *Flam and Flam, New York City* (1936; *pl. 33*). Isn't it a bit of a swindle that the upper-story windows at once invite the eye and deny it entry?

Mirror and window have long been used as ready metaphors for describing the work of the photograph, at least the most obvious "pointing" work of indicating things in the world.[25] Windows open to the outside and the inside at the same time, a transparency that defines a threshold marked by an act of vision: looking in, looking out. Mirrors are a more troubling medium; they reflect whatever is in front of them, and while the reflection is always of something there, what you see depends on where you stand in relation to the mirroring surface, in front of it or at an angle. As a metaphor for the photograph, mirror means not just that everything in view gets shown or seen but, equally important, that what you see is contingent on the placement of your body, not in relation to the world reflected in the mirror but in relation to the mirror itself, the reflecting element. Place a mirror or any reflective mirroring surface in a photograph, and the entire image takes on an intriguing aspect of ambiguity.

Where are we in Brassaï's *Groupe joyeux au bal musette des Quatre Saisons, rue de Lappe* (Happy Group at the Four Seasons Ball, rue de Lappe, ca. 1932; *pl. 183*)? It takes a calibrated

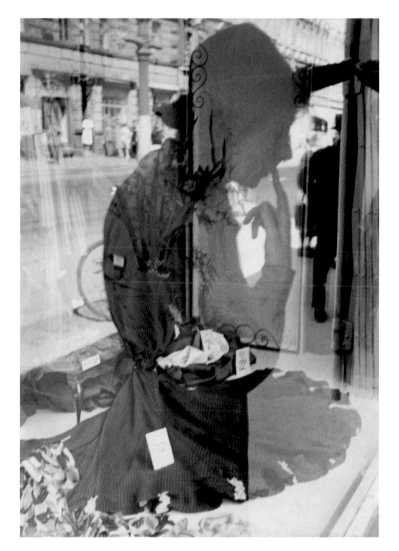

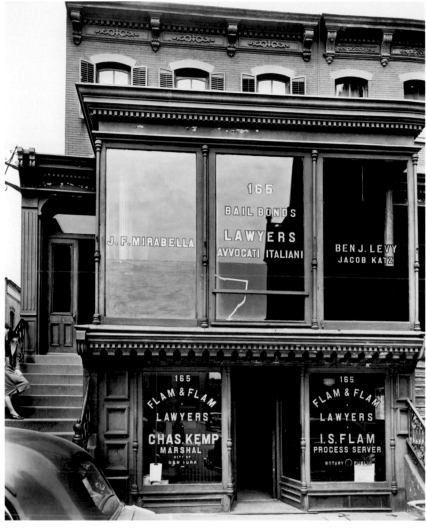

adjustment of vision to realize that we are standing at a slight angle to a mirror, which shows what the threesome at the table are looking at. The figures reflected in the mirror behind and above the threesome are actually, the mirror reveals, seated opposite and in front of them. We do not see the interaction except in the mirror; the mirror shows what we do not see, the actual conversing and joking faces, because we are standing behind them. In this sense the mirror in the picture mirrors and mimics the work of the camera in the hands of the photographer. And by cropping the reflected image into framed fragments of the scene, the lines that mark the separate plates of which the mirror consists further mimic the work of the camera in abstracting pictures from the world, making *scenes* out of the array of visual information.

This work of mirrors is placed directly adjacent to the work of windows in Lee Friedlander's *Route 9W, New York* (1969; *pl. 208*), where the wing mirror of the automobile

32. **Umbo** (Otto Umbehr)
Ob's reicht? (Will It Be Enough?), 1940s
Gelatin silver print
11 3/4 x 8 1/8 in. (29.8 x 20.6 cm)

33. **Berenice Abbott**
Flam and Flam, New York City, 1936
Gelatin silver print
9 9/16 x 7 5/8 in. (24.3 x 19.4 cm)

captures the exact moment of exposure as well as the exact position of the photographer as he points his camera out of the car window. The result is a flat collage of perspectives, dimensions, and viewing positions, yoking together lens, eye, mirror, and window—like the Brassaï, a "happy group" of elements, one of whose riotous revelations is that the automobile itself has become an instrument of vision, distinctly modern, distinctly American.

David Octavius Hill and Robert Adamson's *The Artist and the Gravedigger* (ca. 1843–47; *pl. 1*) offers another tantalizing allegory: a tombstone, a man reading, two women in meditation or grief, and the gravedigger, the only figure who casts a bold, distinguishable shadow, a symbol of mortality. There's an implicit enunciation of the *vanitas* theme here, and perhaps in all photographs. Made by light passing through air, places in photographs and places *as* photographs make visible what has already passed away, thereby resembling tombs.

Taking place is a function photographers have performed since the beginning of the medium. The function can have a redemptive effect. The variety of places in photographs is limitless, but all resolve into whispers of mortality heard across the threshold of a window. It is in the face of flux, of natural and man-made catastrophes, of vicissitude in nature and in culture, finally in the face of death—the ultimate negative—that place-worlds serve the human need for communal dwelling. Photographs offer alternative ways of possessing the world, outside the constraints of private property; they are free of contracts, deeds, leases, and rental agreements; they may be owned but always belong to the realm of light and air. Rather than merely recording what already exists, they construct or invent their subjects by the act of photographing them.

Viewed in this light, the photographic taking and making of place holds illuminating lessons for human existence. In its diversity of places and experiences collected into one continuous artifact—the collection and the exhibition—*Taking Place* becomes an extended, nuanced meditation on how photographers have served the human need to dwell *somewhere,* in places made real and held firm by imagination.

NOTES

For their helpful and sympathetic reading of drafts of this essay, I'd like to thank Steve Arkin, Jerry Liebling, Betty Trachtenberg, and Zev Trachtenberg.

1. Eudora Welty, *The Eye of the Story: Selected Essays and Reviews* (New York: Random House, 1977), 286.

2. This applies only to the exposure in the camera and not to the subsequent processing required in traditional (nondigital) photography to produce a final picture. It is misleading to say that a photograph takes place all at once. But the initial event, the exposure in the camera, is fundamental.

3. Graham Clark, *The Photograph* (New York: Oxford University Press, 1997), 11.

4. Stanley Cavell, *The World Viewed: Reflections on the Ontology of Film* (Cambridge, Mass.: Harvard University Press, 1979), 18.

5. Roland Barthes, *Camera Lucida: Reflections on Photography,* trans. Richard Howard (New York: Hill & Wang, 1981), 92–94 passim.

6. Nathaniel Hawthorne, *The House of the Seven Gables* (1851), Centenary Edition (Columbus: Ohio State University Press, 1965), 256.

7. Karl Marx and Friedrich Engels, *Manifesto of the Communist Party* (1847), in Marx and Engels, *Selected Works,* vol. 1 (Moscow: Foreign Languages Publishing House, 1955), 37.

8. "Form is henceforth divorced from matter," wrote Oliver Wendell Holmes in "The Stereoscope and the Stereograph," reprinted in Alan Trachtenberg, ed., *Classic Essays on Photography* (New Haven, Conn.: Leete's Island Books, 1980), 71–82. See also Alan Trachtenberg, "Mirror in the Marketplace: American Responses to the Daguerreotype, 1839–1851," in John Wood, ed., *The Daguerreotype: A Sesquicentennial Celebration* (Iowa City: University of Iowa Press, 1989), 60–73.

9. Keith H. Basso, *Wisdom Sits in Places: Landscape and Language among the Western Apache* (Albuquerque: University of New Mexico Press, 1996), 5. See also E. Casey, *Getting Back into Place: Toward a Renewed Understanding of the Place-World* (Bloomington: Indiana University Press, 1993).

10. My thinking here is indebted to Martin Heidegger, "Building, Dwelling, Thinking," in *Poetry, Language, Thought,* trans. Albert Hofstadter (New York: Harper & Row, 1971), 143–62.

11. For a fascinating discussion of the troubled place of this image in formal histories of photography, see Geoffrey Batchen, *Burning with Desire: The Conception of Photography* (Cambridge, Mass.: MIT Press, 1997), 120–27. On Niépce and his career, see Helmut and Alison Gernsheim, *The History of Photography, 1685–1914* (New York: McGraw-Hill, 1969), 55–64. Also see John Szarkowski, *Photography Until Now* (New York: Museum of Modern Art, 1989), 22–24, and Aaron Scharf, *Pioneers of Photography: An Album of Pictures and Words* (New York: Harry N. Abrams, 1976), 36–41. An invaluable discussion of the social and economic context of Niépce's experiments can be found in Anne McCauley, "Political Economy, Lithography, and the Invention of Photography in Restoration France," in *Nicéphore Niépce — Une nouvelle image* (Chalon-sur-Saône, France: Musée Niépce, 1999), 80–99.

12. Gernsheim, *History of Photography,* 58.

13. I am indebted to Jonathan Crary's learned and astute discussion of early-nineteenth-century uses of the camera obscura in *Techniques of the Observer: On Vision and Modernity in the Nineteenth Century* (Cambridge, Mass.: MIT Press, 1990), especially 25–66.

14. On the relation between early photography and painting, see Peter Galassi, *Before Photography: Painting and the Invention of Photography* (New York: Museum of Modern Art, 1981), and Aaron Scharf, *Art and Photography* (Baltimore: Allen Lane, 1969). Scholarship on windows in paintings includes Lorenz Eitner, "The Open Window and the Storm-Tossed Boat: An Essay in the Iconography of Romanticism," *Art Bulletin* 37 (1955): 281–90, and Carla Gottlieb, *The Window in Art: A Survey of Window Symbolism in Western Painting* (New York: Abaris Books, 1941).

15. Quoted in D. B. Thomas, *The Science Museum Photography Collection* (London: Her Majesty's Stationery Office, 1969), 56–57.

16. Anne McCauley, "Talbot's Rouen Window: Romanticism, *Naturphilosophie,* and the Invention of Photography," *History of Photography* 26 (Summer 2002): 124–31.

17. Gernsheim, *History of Photography,* 58.

18. William Henry Fox Talbot, *The Pencil of Nature* (London, 1844–46; reprinted New York: Da Capo Press, 1968), pl. I.

19. Talbot, *The Pencil of Nature,* pl. II.

20. See Crary, *Techniques of the Observer,* passim, on the nineteenth-century remaking of the observer into a passive, private consumer of dematerialized images of the specular world.

21. Georg Simmel, "The Ruin," in Kurt H. Wolff, ed., *Essays on Sociology, Philosophy, and Aesthetics by Georg Simmel and Others* (New York: Harper Torchbooks, 1965), 263, 265.

22. Paraphrase of Walter Benjamin, in Eduardo Cadava, *Words of Light: Theses on the Photography of History* (Princeton, N.J.: Princeton University Press, 1997), 128.

23. Quoted in Michael S. Roth et al, *Irresistible Decay: Ruins Reclaimed* (Los Angeles: Getty Research Institute for the History of Art and the Humanities, 1997), 71.

24. Siegfried Kracauer, *Theory of Film: The Redemption of Physical Reality* (New York: Oxford University Press, 1960), 12–23.

25. The terms mirror and window gained new currency in regard to photographs as a result of the exhibition and catalogue by John Szarkowski, *Mirrors and Windows: American Photography since 1960* (New York: Museum of Modern Art, 1978).

PLATES

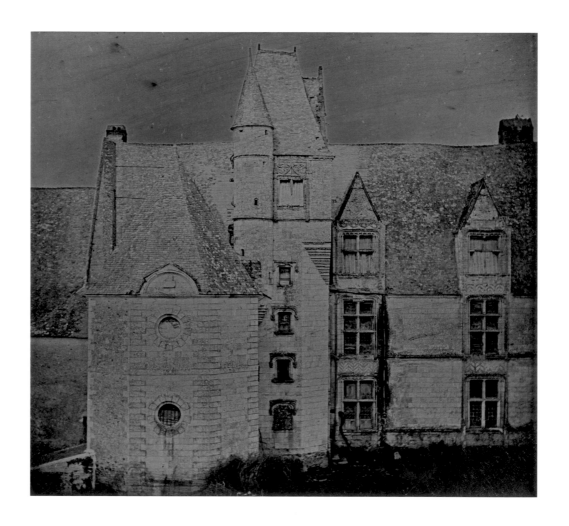

34. Unknown Artist
Untitled [Château de Goulaine], ca. 1840
Daguerreotype
5½ x 6 in. (14 x 15.2 cm)

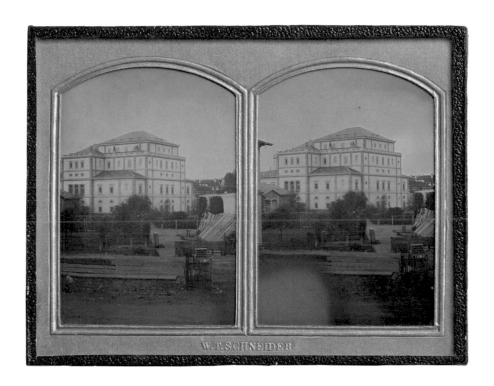

35. **Trudpert Schneider and Soehne Ehrenstetten**
Untitled [Workyard behind a Royal Residence], ca. 1840
Stereo daguerreotype
2 5/8 x 1 13/16 in. (6.7 x 4.6 cm)

36. **Unknown Artist**
Untitled [Crystal Palace, Main Gallery], 1850s
Stereo daguerreotype
2 11/16 x 2 5/16 in. (6.8 x 5.9 cm)

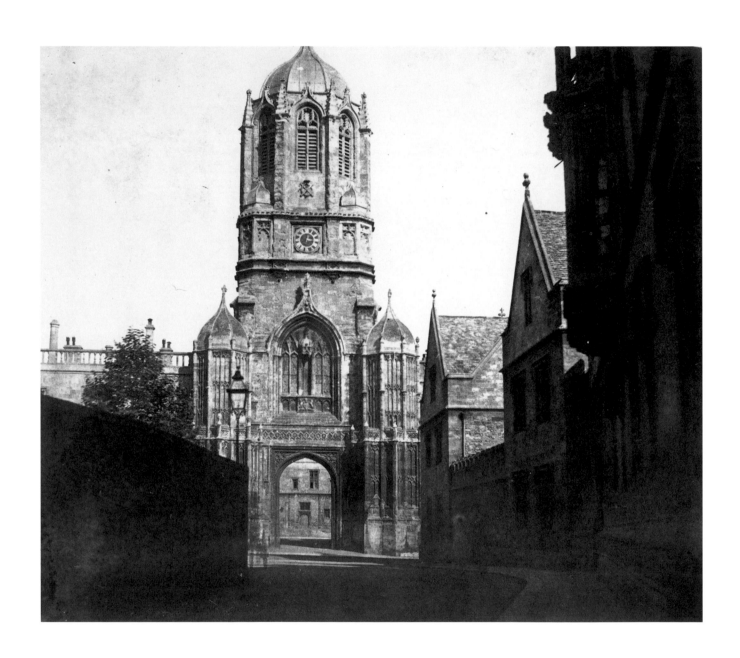

37. **William Henry Fox Talbot**
Gate of Christchurch, ca. 1844–46
Salt print from a paper negative
6⁵/₈ x 7³/₄ in. (16.8 x 19.7 cm)

38. **William Henry Fox Talbot**
Paris, 1843
Salt print from a paper negative
6 5/8 x 6 13/16 in. (16.8 x 17.3 cm)

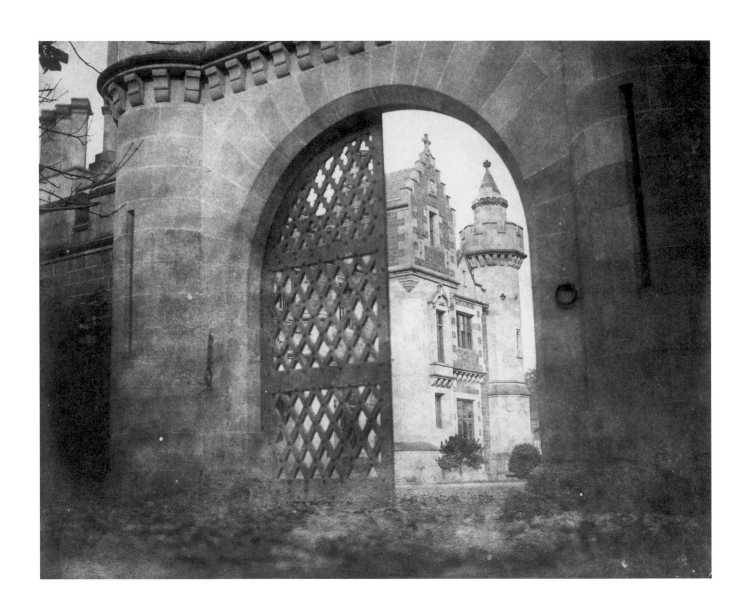

39. William Henry Fox Talbot
Abbotsford Gate, 1844
Salt print from a paper negative
6 1/2 x 8 3/16 in. (16.5 x 20.8 cm)

40. David Octavius Hill and Robert Adamson
Miss Crampton of Dublin, ca. 1843–47
Salt print from a paper negative
8 1/16 x 6 in. (20.5 x 15.2 cm)

41. Jean Baptiste Frénet
Untitled [Man on Horseback], 1855
Salt print
6 7/8 x 9 1/4 in. (17.5 x 23.5 cm)

42. David Octavius Hill and Robert Adamson
*Professor Alexander Campbell Fraser, Reverend James
Walker, Reverend Robert Taylor, Reverend John Murray,
Reverend Doctor William Welsh, and Reverend Doctor
John Nelson,* ca. 1843–47
Salt print from a paper negative
9 1/2 x 12 7/8 in. (24.1 x 32.7 cm)

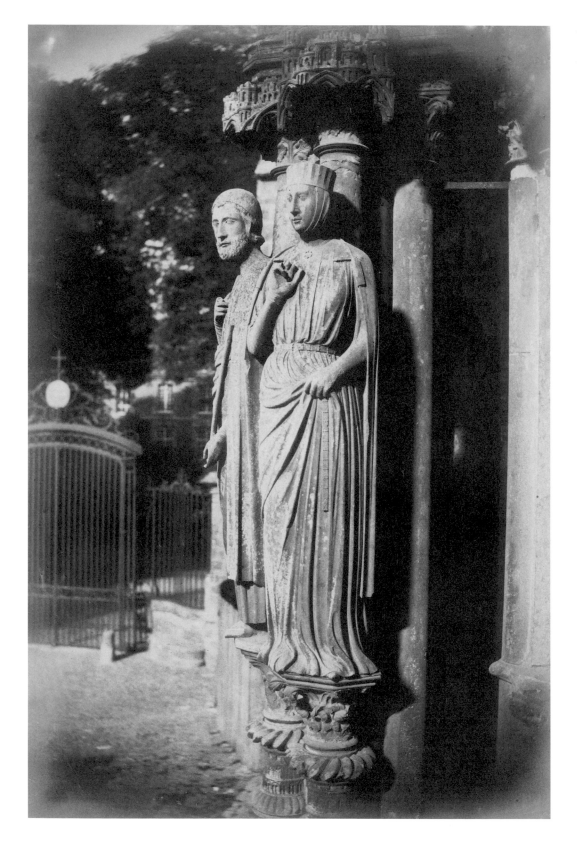

43. **Henri Jean-Louis Le Secq**
Untitled [Study of Chartres Cathedral], 1852
Salt print
13 7/16 x 8 7/8 in. (34.1 x 22.5 cm)

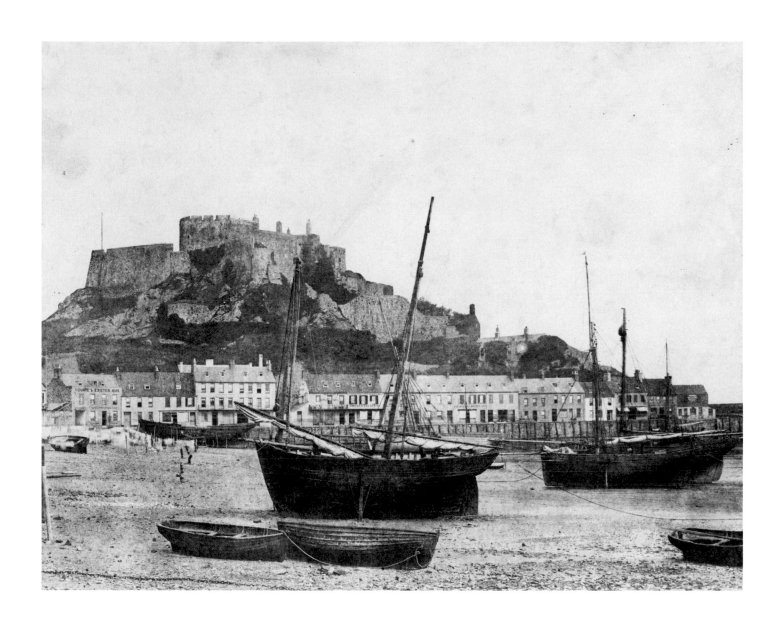

44. **Thomas Sutton**
Souvenir of Jersey, 1854
Salt print from a paper negative
8⁷/₁₆ x 10⁷/₈ in. (21.4 x 27.6 cm)

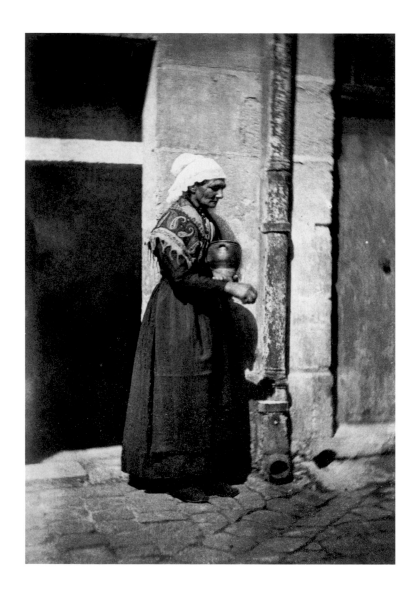

45. **Charles Nègre**
Portrait d'une femme tenant un pot, au 21, quai de Bourbon
(Woman Holding a Pot, 21 quai de Bourbon), 1852
Salt print from a paper negative
7¼ x 5⅛ in. (18.4 x 13 cm)

46. **Charles Nègre**
Portrait d'une femme tenant un pot, au 21, quai de Bourbon
(Woman Holding a Pot, 21 quai de Bourbon), 1852
Paper negative
7⅝ x 6 in. (19.4 x 15.2 cm)

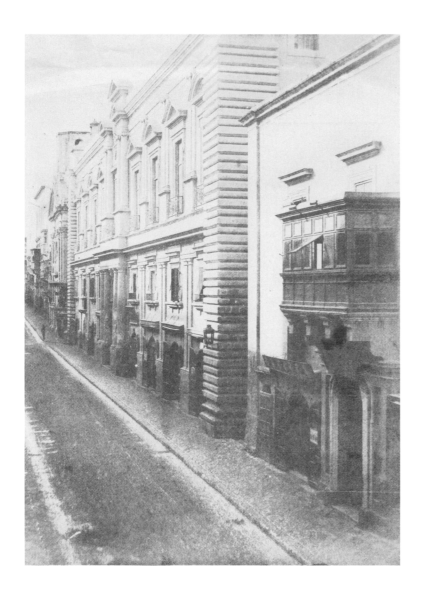

47. **Calvert Richard Jones**
Street Scene in Valetta, Malta, 1846
Salt print from a paper negative
8 5/16 x 5 15/16 in. (21.1 x 15.1 cm)

48. **Calvert Richard Jones**
Street Scene in Valetta, Malta, 1846
Paper negative
8 5/16 x 5 15/16 in. (21.1 x 15.1 cm)

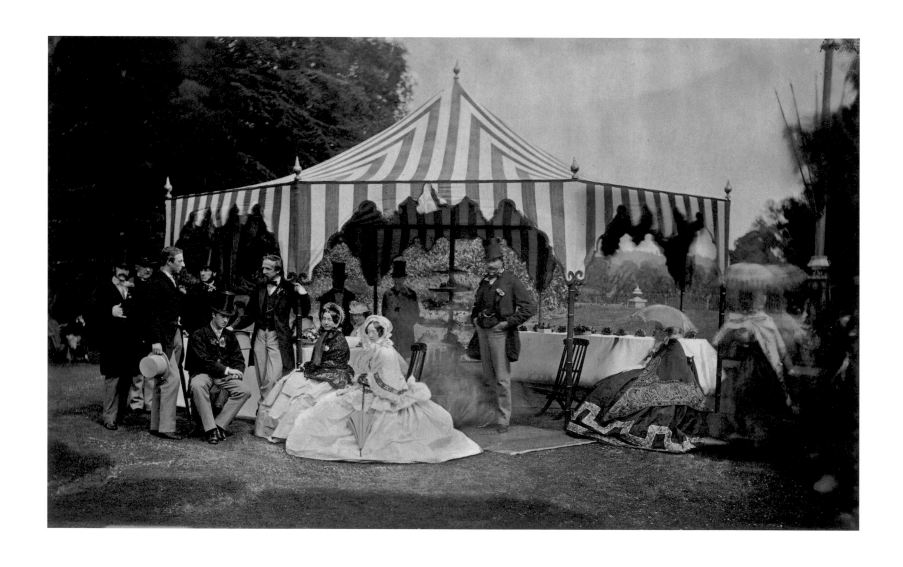

49. **Camille-Léon-Louis Silvy**
Orléans House, Fête Champêtre [Page Four], 1864
Albumen print
3 15/16 x 6 9/16 in. (10 x 16.7 cm)

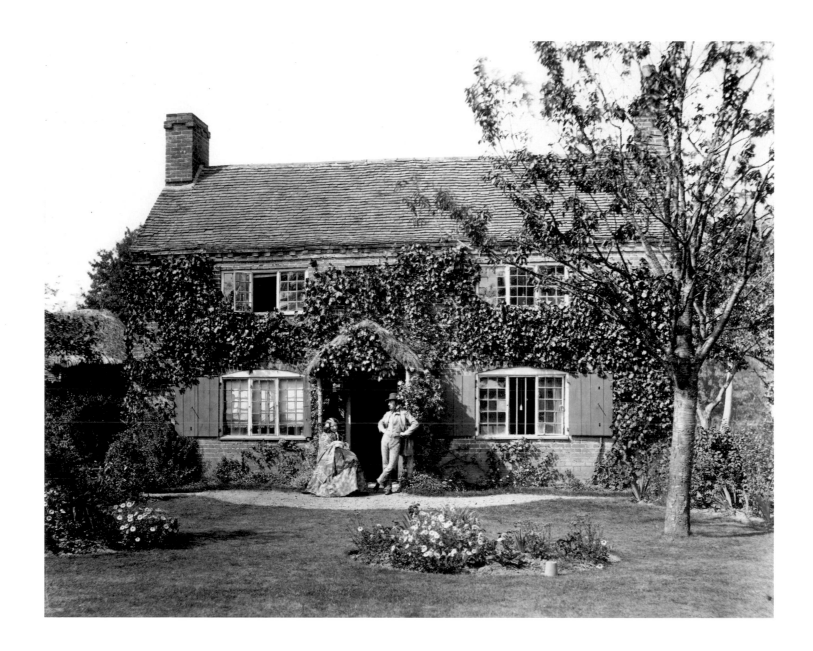

50. **Henry White**
Untitled [Country Cottage with Couple], 1856
Albumenized salt print from a glass negative
7 13/16 x 9 3/4 in. (19.8 x 24.8 cm)

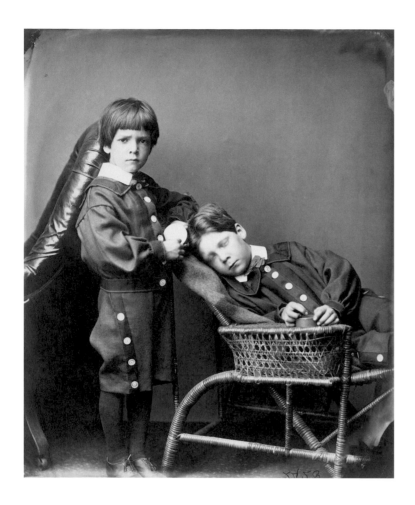

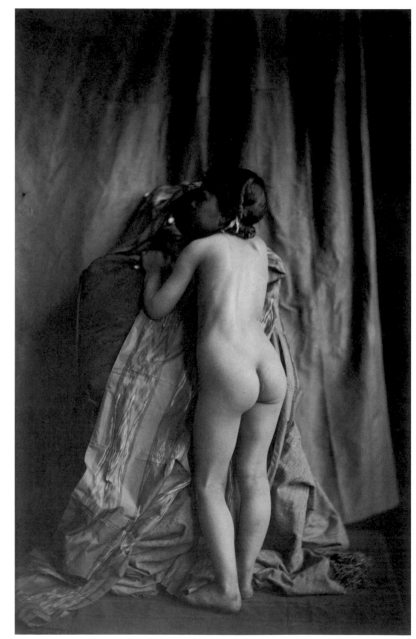

51. Lewis Carroll
Brook and Hugh Kitchin, 1876
Albumen print from a glass negative
5¹³/₁₆ x 4¹¹/₁₆ in. (14.8 x 11.9 cm)

52. Eugène Durieu
Untitled [Female Nude], 1850s
Albumen print from a glass negative
8 x 5⅛ in. (20.3 x 13 cm)

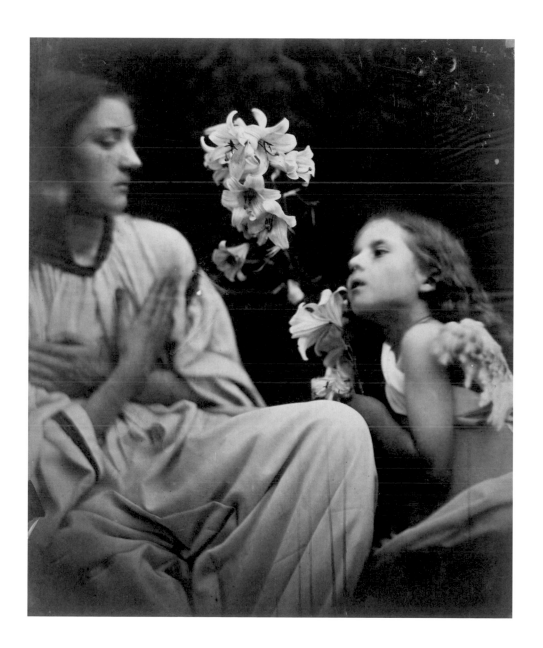

53. **Julia Margaret Cameron**
After Perugino; the Annunciation, 1865
Albumen print from a glass negative
13 1/4 x 11 in. (33.7 x 27.9 cm)

BEGINNINGS

The invention of photography in the 1830s introduced a new kind of picture to Western society, one unique in its ability to revive moments from the past and to describe the visible world with the supreme precision of a machine. Less recognized is how the innovative technology also brought into being a new kind of viewer. The reasons for this disregard are not difficult to fathom: history narrates the lives of artists, inventors, and their creations much more thoroughly than it does the reactions of those who utilize their achievements, if only because makers of things leave better, more available paper trails than do their audiences. Nonetheless, every photograph implies both a maker and a viewer. As an instrument of communication, it represents the slippery point of contact between the one who furnishes the photograph and the one who engages in making sense of it.

The notion that a viewer in the nineteenth century might have looked upon any particular photograph differently from the way it is perceived by a present-day viewer may at first seem counterintuitive: those historical observers ostensibly depended on a pair of eyes just as we do. The difference is not one of physiology, however, but of enculturation. When we examine an untitled daguerreotype of the Château de Goulaine

(*pl. 34*)—probably the earliest photograph represented in the Sack Collection, dating from the first few years of the daguerreotype's existence—we discern the facade of a grand building rendered in ghostly tones on the surface of a plate. In its austere frontality, the way its balanced geometry fills the frame with visual information, the image can readily satisfy an aesthetic informed by a century of modernism. Yet the observer to whom the image addressed itself around 1840 was not like us, and not so modern. This being a large daguerreotype of an architectural subject, we can assume that the unidentified maker created it, if not as a personal experiment, then to show to others. (Architecture was a more practical quarry than portraits at this stage because the process required lengthy exposure times.) By choosing the motif, the daguerreotypist assumed that his viewer was learned, perhaps aristocratic: in the nineteenth century, buildings and monuments were often the subjects of photographs because of their historical (which is to say, politically symbolic) associations. A literate Frenchman of the day would have recognized the famous château near Nantes, built in the Renaissance style in the fifteenth century on the site of a medieval fortress. The Goulaine family owned it through a thousand-year succession dating back to the earliest known

French kings—that is, until 1788, when the region around Nantes was consumed with revolutionary fever and noble families like the Goulaine fled for their lives. Thus the daguerreotype viewer in the 1840s would have appreciated it as an example of Renaissance architecture, but he or she might also have seen in the Goulaine image an emblem of French patrimony, a site symbolic of feudalism, and a reminder of that great national drama—the French Revolution—and those bloody events still residing within memory of some living citizens.

Photography by itself did not engender thoughtful viewership—pictures had long been assumed to carry meanings beyond their surface information. What it did was marry poetic association with an abiding sense of actuality, effectively confusing the materiality of the world with (for those prepared to see it) the spiritual, the literary, the theological, and the socially symbolic. The images in this section of the catalogue derive from the first twenty-five years of photography's existence. What they illustrate, more than anything, is how nineteenth-century viewing involved a simultaneous looking backward and forward in history.

The photography of medieval architecture in this period—Henri Jean-Louis Le Secq's study of statuary on the exterior of Chartres Cathedral (pl. 43), Hippolyte Bayard's church in Louviers (pl. 54), William Henry Fox Talbot's Christchurch and Abbotsford Gates (pls. 37, 39)—all speak to a broader cultural co-optation of the past, as Great Britain, France, and Germany each claimed the Gothic as its own indigenous style. Chartres and the church in Louviers were actual twelfth-century structures, examples of an architectural heritage appropriated as part of France's patrimony by everyone from the Romantic novelist Victor Hugo to Emperor Napoleon III. Christchurch and Abbotsford, conversely, are historical pastiches; the Englishman Talbot depicted the celebrated Tom Tower at Oxford, its gate and lower half reflecting Cardinal Thomas Wolsey's original Tudor plan for the college, its upper segment applied in 1681 by Christopher Wren. Abbotsford—the estate Sir Walter Scott built for himself near Melrose in 1824—sports re-created battlements and turrets in conscious emulation of earlier buildings, just as Sir Charles Barry and A. W. N. Pugin's 1836 design for the Houses of Parliament in London would consecrate High Gothic as Britain's national style.

Emblematically, such images suggested to their period viewer a synthesis—that of a modern nation built upon a glorious past, one that united the progress of technology and rational planning with the spirituality and valor of the Middle Ages. Reconstruction of the past was both a figurative and a literal proposition: in the Bayard photograph, for instance, we see scaffolding and other evidence of the church's actual restoration in the 1850s, as the French government sponsored—with varying degrees of historical accuracy—the refurbishment of its deteriorating Gothic infrastructure. A viewer in 1865 would even have found Julia Margaret Cameron's *After Perugino; the Annunciation* (pl. 53) symptomatic of this synthetic urge. Cameron casts her housemaid, Mary Ryan, as the Virgin Mary and Elizabeth Keown as the Angel Gabriel in this Annunciation scene styled in professed emulation of the Italian Renaissance masters. The audience saw in Miss Ryan the embodiment (for Cameron) of Victorian womanhood, an archetype of selfless innocence portrayed as nascent in every living person.

Though photography was born into an era of imaginative viewership, the cultural skill of reading a picture poetically was already on the wane in the mid-nineteenth century. In fact, the photograph's emphatic rendering of the material world, as something conceivably existing independent of higher meaning, may well have contributed to the demise of the Romantic viewer and the advent of the modern viewer.

—D.R.N.

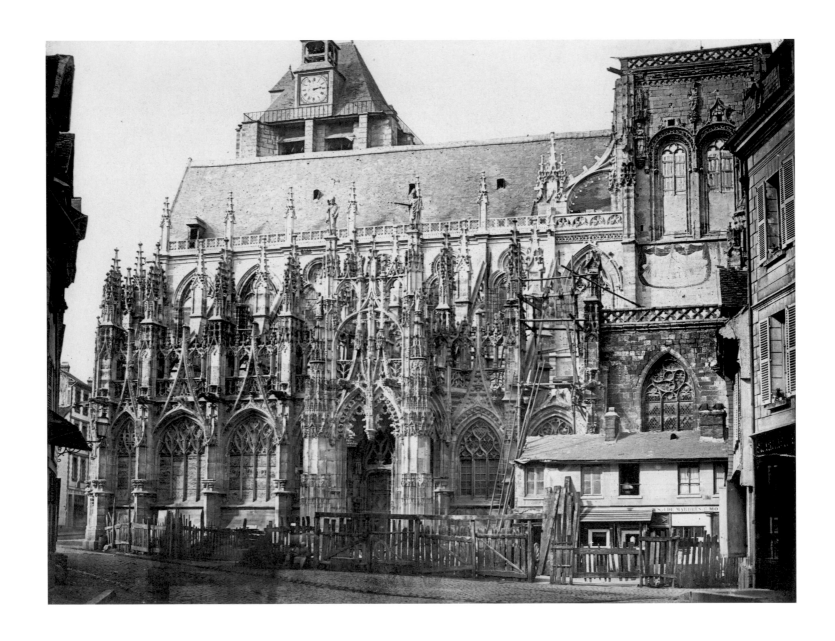

54. Hippolyte Bayard
Église à Louviers (Church, Louviers), 1851
Salt print
7 5/8 x 10 1/4 in. (19.4 x 26 cm)

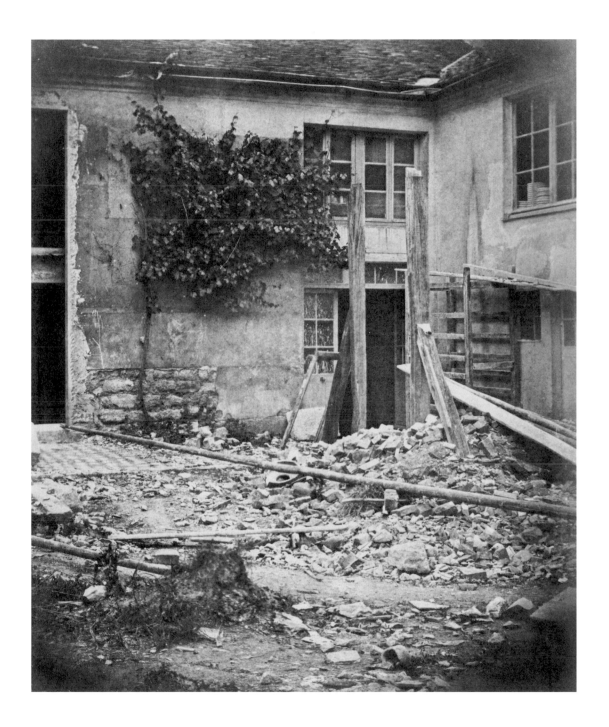

55. Henri-Victor Regnault
Old House at Sèvres, ca. 1851
Salt print from a paper negative
9 x 7½ in. (22.9 x 19.1 cm)

56. Charles Marville
Rue de la Montagne-Sainte-Geneviève. Vue prise vers l'église Saint-Étienne-du-Mont. À droite,
la rue de l'École-Polytechnique (Rue de Montagne-Sainte-Geneviève. View Taken toward the
Church of Saint-Étienne-du-Mont. On the Right, the rue de l'École-Polytechnique), 1868
Albumen print
11 3/8 x 10 7/16 in. (28.9 x 26.5 cm)

57. **Charles Marville**
Bois de Boulogne, ca. 1853–58
Albumen print from a paper negative
13 13/16 x 10 5/16 in. (35.1 x 26.2 cm)

58. **Édouard Baldus**
Creil, 1855
Salt print from a paper negative
12 11/16 x 17 7/16 in. (32.2 x 44.3 cm)

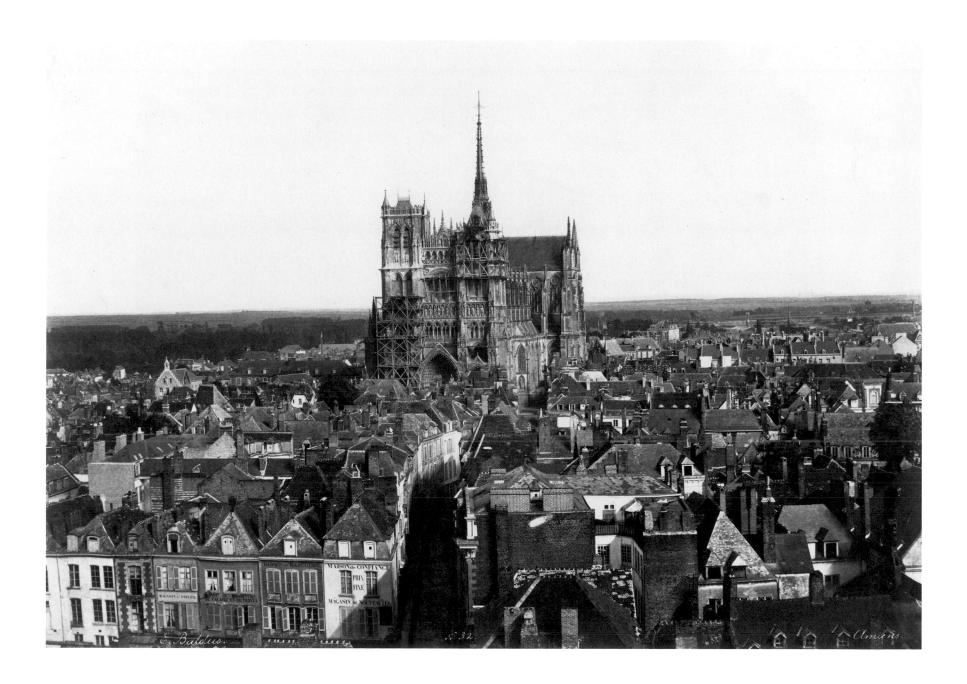

59. Édouard Baldus
Amiens (vue générale) (Amiens [General View]), 1855
Salt print from a paper negative
12 1/8 x 17 5/16 in. (30.8 x 44 cm)

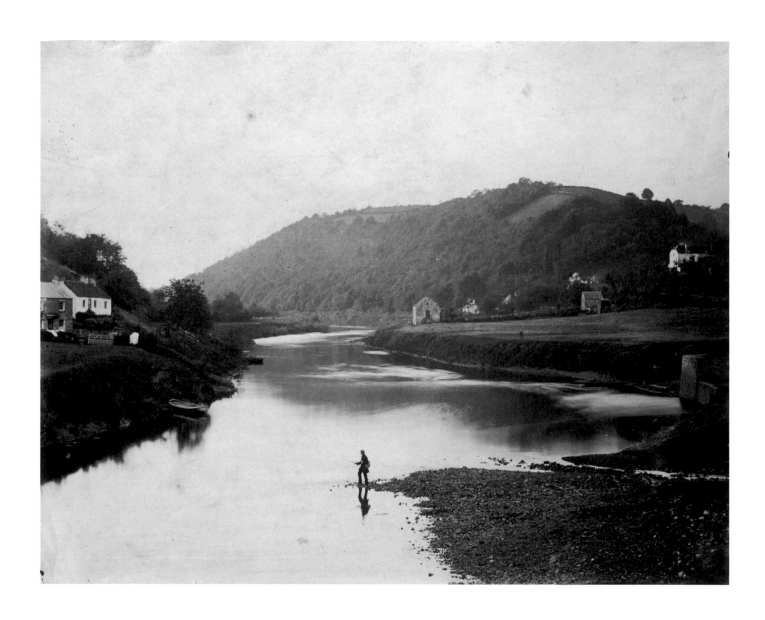

60. Roger Fenton
On the Wye, ca. 1855
Salt print from a glass negative
7 1/4 x 9 1/8 in. (18.4 x 23.2 cm)

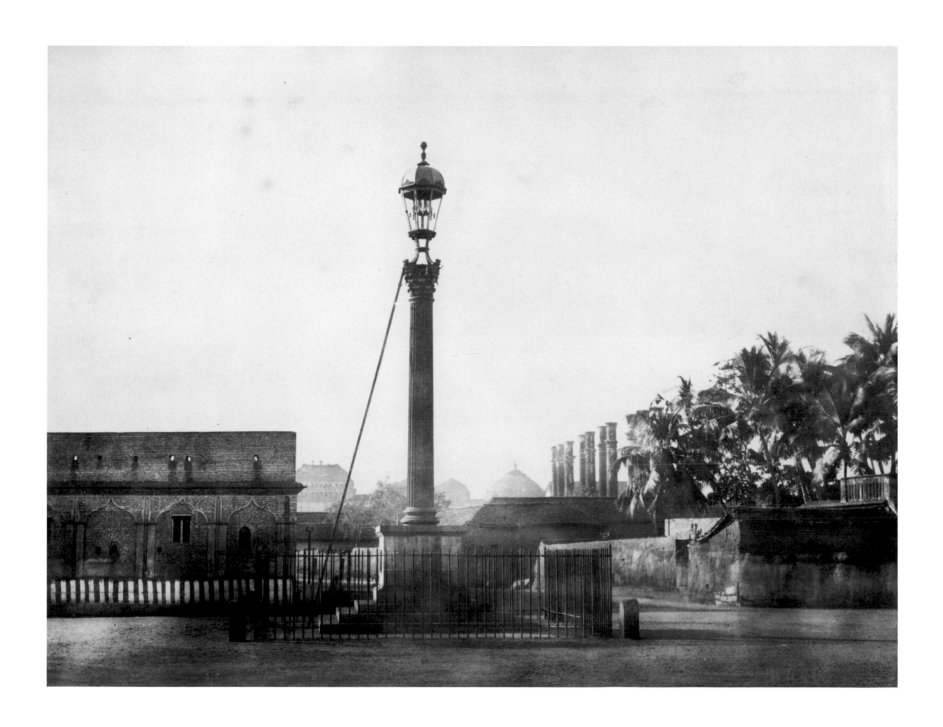

61. Linnaeus Tripe
Madura. Blackburn Testimonial, 1858
Salt print from a paper negative
10 3/8 x 13 9/16 in. (26.4 x 34.4 cm)

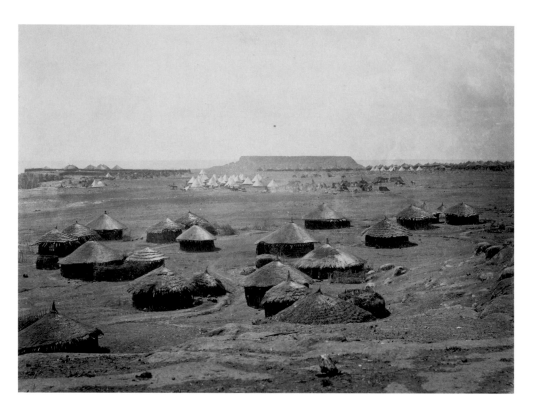

62. **Sergeant Harrold and the Royal Corps of Engineers**
Abyssinian Dwellings, 1868
Albumen print from a glass negative
7 5/8 x 10 1/8 in. (19.4 x 25.7 cm)

63. **Félix Bonfils**
Piscine probatique, Jerusalem (Pool of Bethesda, Jerusalem), 1870s
Albumen print from a glass negative
11 3/8 x 15 3/8 in. (28.9 x 39.1 cm)

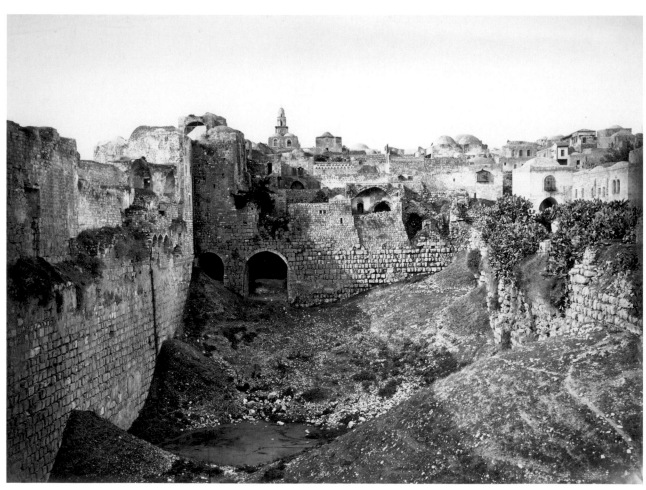

64. Ernest de Caranza
Untitled [Harbor Scene, Turkey], 1854
Salt print from a paper negative
6 11/16 x 8 13/16 in. (17 x 22.4 cm)

65. Gioacchino Altobelli
Fontana dell'Accademia di Francia — Villa Medici
(Fountain of the French Academy — Villa Medici),
ca. 1859–64
Albumen print from a glass negative
10 1/16 x 14 7/8 in. (25.6 x 37.8 cm)

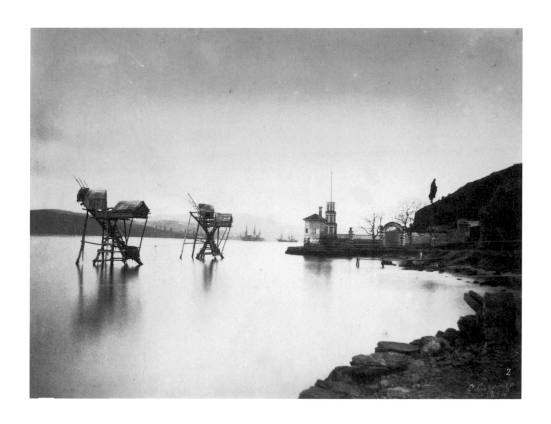

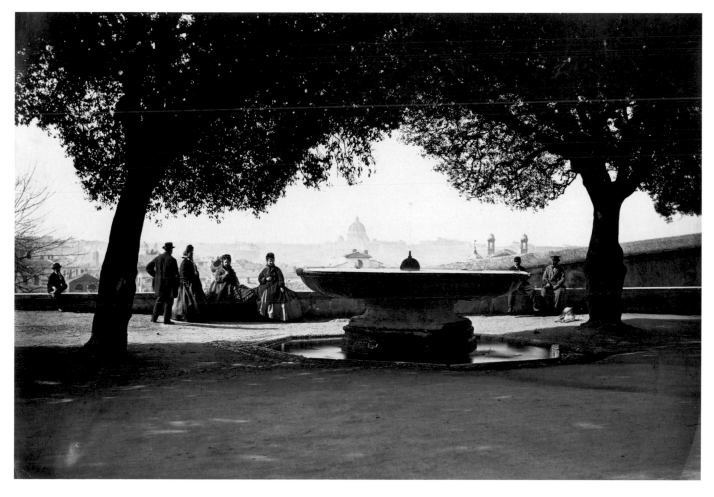

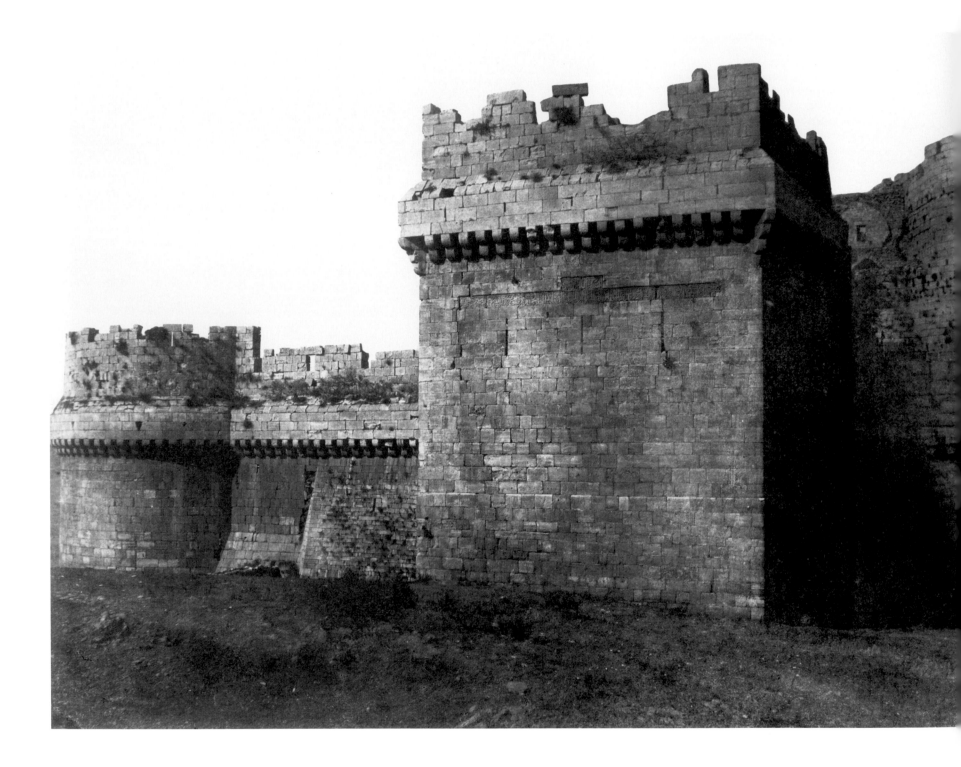

66. Louis De Clercq
Kalaat el Hosn, première enceinte midi (Krak of the Knights,
First Southern Enclosure), 1859
Albumen print from a paper negative
8 5/16 x 22 1/4 in. (21.1 x 56.5 cm)

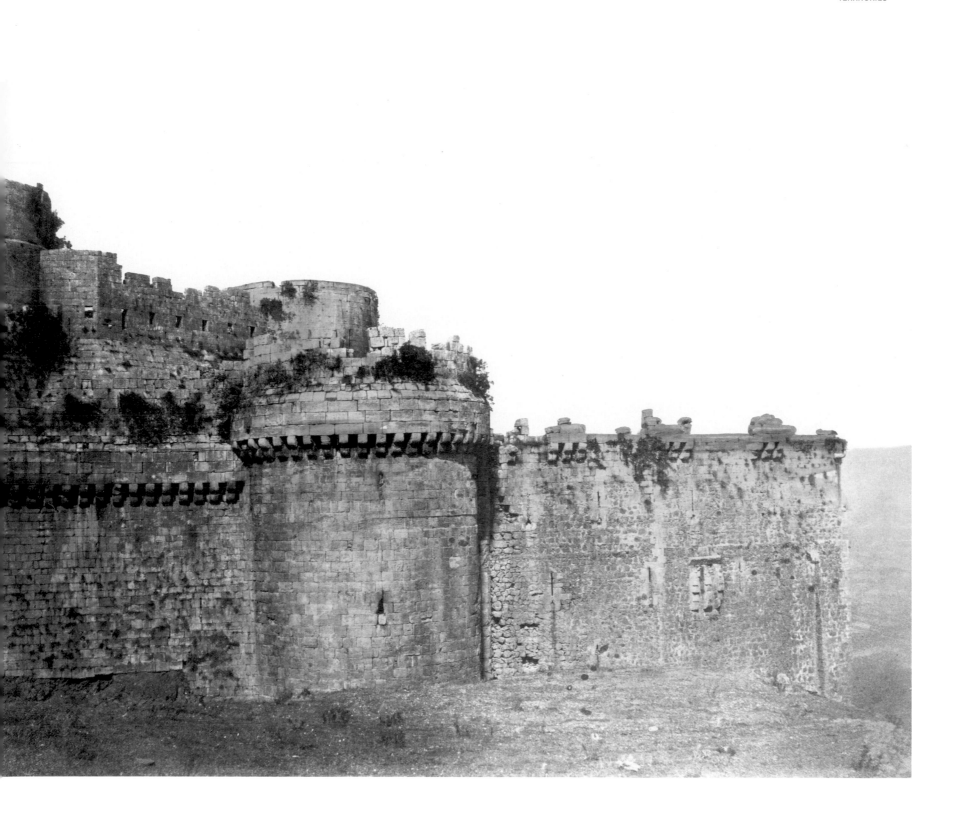

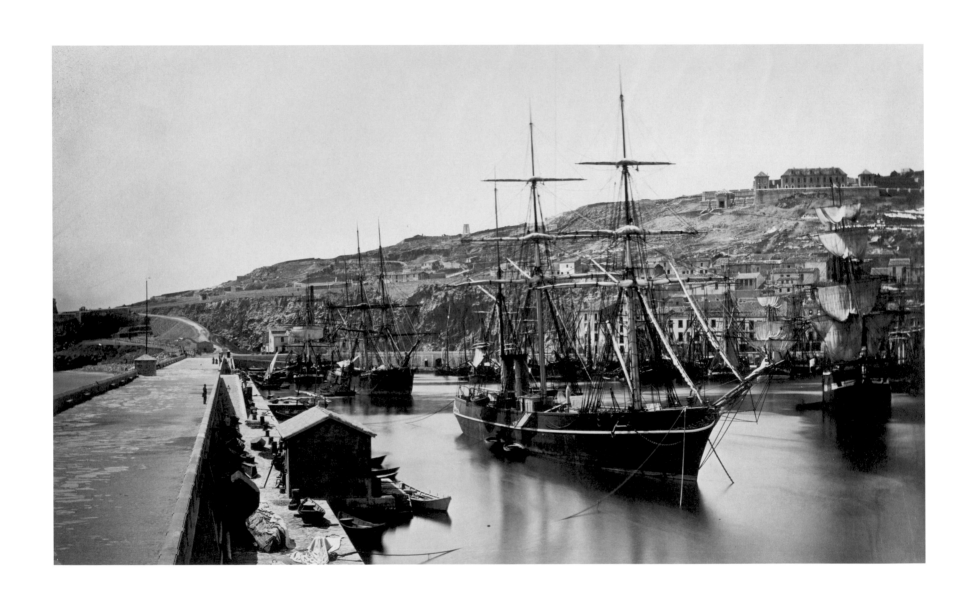

67. Gustave Le Gray
The Steamer Saïd, *Sète,* 1857
Albumen print from a glass negative
9 ¹/₂ x 15 ¹³/₁₆ in. (24.1 x 40.2 cm)

68. Gustave Le Gray
Maneuvers, Camp de Châlons, 1857
Albumen print from a glass negative
11 5/8 x 13 7/16 in. (29.5 x 34.1 cm)

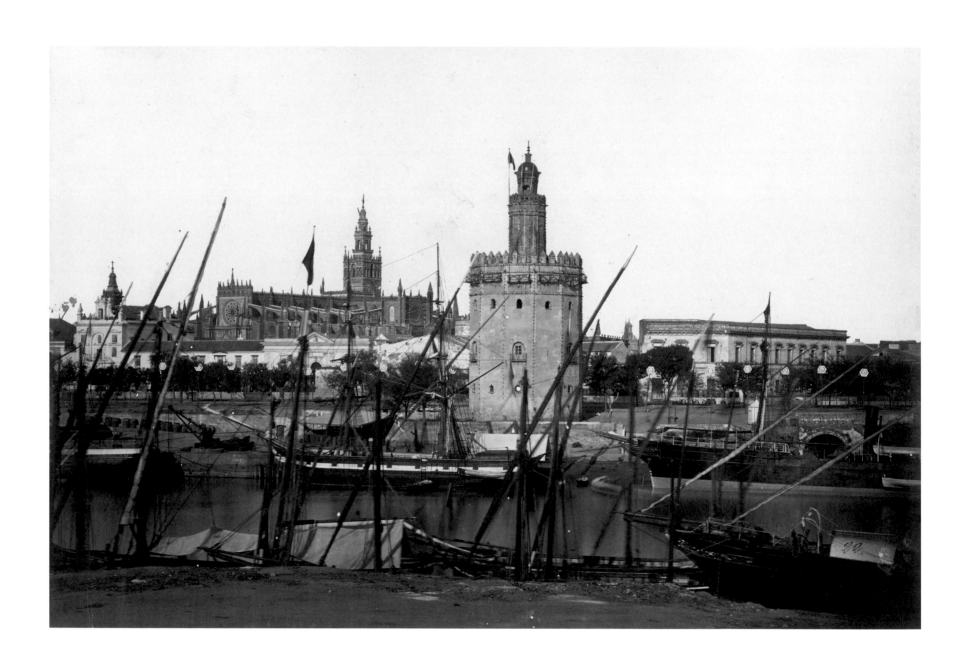

69. Charles Clifford
Sevilla: Torre del Oro (Seville: Tower of Gold), 1862
Albumen print from a glass negative
11 1/4 x 16 3/4 in. (28.6 x 42.5 cm)

TERRITORIES

Photography may be regarded as quintessentially modern, not simply because it is an art derived from a technology, but because its birth and growth overlap the period in Western history that gave rise to all of our most modern institutions and ideas. Indeed, photography bore witness to the Age of Empire and has played a key role in making the world a smaller and seemingly more knowable place. Like its contemporaries—the telegraph, the locomotive, and the steamship—the Victorian camera connected parts of the Earth that were, for most westerners, still more legendary than real. As a consequence, photography was drafted into the project of global exploration and scientific discovery.

This era of new mobility began at one's doorstep. Escaping the disease, poverty, overpopulation, and urban crime of big cities, those who could afford to leave the metropolis for extended visits to the countryside did so. The English invaded the Lake District, Scotland, and Wales: Roger Fenton, for example, composed his idyllic scene of a lone fisherman on the Wye River (pl. 60) in Wales, one of the "deep rivers and lonely streams" that inspired William Wordsworth to write "Tintern Abbey." To commemorate Queen Victoria's trip on France's new northern railroad line, Édouard Baldus

assembled for her an 1855 presentation album containing photographs of sights—such as Creil and Amiens (pls. 58–59)—that one could visit along the route. In 1857 Gustave Le Gray availed himself of the progress of the railroad from Toulouse to the Mediterranean port of Sète to complete his revolutionary series of seascapes, and there he composed a portrait of the steamship *Saïd* at anchor (pl. 67). Like the Barbizon and impressionist painters, Baldus and Le Gray left Paris for the light-filled countryside and coastal resorts made newly accessible by trains. Their photographs served as keepsakes for the well-heeled tourists who began frequenting these places.

After an interruption occasioned by the Napoleonic Wars, the Grand Tour was revived in Victorian times, now updated, modernized, and extended to new territories. The traditional destinations in Italy—the Rocca Pia in Tivoli (pl. 73), the French Academy at Rome's Villa Medici (pl. 65), and the Roman Forum (pl. 75)—were rendered by commercial practitioners (such as Robert MacPherson and Gioacchino Altobelli) as photographs that functioned as aide-mémoire, architects' studies, and—for those unable to travel—virtual encounters. Regular steamship service brought new localities into reach for a burgeoning tourist

market; Egypt, Constantinople, the Holy Land, and North Africa, once inaccessible, attracted unprecedented numbers of European visitors in the second half of the nineteenth century, even as the photographers who catered to Western audiences often endeavored to preserve the illusion that these places remained distant, exotic, and unaffected by tourism. By extension, those locations that were still truly remote—Désiré Charnay's Oaxaca, in the interior of Mexico (*pl. 79*), or Jabalpur, in central India (*pl. 78*)—were subject to a logic of progress that saw any corner of the globe as a potential colony.

Photography's veritable invasion of the world was more than a conceit. Egypt, the Ottoman Empire, India, Mexico, and other such places were colonized, administered, and periodically invaded by various Western powers in the modern period, and after 1850 these overseas adventures increasingly would have photographers in tow. Fenton's view of British and French warships in the harbor at Balaklava (*pl. 70*) was derived from a frankly propagandistic government campaign to garner public support for the unpopular Crimean War of 1853–56. (The British, French, and Ottoman Turks joined forces to prevent the Russians from taking Constantinople or, worse yet, sacred sites in the Holy Land.) Although ultimately successful in strategic terms, the war came to symbolize military incompetence. In

response, Napoleon III instituted reforms in his army, and in the summer of 1857 he ordered ten thousand troops to maneuvers at the Camp de Châlons. Le Gray was commissioned to photograph the exercises and create special presentation albums for dignitaries. The geometry of Le Gray's images (*see pl. 68*) was intended to counteract any lingering suggestion of disorder.

At the beginning of the photographic era, the average Londoner was as likely to visit the ruins of Egypt as the moon—and perhaps would have looked upon Francis Frith's view of the pyramids (*pl. 71*) as we, in our own time, beheld the photography of the Apollo missions. Yet, in a remarkably short span of time, the photograph as surrogate *for* travel also became the souvenir *of* travel. Everything from Parisian alleys to Abyssinian huts soon became a photograph—as the Sack Collection attests— and the human world was rendered in miniature, ready for systematic placement in file drawers or albums. What we now call globalization is but one complex outcome of the course of empire, ratified by photography's first great epoch.

—D.R.N.

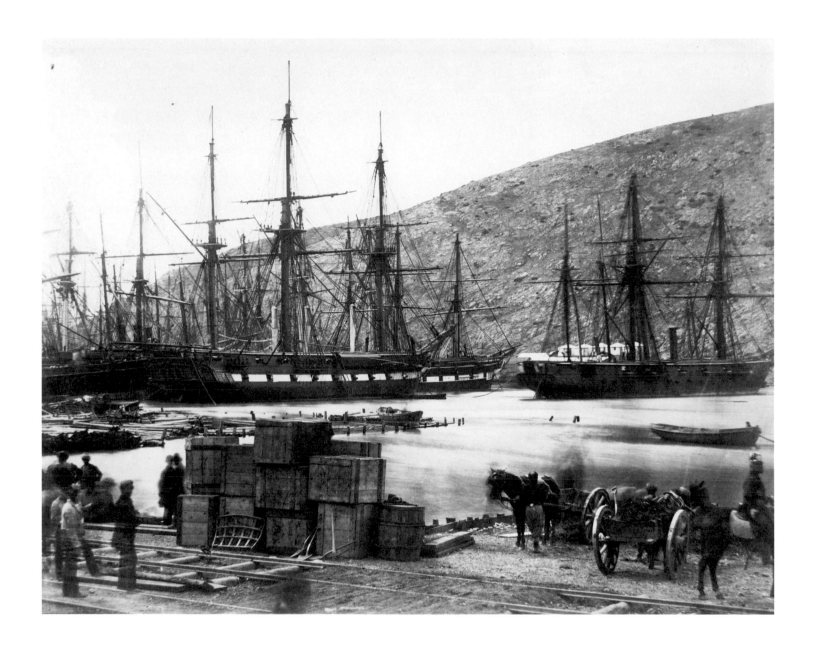

70. **Roger Fenton**
Head of Harbour, Balaklava, 1856
Salt print from a glass negative
8 x 10 1/16 in. (20.3 x 25.6 cm)

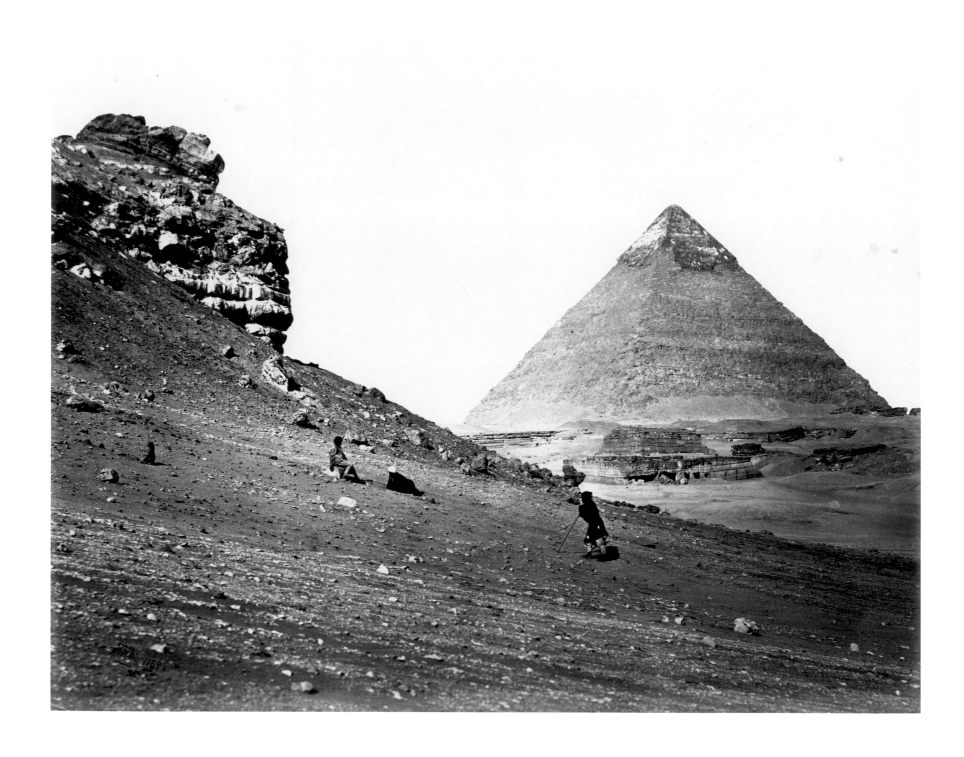

71. Francis Frith
The Second Pyramid from the Southeast, 1858
Albumen print from a glass negative
15 x 18⁷⁄₈ in. (38.1 x 47.9 cm)

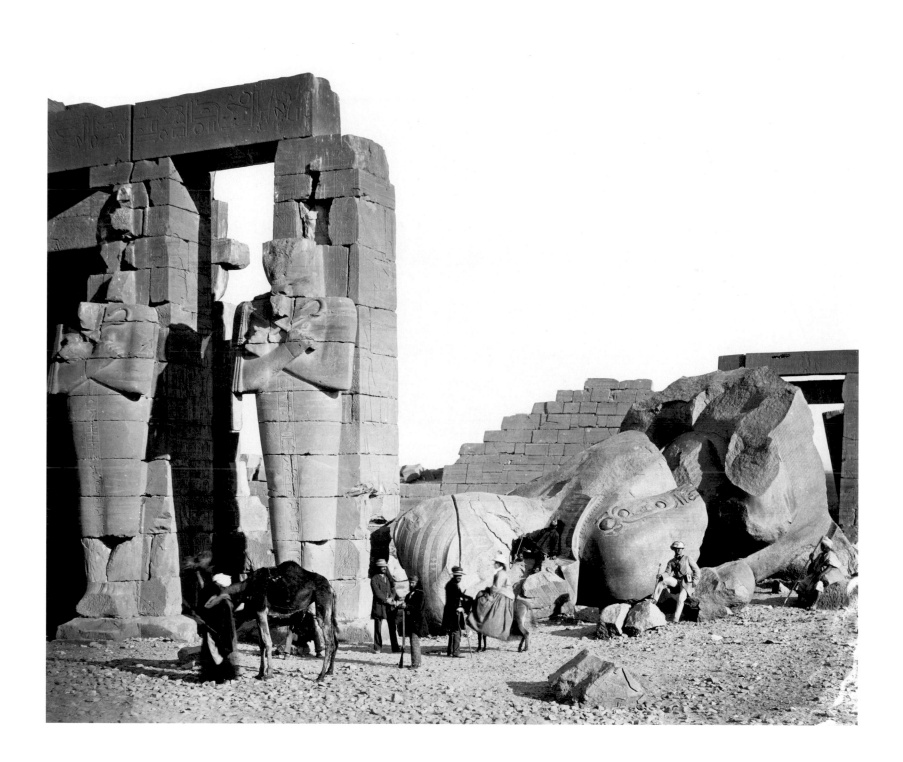

72. **Francis Frith**
The Rameseum of El-Kurneh, Thebes—First View, ca. 1857
Albumen print from a glass negative
15 3/8 x 17 3/4 in. (39.1 x 45.1 cm)

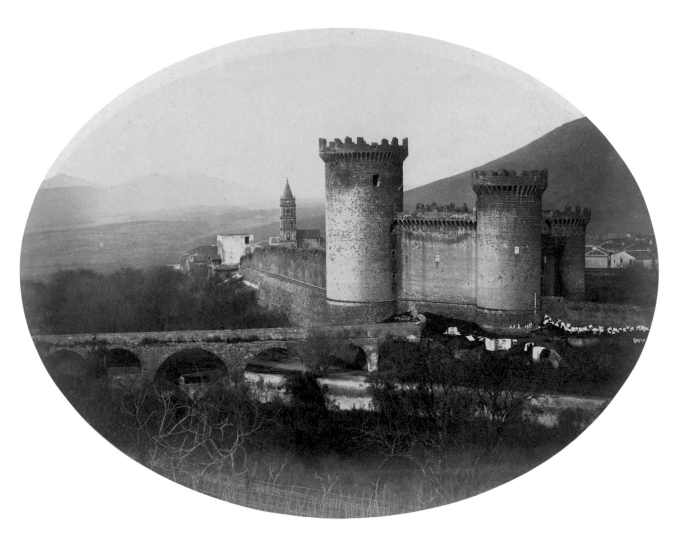

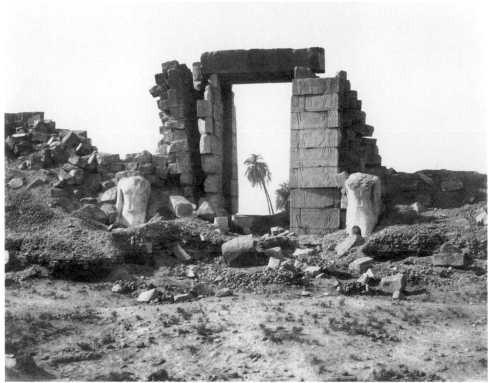

73. **Robert MacPherson**
Rocca Pia, Tivoli, ca. 1860
Albumen print
12 1/16 x 15 3/8 in. (30.6 x 39.1 cm)

74. **Félix Teynard**
Karnak (Thèbes)—premier pylône—ruines de la porte et des colosses, vues du point E (Karnak [Thebes]—First Pylon—Ruins of the Gate and the Colossi Seen from Point E), ca. 1851–52, printed ca. 1853–54
Salt print from a paper negative
9 5/8 x 12 1/8 in. (24.4 x 30.8 cm)

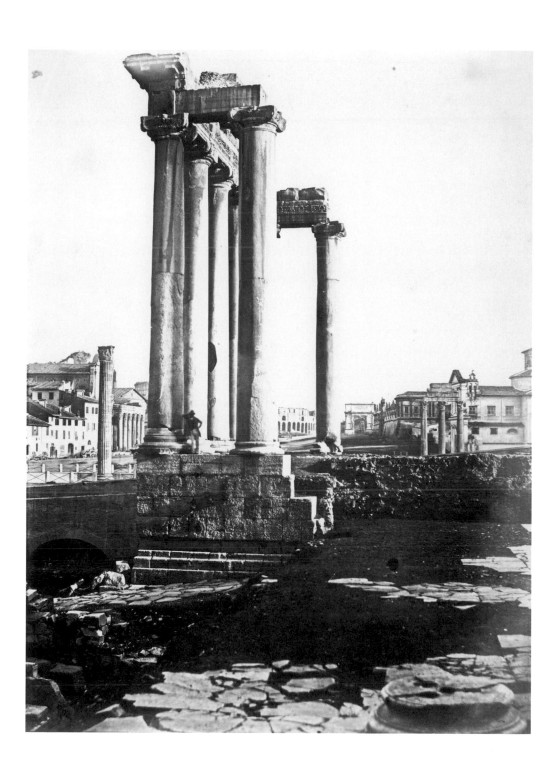

75. Robert Eaton
Roman Forum, 1853
Salt print from a glass negative
10 x 7³/₈ in. (25.4 x 18.7 cm)

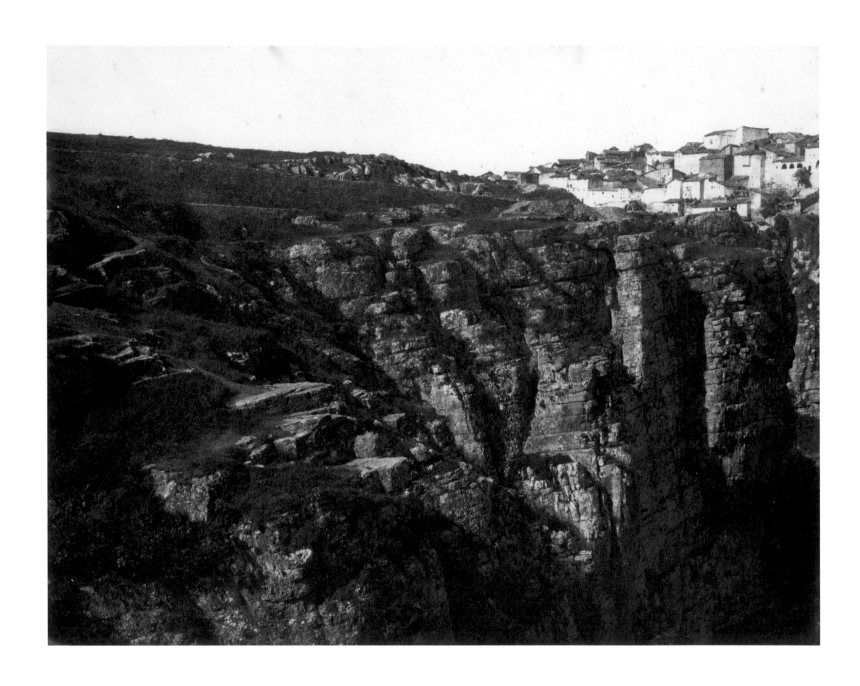

76. **John Beasley Greene**
Untitled [Clifftop Town], 1850s
Salt print
9 3/8 x 12 in. (23.8 x 30.5 cm)

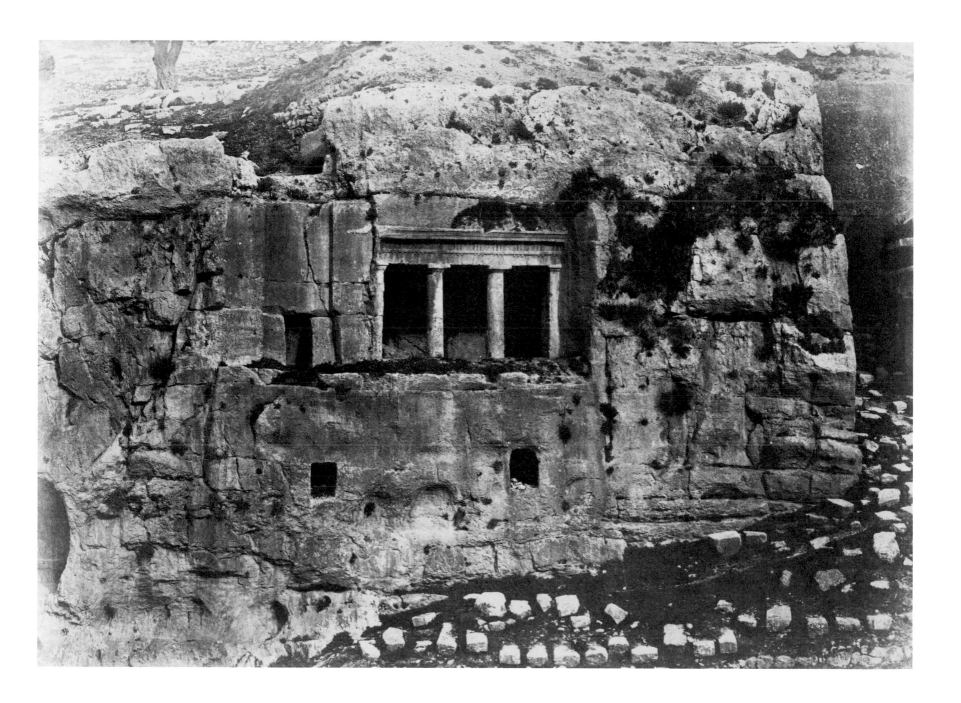

77. Auguste Salzmann
Jérusalem, Vallée de Josaphat, Tombeau de Saint-Jacques
(Jerusalem: Valley of Jehoshaphat, Tomb of Saint James),
ca. 1854–56
Salt print from a paper negative
9³/₁₆ x 12¹¹/₁₆ in. (23.3 x 32.2 cm)

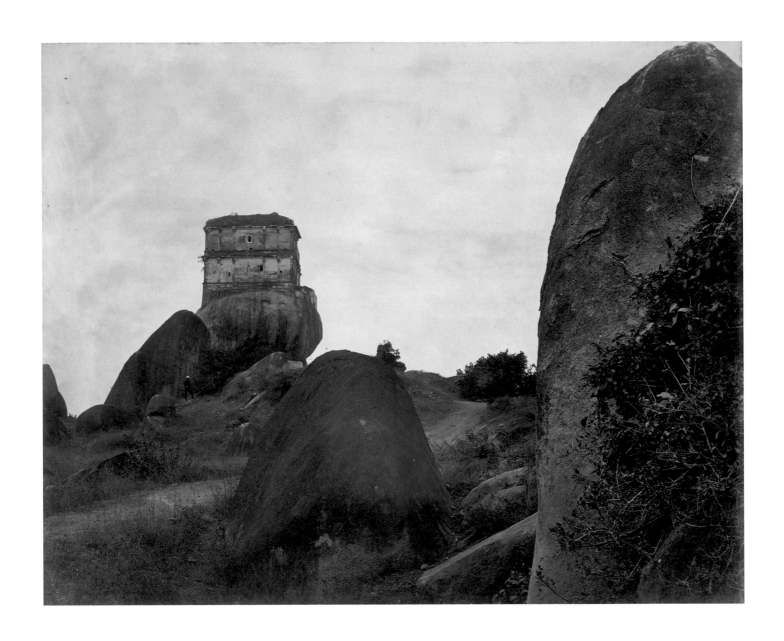

78. Unknown Artist
Muddin Mahal, Jubulpur, ca. 1870
Albumen print from a glass negative
9 1/16 x 11 5/16 in. (23 x 28.7 cm)

79. Désiré Charnay
Maison du curé—Mitla, Oaxaca (Priest's House—Mitla,
Oaxaca), 1859
Albumen print from a glass negative
10 5/8 x 15 3/4 in. (27 x 40 cm)

80. **Unknown Artist**
Untitled [American Farm Landscape], 1850s
Daguerreotype
5 1/4 x 7 1/4 in. (13.3 x 18.4 cm)

81. **Unknown Artist**
Untitled [Ambrotype Studio], ca. 1840
Ambrotype
3 1/2 x 4 3/4 in. (8.9 x 12.1 cm)

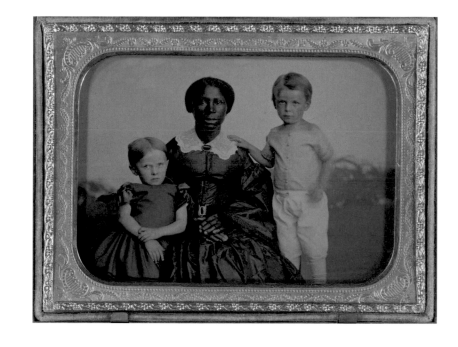

82. Unknown Artist
Untitled [African American Woman with Two White Children], ca. 1860
Ambrotype
2 1/2 x 3 1/2 in. (6.4 x 8.9 cm)

83. Unknown Artist
Untitled [Man and Horse], ca. 1850
Ambrotype
2 1/8 x 2 5/8 in. (5.4 x 6.7 cm)

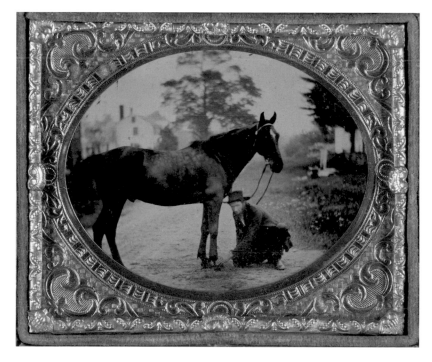

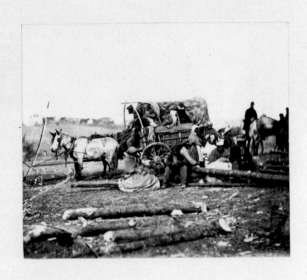

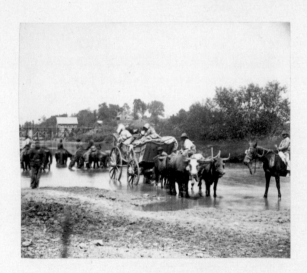
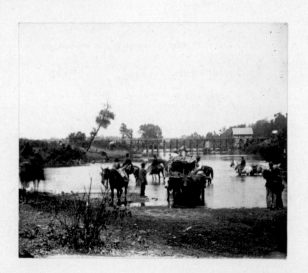

Fugitive Negro Family Fording Rappahannock River, near Farquier Court House, Va., Nov. 1862.

84. Timothy H. O'Sullivan
Fugitive Negro Family Fording Rappahannock River,
near Farquier Court House, Virginia, 1862
Three albumen prints mounted to board
10 1/16 x 12 in. (25.6 x 30.5 cm) overall

85. Mathew B. Brady
View of Richmond, Virginia, ca. 1865
Albumen stereo view
3 15/16 x 9 3/4 in. (10 x 24.8 cm)

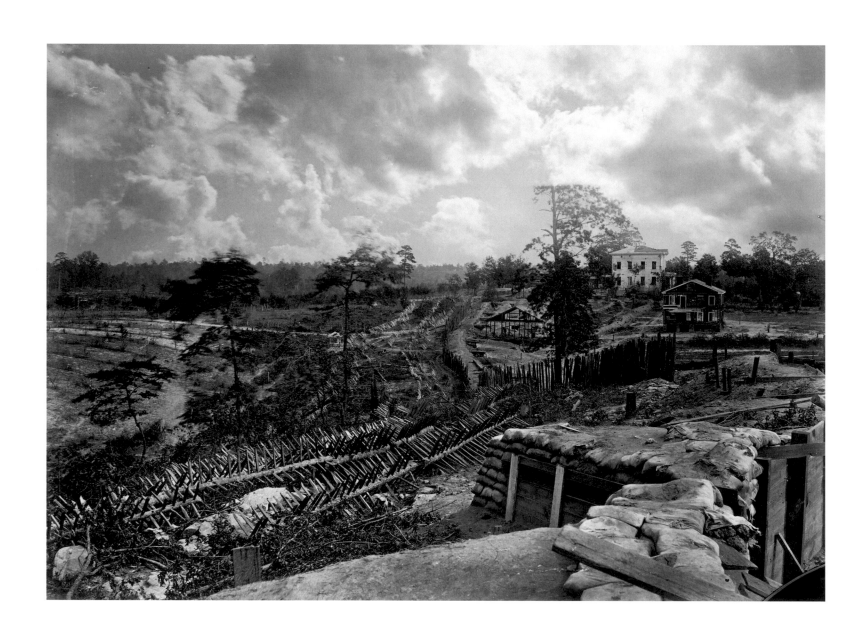

86. **George N. Barnard**
Rebel Works in Front of Atlanta, Georgia, no. 1, 1864
Albumen print
10 1/8 x 14 1/8 in. (25.7 x 35.9 cm)

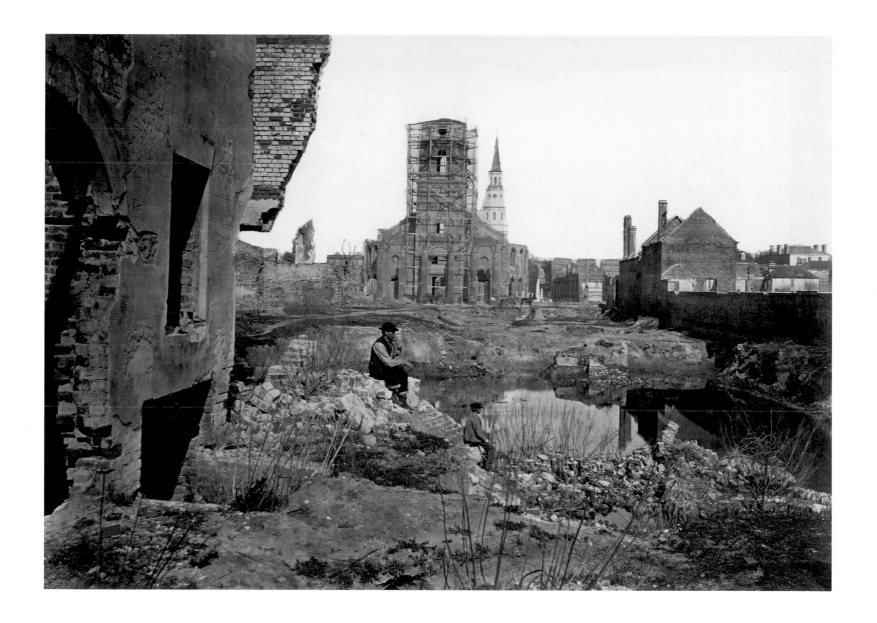

87. **George N. Barnard**
Ruins in Charleston, South Carolina, ca. 1865–66
Albumen print
10 1/8 x 14 1/8 in. (25.7 x 35.9 cm)

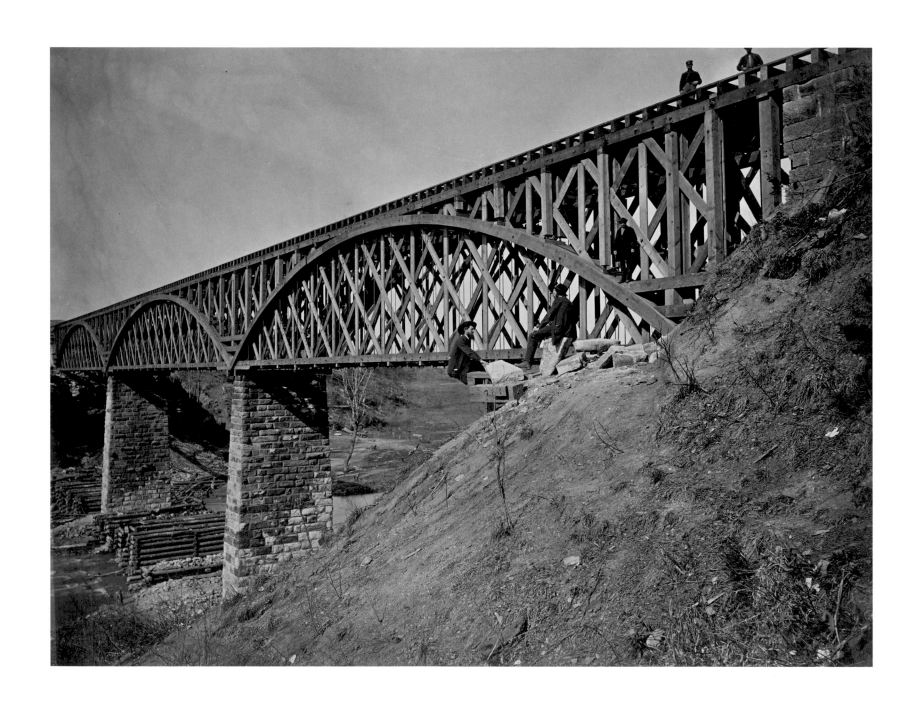

88. **Andrew Joseph Russell**
Untitled [Railroad Bridge, Civil War], 1861
Albumen print
11⁷/₈ x 15⁵/₈ in. (30.2 x 39.7 cm)

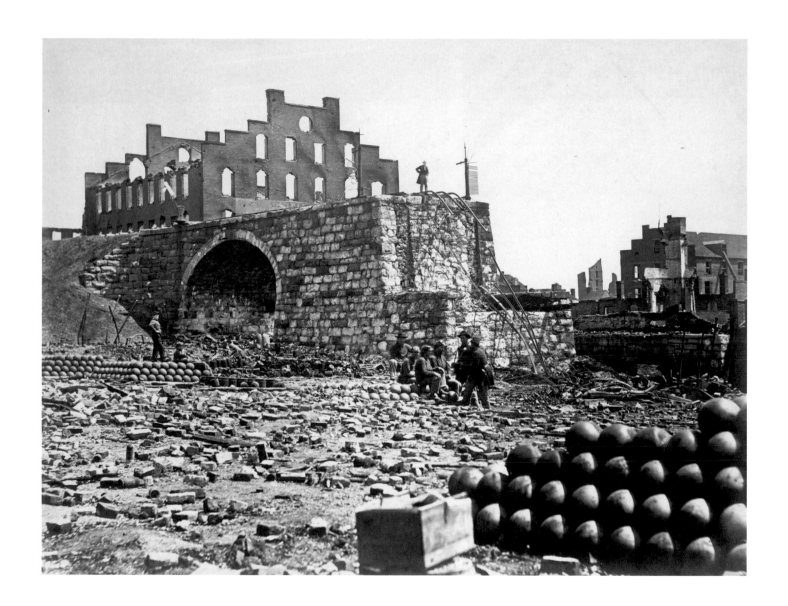

89. **Alexander Gardner**
Ruins of Arsenal, Richmond, Virginia, 1865
Albumen print
6 13/16 x 8 7/8 in. (17.3 x 22.5 cm)

NORTH AND SOUTH, EAST AND WEST

Photography may have been invented in Europe, but it was immediately adopted by America. Photography spoke to the value Americans placed on progress and invention and held out the promise of a new kind of democratic picture making. It was in the photographer's studio—whether in Mathew B. Brady's lavish salon or against the makeshift backdrop of an itinerant daguerreotypist—that the young nation first determined what it meant to look and act like an American. The cherished daguerreotypes produced in the mid-nineteenth century preserve in minute detail an archaeology of customs and fashions, offering a portrait of a nation on the cusp of modernity. Over the course of the nineteenth century, however, photography would play a role in the shaping of American identity in less individual and literal ways, changing conventions for the making and recording of a collective history and forging a pictorial rhetoric with which to represent the new nation.

The Civil War, though ignited by the fierce debate over slavery, was rooted in a complex and bitter contest over the nation's identity and future, pitting the North against the South; industrialized, capitalist market economies against traditional agrarian values; centralized government against states' rights. Frequently described as the first "modern" war, it was not only waged with a panoply of new technologies—from the railroad and the submarine to the telegraph and rifled musket—but it was also extensively documented with one. Tens of thousands of photographs were made during the war by hundreds of photographers. A large portion of these were portraits: some for private use, and others, in the case of generals or other prominent figures, for sale to the public as *cartes-de-visite*. Other pictures depicted life in the encampments, military operations, and, less frequently but to profound effect, the aftermath of battle. Reproduced as engravings in the popular illustrated journals, these photographs brought the grim reality of the bloodiest war in American history into northern homes.

No known pictures of actual combat exist among the many photographs made during the war. The technical complexities of photography at the time and the deadly effectiveness of new long-range weapons kept photographers at a distance from the action. As a consequence, many of the most haunting photographs depict empty battlefields; sometimes they are dotted with the unburied bodies of fallen soldiers, but more often destroyed buildings and trampled foliage are the sole evidence of the war's terrible violence.

In George N. Barnard's *Rebel Works in Front of Atlanta, Georgia, no. 1 (pl. 86)*, we look out over the abandoned fortifications of a former Confederate encampment. Barnard, a highly successful daguerreotypist from upstate New York, photographed for both Mathew B. Brady and the military during the war. In 1866 he published an album of sixty photographs entitled *Photographic Views of Sherman's Campaign*. Though many of these pictures were made during the war, others were taken shortly afterward, retracing General William T. Sherman's destructive path through Georgia and South Carolina. The pictures in Barnard's album are quiet, melancholy, and almost completely unpeopled.

Barnard's photographs, like those of many of his wartime colleagues, are a meditation on the sense of history, even sanctity, that the idea of place came to assume in the Civil War. Abraham Lincoln invoked this symbolic status in his Gettysburg Address of 1863: "But, in a larger sense, we cannot dedicate—we cannot consecrate—we cannot hallow—this ground. The brave men, living and dead, who struggled here have consecrated it, far above our poor power to add or detract." The photographs made of

these now-historic sites served commemorative rather than strictly documentary purposes. Their makers attempted to depict what is almost impossible to represent: the transformation of site into memorial, the passage of the brutal and bloody present into history's safe custody.

Many of the photographers who recorded the catastrophic destruction of the Civil War were soon engaged in the forward-looking enterprise of nation building. In 1862 Congress authorized construction of a transcontinental railroad, which began in earnest after the war. Some photographers were hired by the railroad companies, while others were employed by expeditions organized to survey the region's natural resources. The discovery of gold in California in 1848 had helped fuel the myth of a land of boundless economic opportunity and a culture that fostered rugged individualism and self-invention. To a nation reeling from civil war, the vast terrain of the West must indeed have seemed utopian, unspoiled by politics and unburdened by history, a place where America might be invented anew.

Just as the immediacy of photography had served to communicate the horrors of war to northern viewers, the pictures taken in the American West were made with a remote audience in mind. Photographs documenting the features and inhabitants of the frontier were disseminated to Congress, the military, and potential investors as well

as to a public eager to see the mythical landscape of the American West. Many of the photographs depict the newly constructed railroads, which became as common to the iconography of the West as its remarkable rock formations and giant trees. The railroad, hurtling through time and space at enormous speed, came to symbolize American progress, collapsing the distance between east and west, past and future. In J. F. Ryder's 1862 photograph (*pl. 98*), as in so many pictures of the era, railroad tracks extend toward the distant horizon, as if destiny lies right around the bend.

The sense of futurity evoked in pictures of the West is equally evident in scenes of its urban centers. Photography flourished in cities where growing numbers of fortune-seekers wanted pictures of themselves. Photographers soon moved from portraits of these urban inhabitants to portraits of the cities, and picturesque San Francisco was one of the most popular subjects. George R. Fardon's *San Francisco Album: Photographs of the Most Beautiful Views and Public Buildings of San Francisco* (1856) was the first published photographic portrait of an American city. The album (*see pl. 97*), designed to entice potential investors, represents not only an attractive city but one with a well-established business community, stately civic architecture, and a full complement of municipal services.

Fardon's dense, street-level views

stand in sharp contrast to the expansive panoramas of Eadweard Muybridge. Composed of thirteen mammoth-plate prints, his 1878 panorama (*pl. 106*) is nearly twenty feet long, mimicking in scale the grand sweep of the hilltop view. Yet Muybridge's portrait of the city was no less programmatic than Fardon's. After the completion of the transcontinental railroad, many of its executives moved to San Francisco and built ornate mansions at the top of California Street Hill (now known as Nob Hill). Muybridge's pictures were taken in succession over the course of a single day, turning 360 degrees on a fixed spot in the tallest tower of the mansion of railroad baron Mark Hopkins, then still under construction. Not only did the site offer a spectacular view of the city, but it was also inextricably associated in the popular imagination with the wealthy and successful men who lived there. At once inventory and metaphor, the panorama also points to the world beyond the city: the busy port bristles with the masts of sailing ships, and rolling hills surround the city. Perched on the country's westernmost shore, San Francisco looks out over the water, which serves here not as a limit but as an infinite horizon.

—C.K.

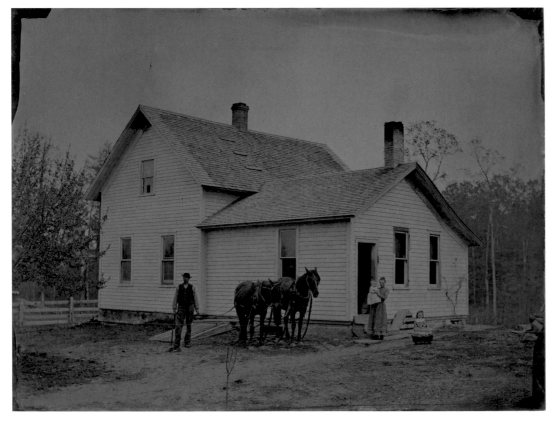

90. **Unknown Artist**
Untitled [Two Men Posing in Front of Niagara Falls,
View of the Canadian Side], ca. 1870
Ambrotype
6 ¹/₂ x 8 ¹/₂ in. (16.5 x 21.6 cm)

91. **Unknown Artist**
Untitled [Family in Front of a Farmhouse], ca. 1870
Tintype
6 ⁷/₈ x 9 in. (17.5 x 22.9 cm)

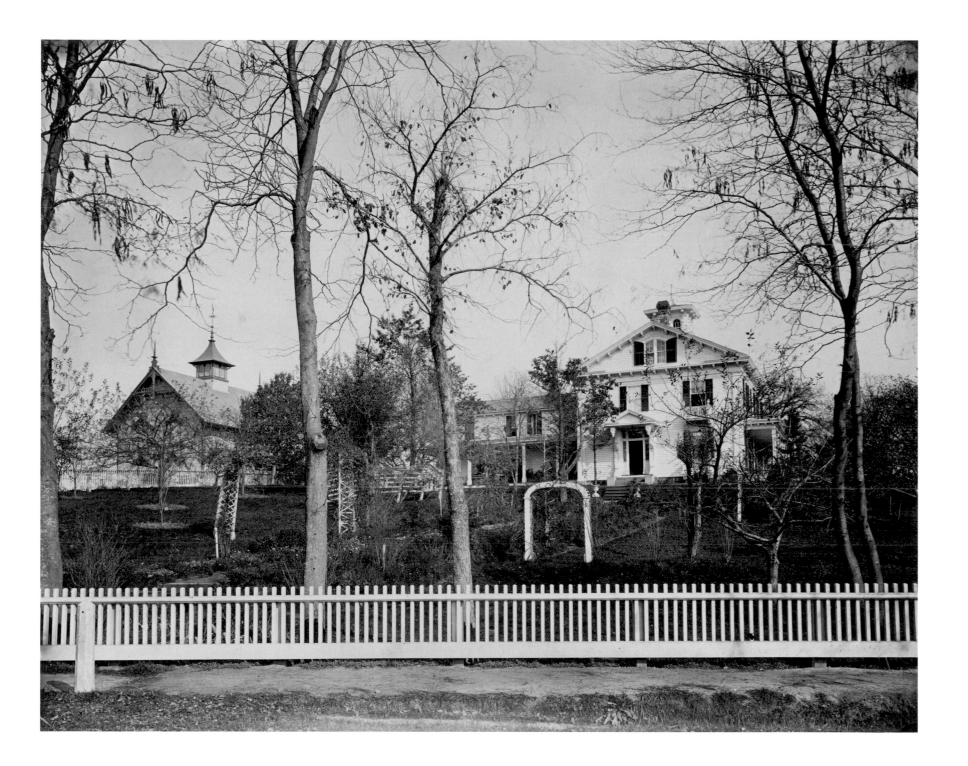

92. **David W. Butterfield**
Untitled [New England Houses], 1870s
Albumen print from a glass negative
16 1/4 x 20 5/16 in. (41.3 x 51.6 cm)

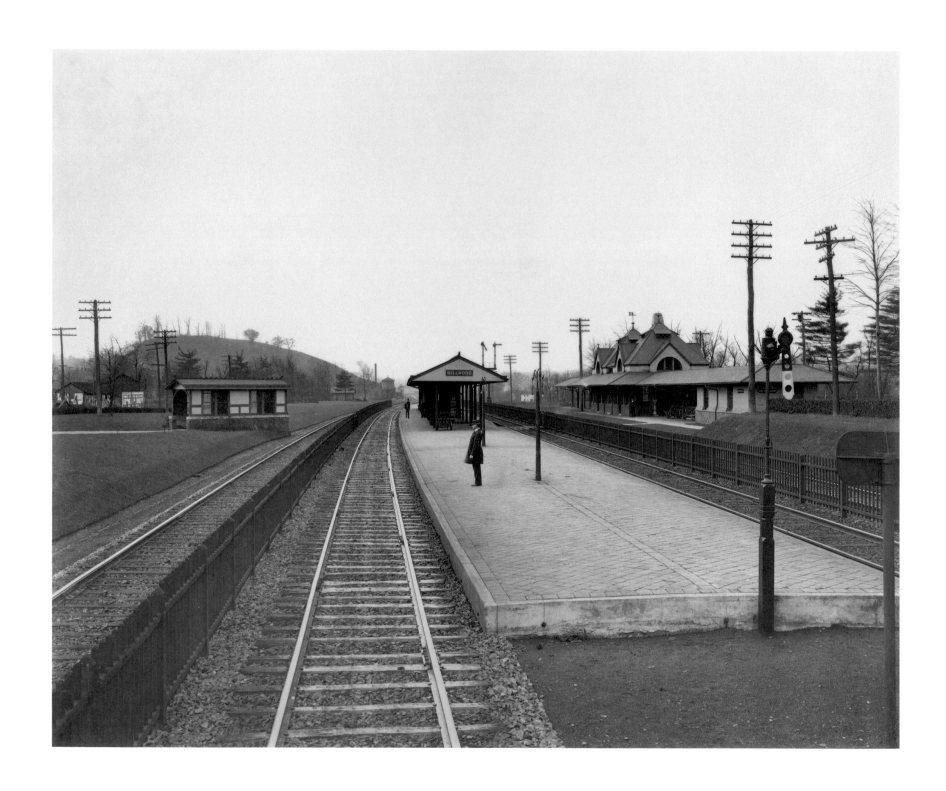

93. **William Herman Rau**
Bellwood Station, Pennsylvania Railroad, ca. 1885
Platinum print
17 1/2 x 21 1/8 in. (44.5 x 53.7 cm)

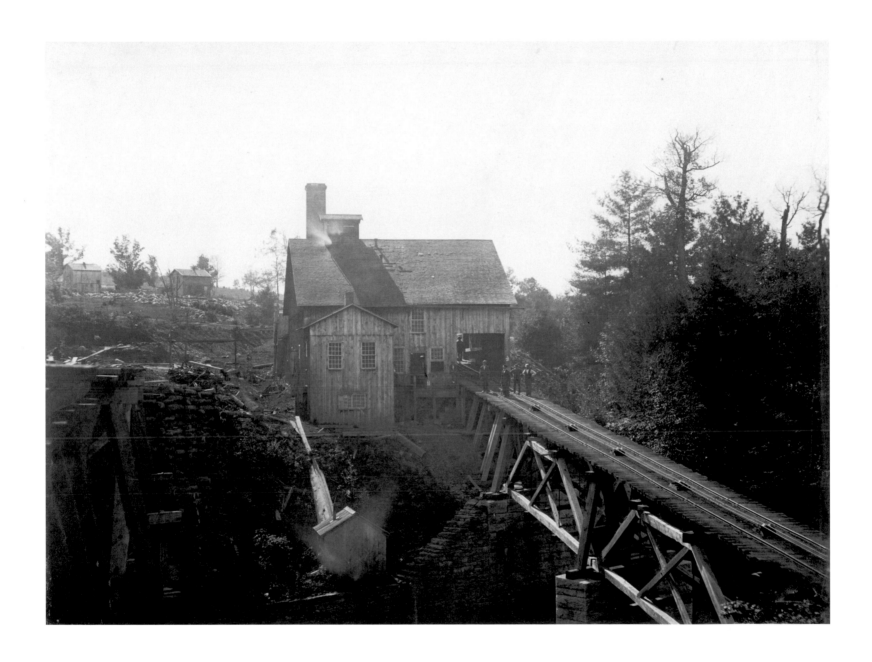

94. **Thomas Johnson**
Inclined Plane, ca. 1865
Albumen print from a glass negative
12 1/8 x 16 1/16 in. (30.8 x 40.8 cm)

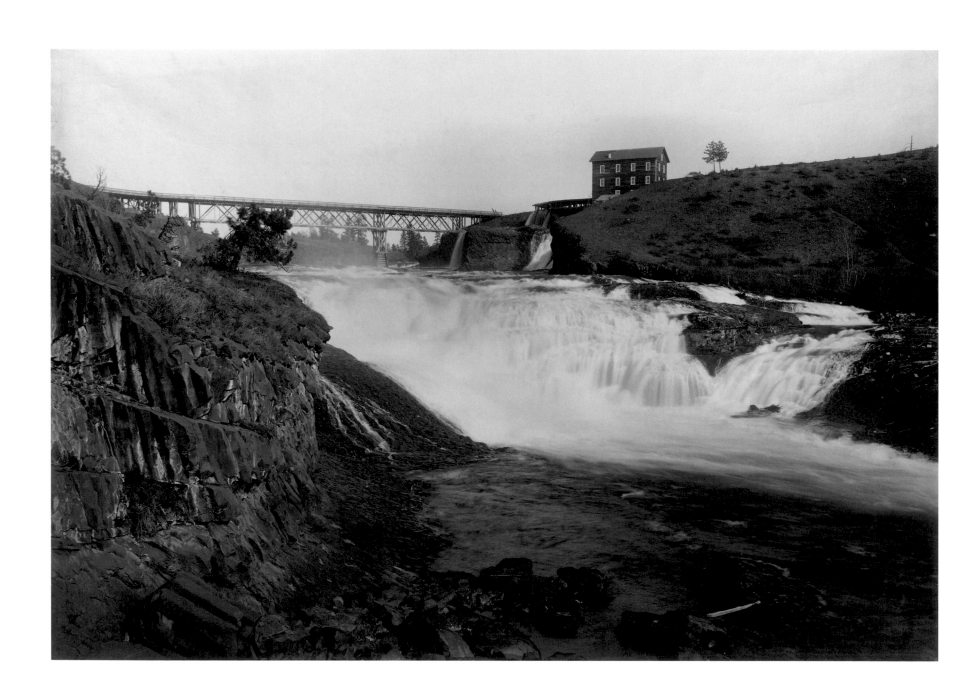

95. Carleton E. Watkins
Spokane Falls, 1882
Mammoth-plate albumen print
14 5/8 x 21 1/16 in. (37.1 x 53.5 cm)

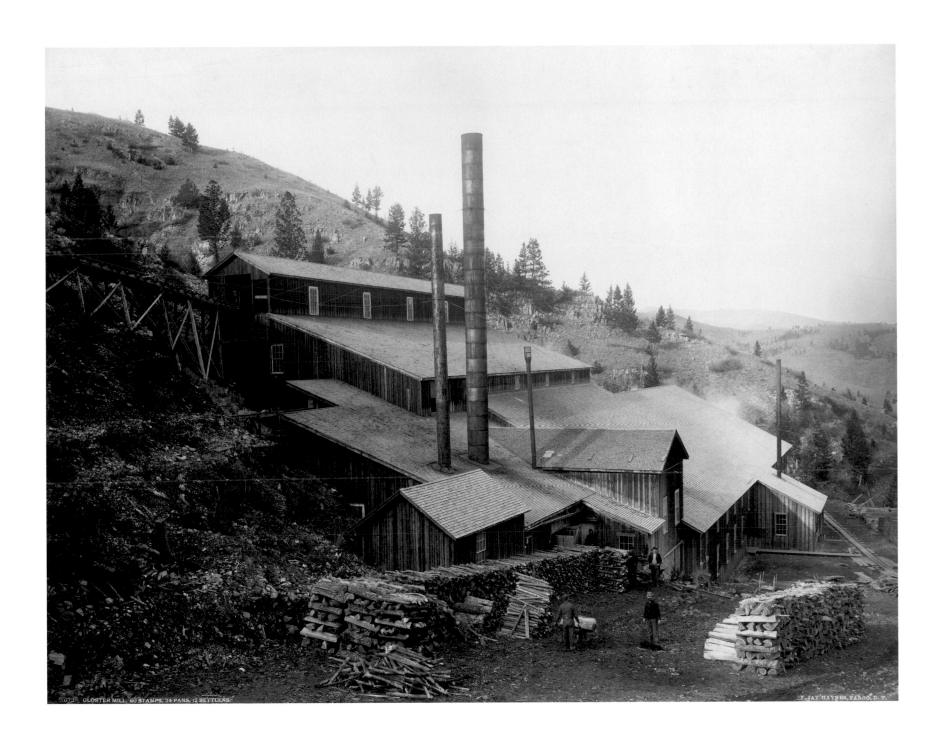

96. Frank Jay Haynes
Gloster Mill, 60 Stamps, 24 Pans, 12 Settlers, ca. 1885
Albumen print from a glass negative
17 1/8 x 21 13/16 in. (43.5 x 55.4 cm)

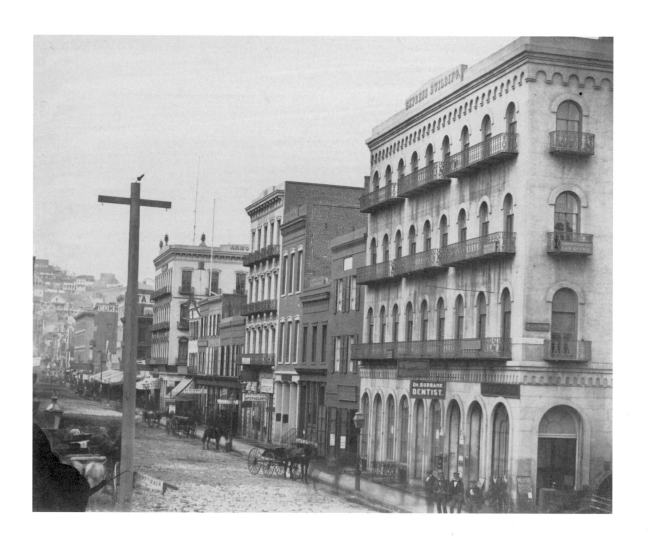

97. George R. Fardon
East Side of Montgomery Street, 1856
Salt print from a glass negative
6¼ x 7½ in. (15.9 x 19.1 cm)

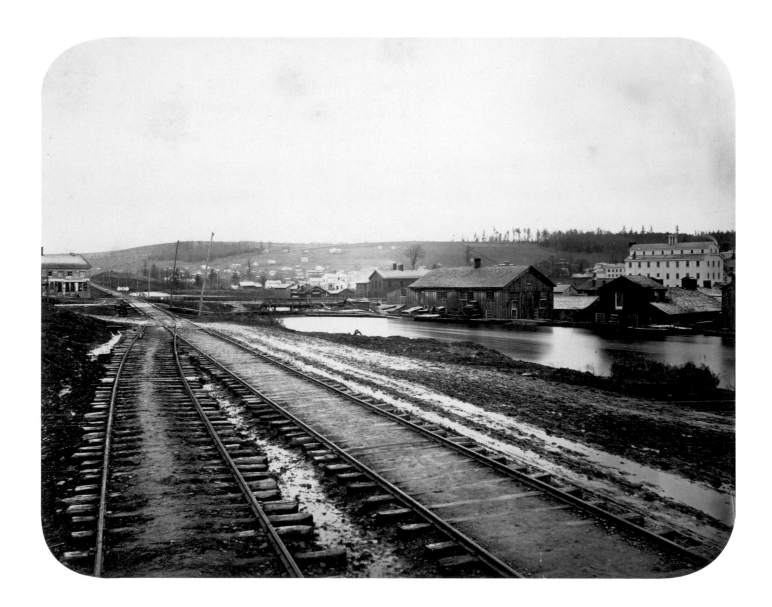

98. J. F. Ryder
Untitled [Train Tracks], 1862
Albumen print
7 1/2 x 9 1/4 in. (19.1 x 23.5 cm)

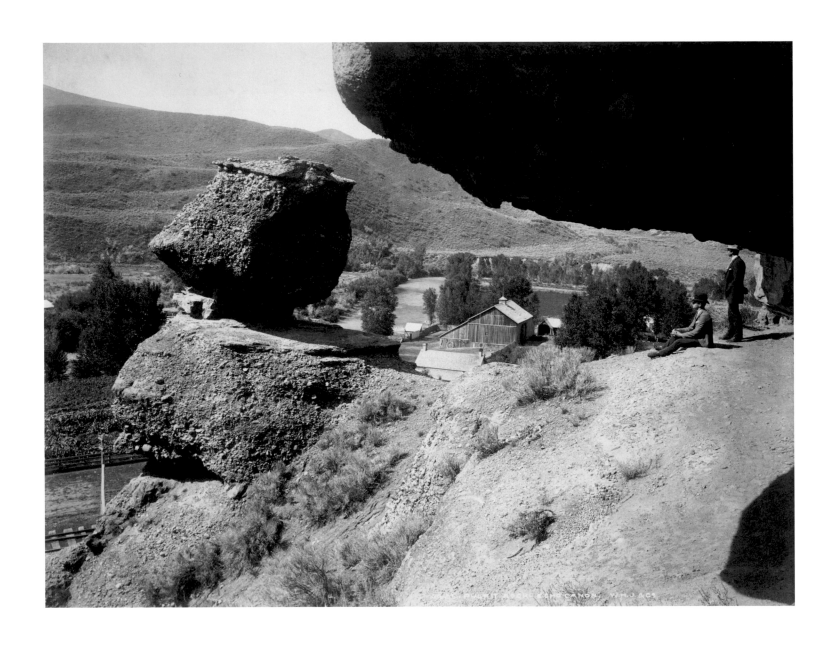

99. **William Henry Jackson**
Pulpit Rock, Echo Canyon, Utah, ca. 1869
Albumen print from a glass negative
7 x 9 3/8 in. (17.8 x 23.8 cm)

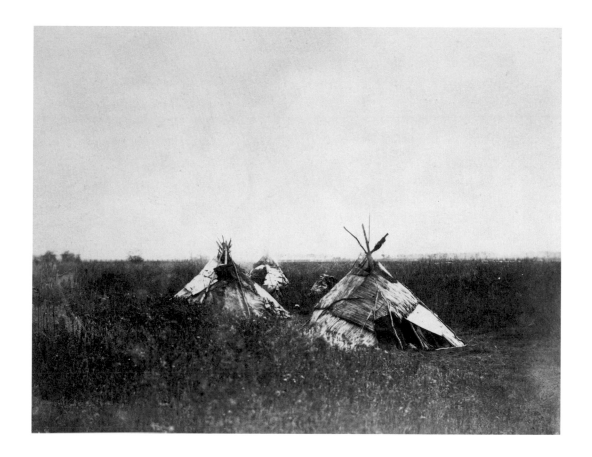

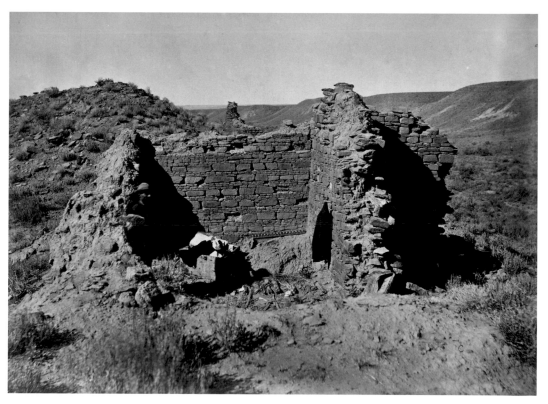

100. **Humphrey Lloyd Hime**
Birch Bark Tents, West Bank of Red River,
Middle Settlement, 1858
Albumen print
5³/₈ x 6¹³/₁₆ in. (13.7 x 17.3 cm)

101. **Timothy H. O'Sullivan**
Ruins in Ancient Pueblo of San Juan,
Colorado, 1874
Albumen print
8 x 10¹³/₁₆ in. (20.3 x 27.5 cm)

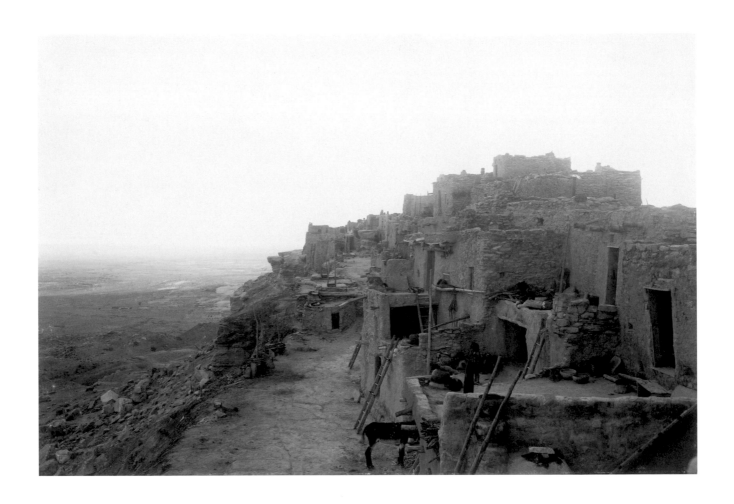

102. **Adam Clark Vroman**
Hopi Mesa, ca. 1897
Gelatin silver print
5 1/4 x 7 5/8 in. (13.3 x 19.4 cm)

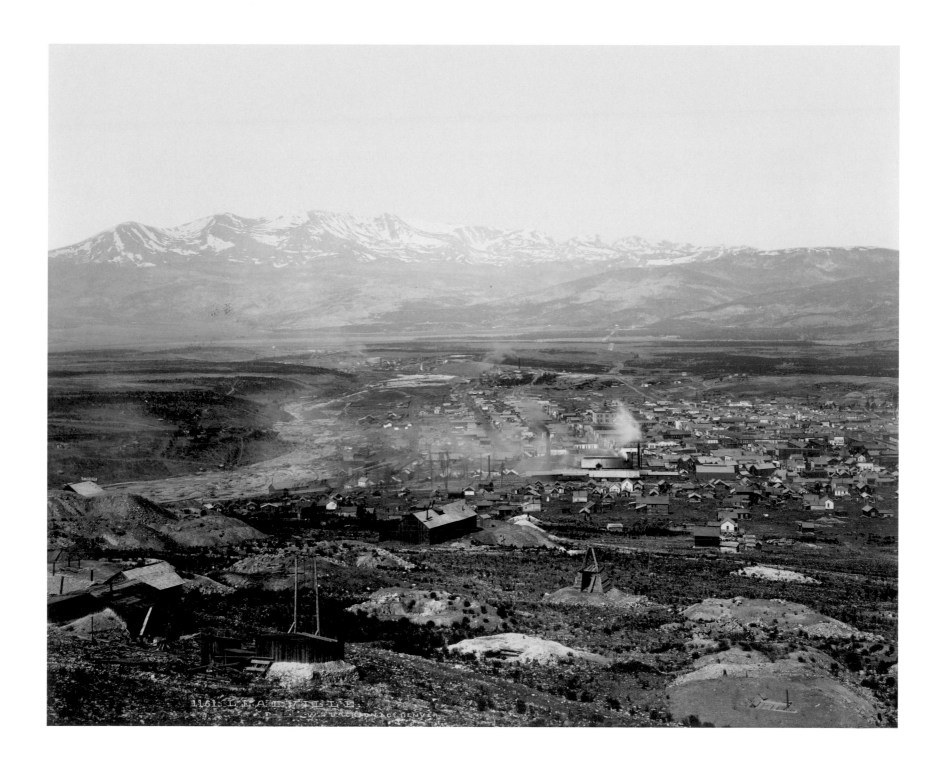

103. William Henry Jackson
Leadville, ca. 1880
Albumen print from a glass negative
17 1/4 x 21 3/8 in. (43.8 x 54.3 cm)

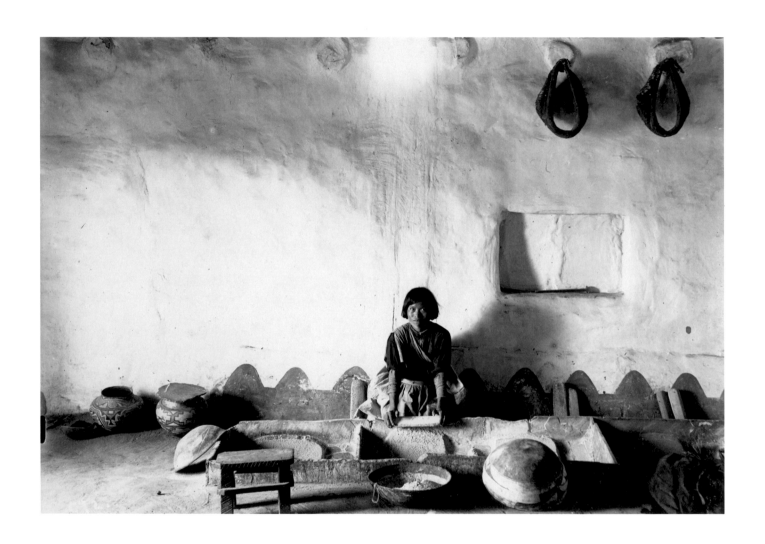

104. **Adam Clark Vroman**
Hopi Woman Grinding Corn, ca. 1897
Gelatin silver print
4 9/16 x 6 9/16 in. (11.6 x 16.7 cm)

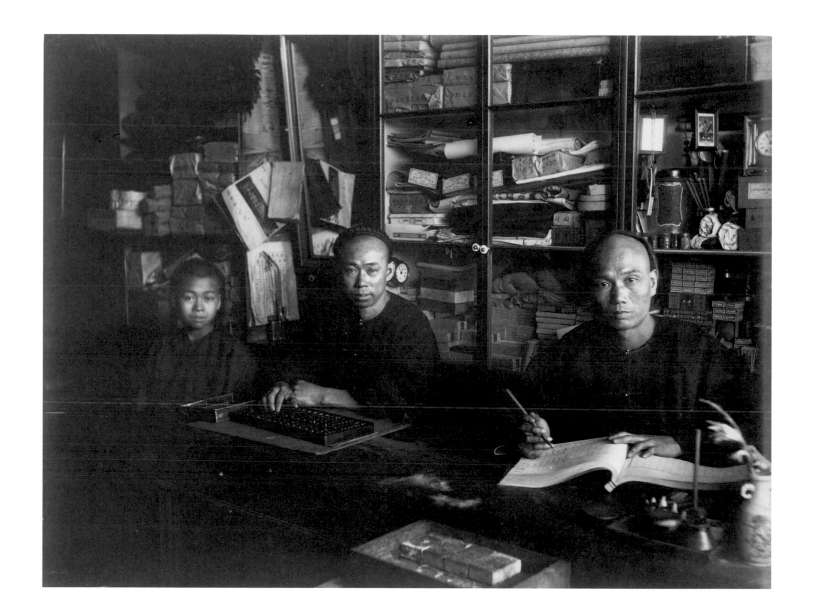

105. **Isaiah West Taber**
Chinese Accountant, Chinatown, San Francisco, California, ca. 1880
Albumen print
7 1/4 x 9 1/2 in. (18.4 x 24.1 cm)

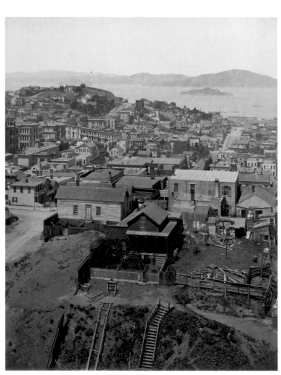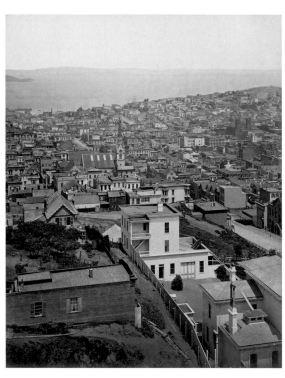

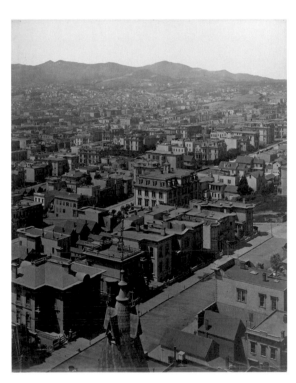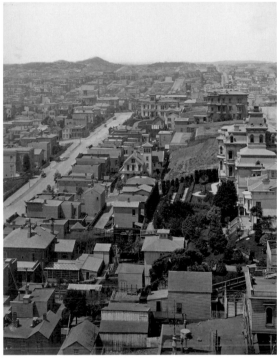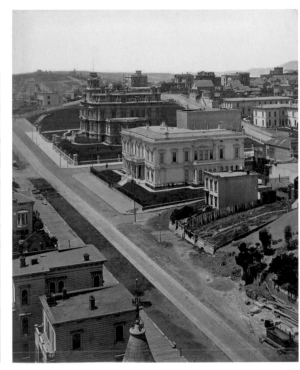

106. **Eadweard Muybridge**
Panorama of San Francisco from California Street Hill, 1878
Thirteen albumen prints from glass negatives
Each: 20 x 15 1/2 in. (50.8 x 39.4 cm)

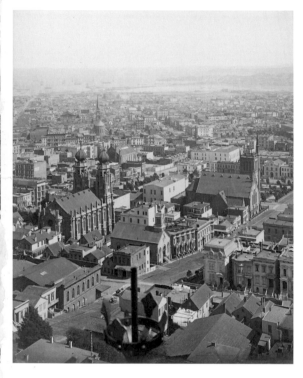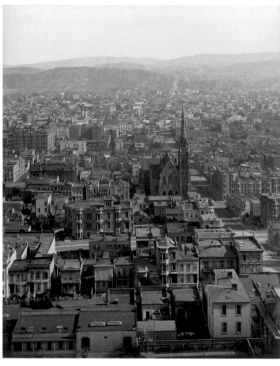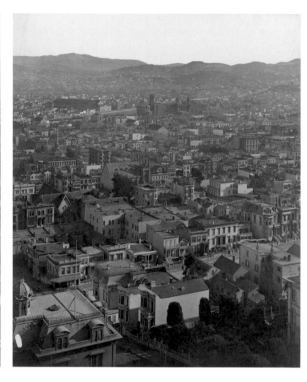

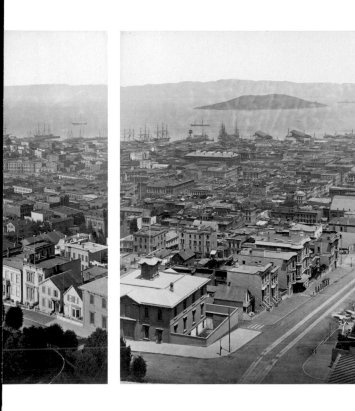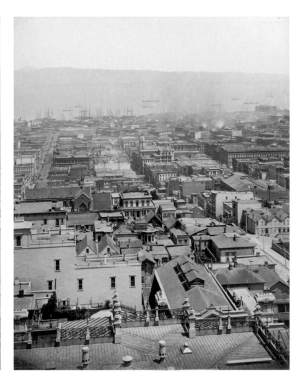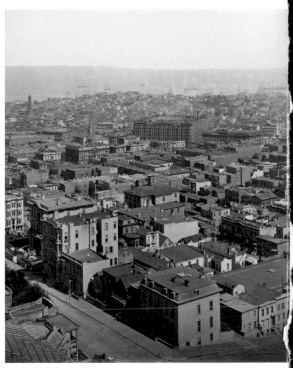

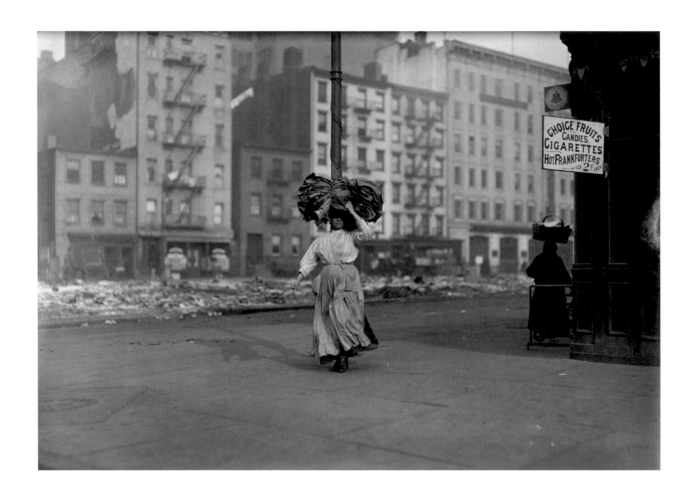

107. **Lewis Wickes Hine**
Italian Immigrant, East Side, New York City, 1910
Gelatin silver print
4 7/8 x 6 13/16 in. (12.4 x 17.3 cm)

108. **Jacob August Riis**
*Shooting Craps: The Game of the Street. Bootblacks
and Newsboys,* ca. 1895, printed ca. 1946
Gelatin silver print
7⁷/₈ x 9³/₄ in. (20 x 24.8 cm)

109. **John Thomson**
Workers on the "Silent Highway," ca. 1877–78
Woodburytype
4 1/2 x 3 1/2 in. (11.4 x 8.9 cm)

110. **John Thomson**
Public Disinfectors, ca. 1877–78
Woodburytype
4 5/8 x 3 5/8 in. (11.7 x 9.2 cm)

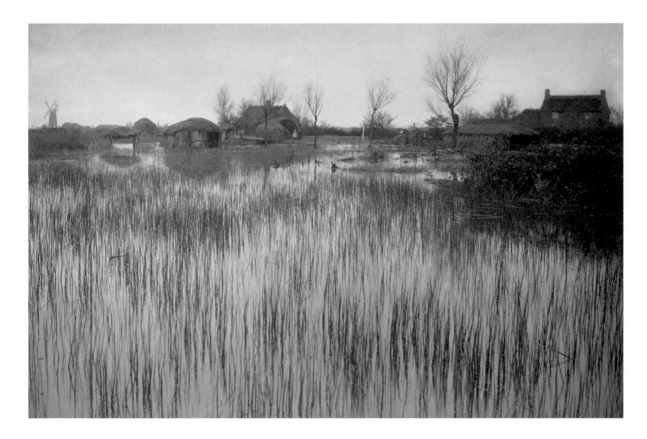

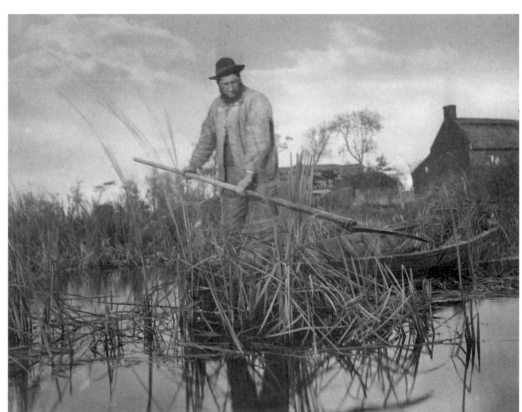

111. **Peter Henry Emerson**
A Rushy Shore, 1886
Platinum print
7 1/2 x 11 3/16 in. (19.1 x 28.4 cm)

112. **Peter Henry Emerson**
Cutting the Gladdon, 1886
Platinum print
7 7/16 x 9 7/16 in. (18.9 x 24 cm)

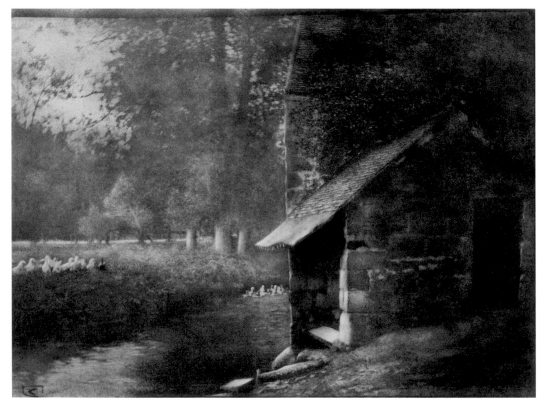

113. Alvin Langdon Coburn
Untitled [Twilight Study], ca. 1910
Platinum print
6 5/16 x 7 13/16 in. (16 x 19.8 cm)

114. Robert Demachy
Untitled [French Cottage], ca. 1910
Oil transfer print
6 5/8 x 9 in. (16.8 x 22.9 cm)

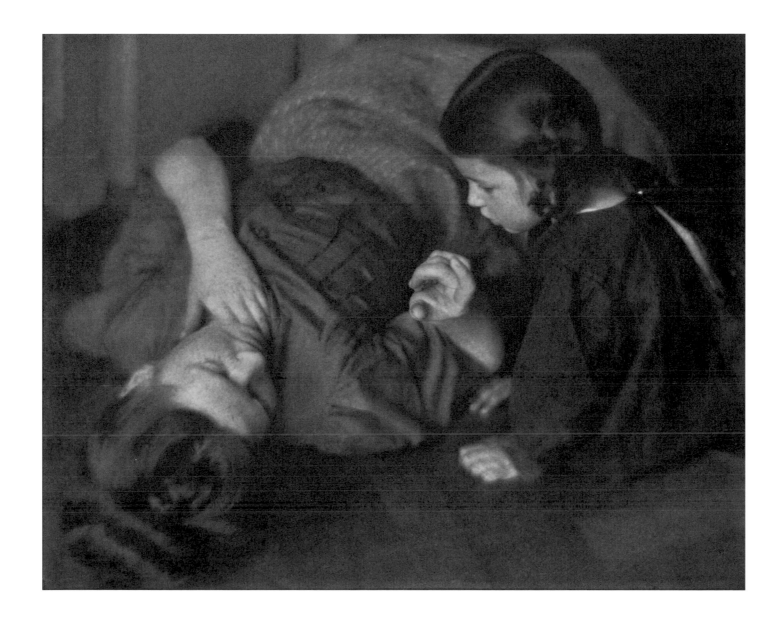

115. **Heinrich Kühn**
Mary and Lotte, Innsbruck-Tyrol, 1908
Gum bichromate print
9 1/8 x 11 1/2 in. (23.2 x 29.2 cm)

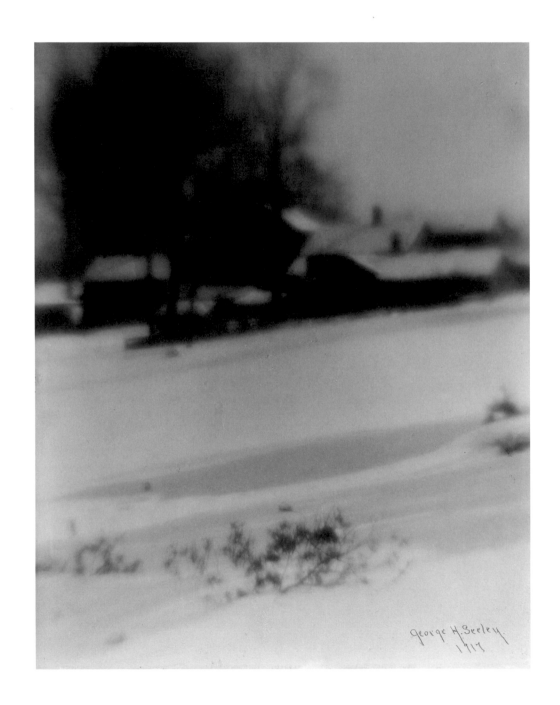

116. **George Henry Seeley**
Untitled [Winter Landscape], 1917
Gelatin silver print
9 5/8 x 7 5/8 in. (24.4 x 19.4 cm)

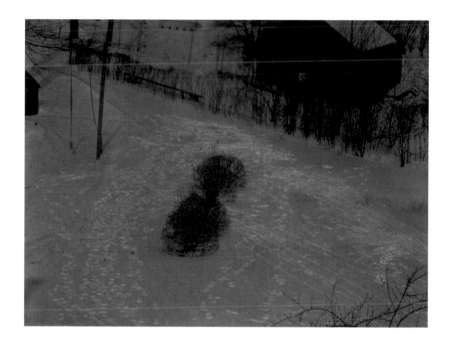

117. Edward Steichen
Rock Hill, Oyster Bay, Long Island, 1920
Gum platinum print
3 9/16 x 4 9/16 in. (9 x 11.6 cm)

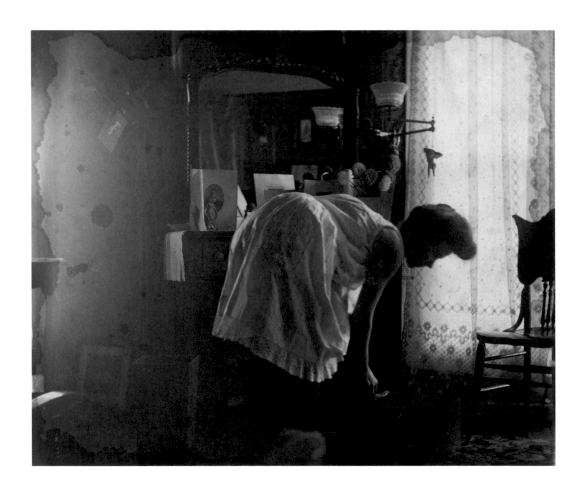

118. Unknown Artist
Untitled [Woman Dressing], ca. 1900
Gelatin silver print
3 3/4 x 4 1/2 in. (9.5 x 11.4 cm)

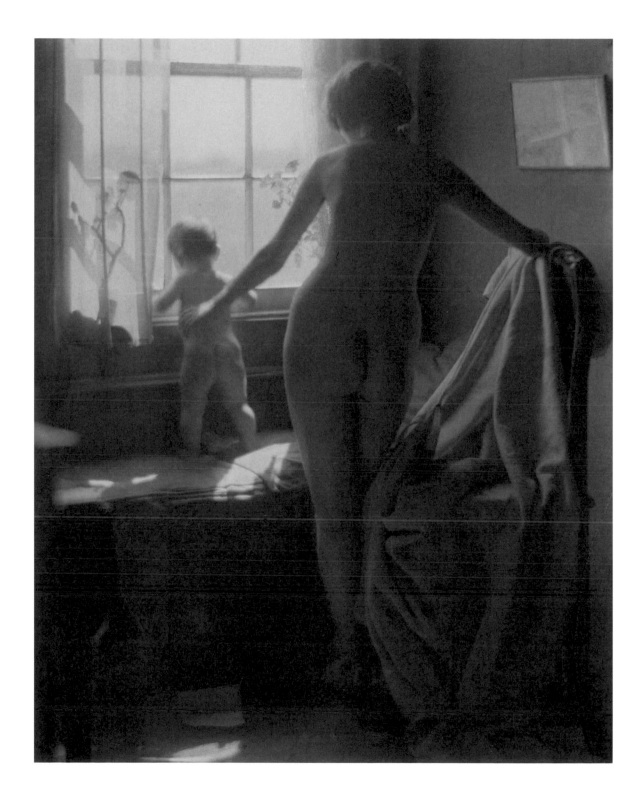

119. **Clarence H. White**
Nude and Baby, 1912
Platinum print
7⁵/₈ x 9⁹/₁₆ in. (19.4 x 24.3 cm)

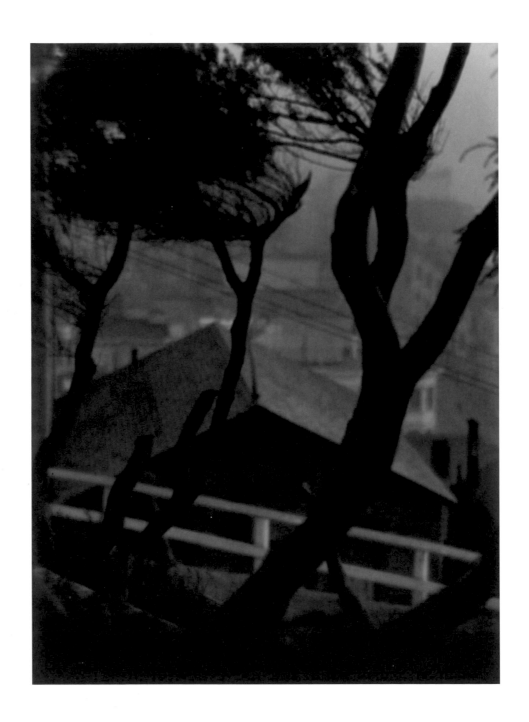

120. **Johan Hagemeyer**
Cypress Trees, Telegraph Hill, San Francisco, 1925
Gelatin silver print
9 1/16 x 6 9/16 in. (23 x 16.7 cm)

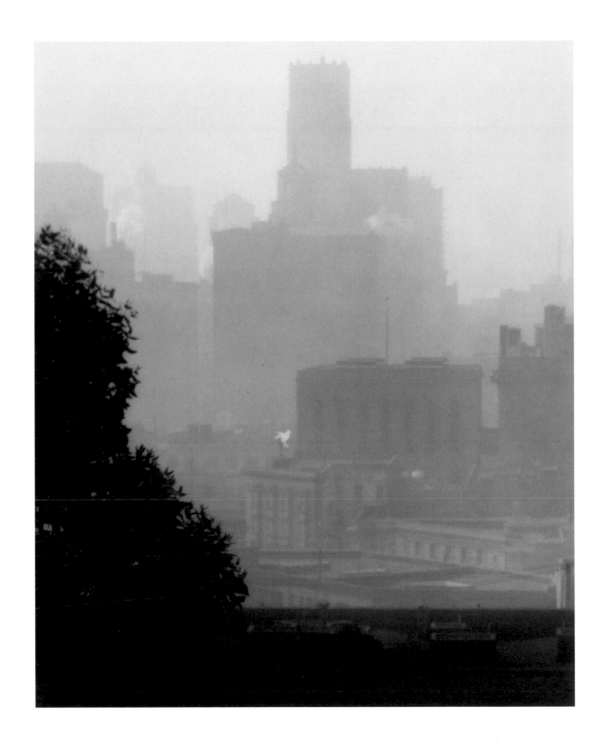

121. **William Edward Dassonville**
The Russ Building, San Francisco, 1925
Gelatin silver print
10 x 8 in. (25.4 x 20.3 cm)

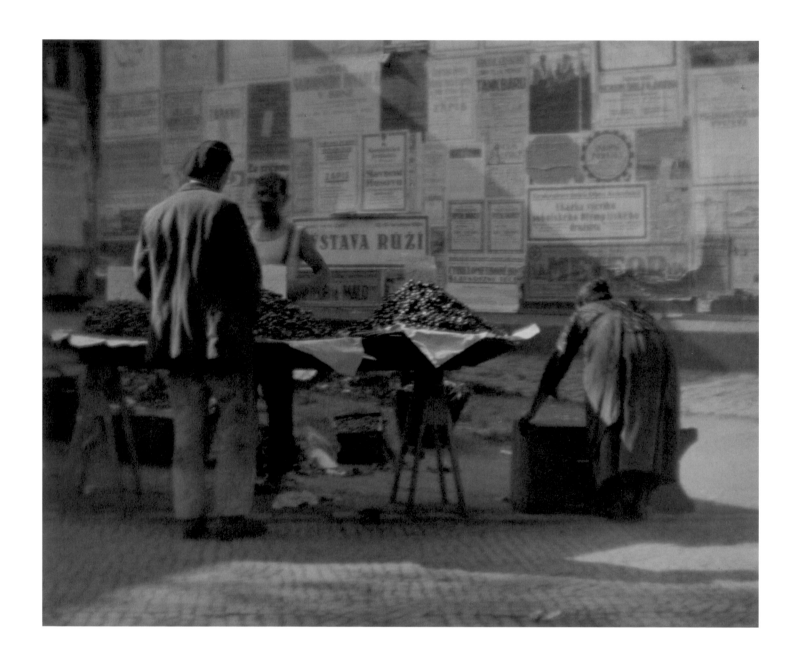

122. **Josef Sudek**
Untitled [Street Vendors], ca. 1924–26
Gelatin silver print
8 7/8 x 10 7/8 in. (22.5 x 27.6 cm)

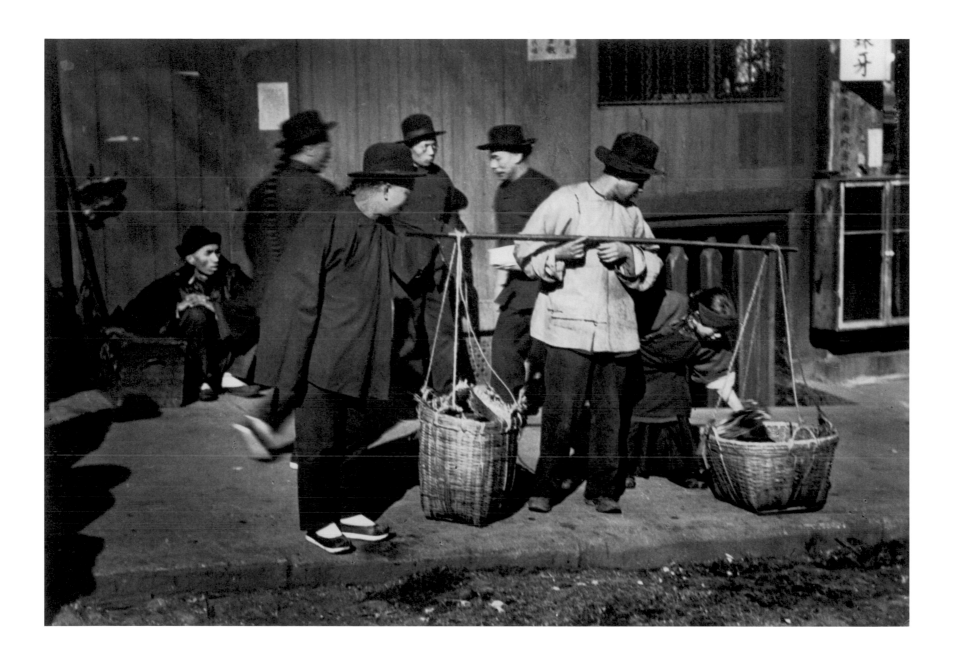

123. Arnold Genthe
Vegetable Peddler, Old Chinatown, San Francisco,
ca. 1895–1906
Gelatin silver print
8 5/8 x 12 1/2 in. (21.9 x 31.8 cm)

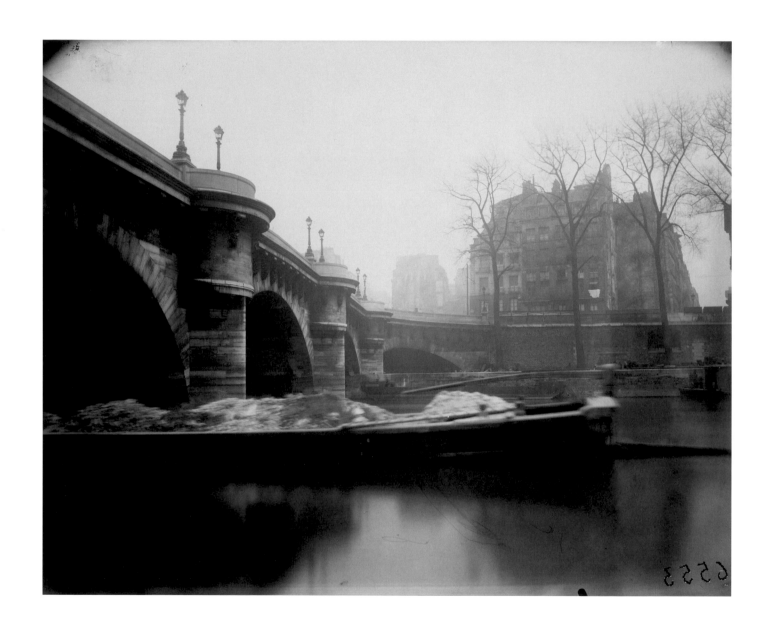

124. **Eugène Atget**
Pont Neuf, 1925
Gold-toned printing-out paper print
6 15/16 x 8 7/8 in. (17.6 x 22.5 cm)

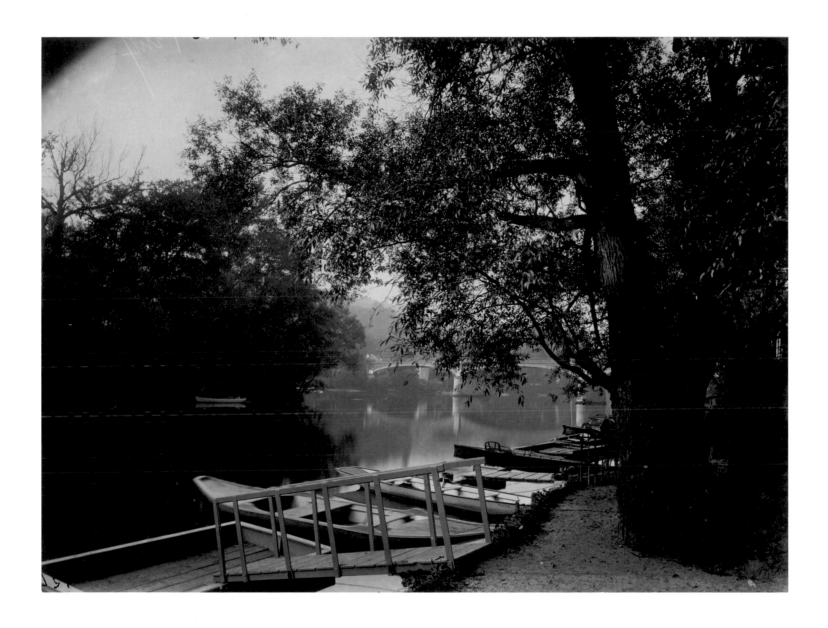

125. **Eugène Atget**
La Marne, La Varenne, 1925
Gold-toned printing-out paper print
6 5/8 x 8 7/8 in. (16.8 x 22.5 cm)

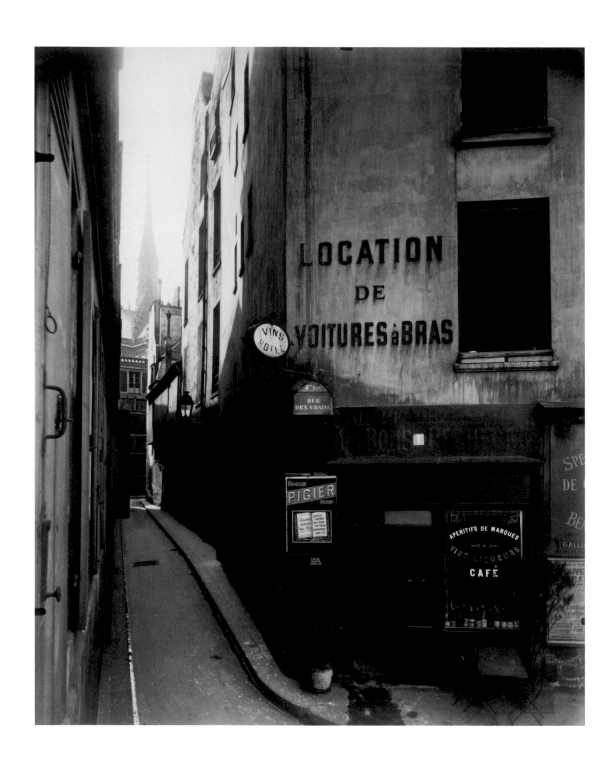

126. Eugène Atget
Rue des Chantres, 1923
Gold-toned printing-out paper print
8 5/8 x 7 in. (21.9 x 17.8 cm)

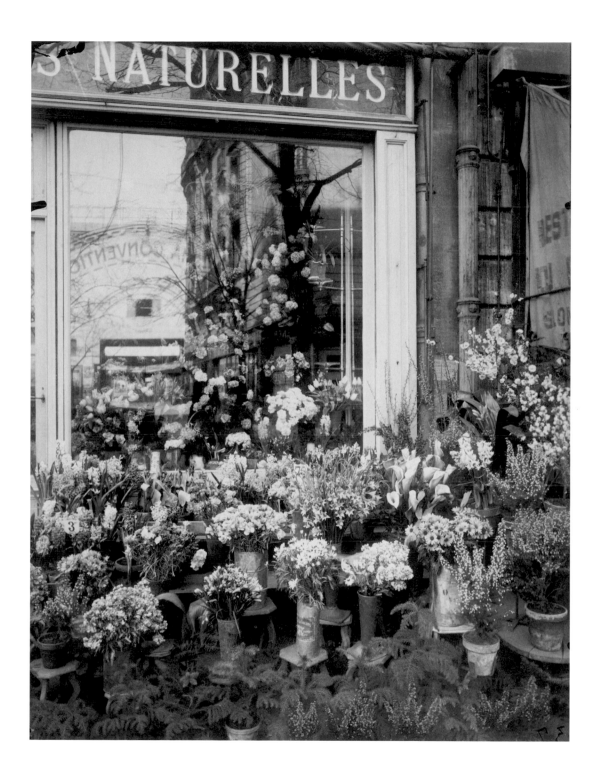

127. Eugène Atget
Boutique—Fleurs—rue de Vaugirard
(Shop—Flowers—rue de Vaugirard), ca. 1923–24
Arrowroot print
9 x 6⅞ in. (22.9 x 17.5 cm)

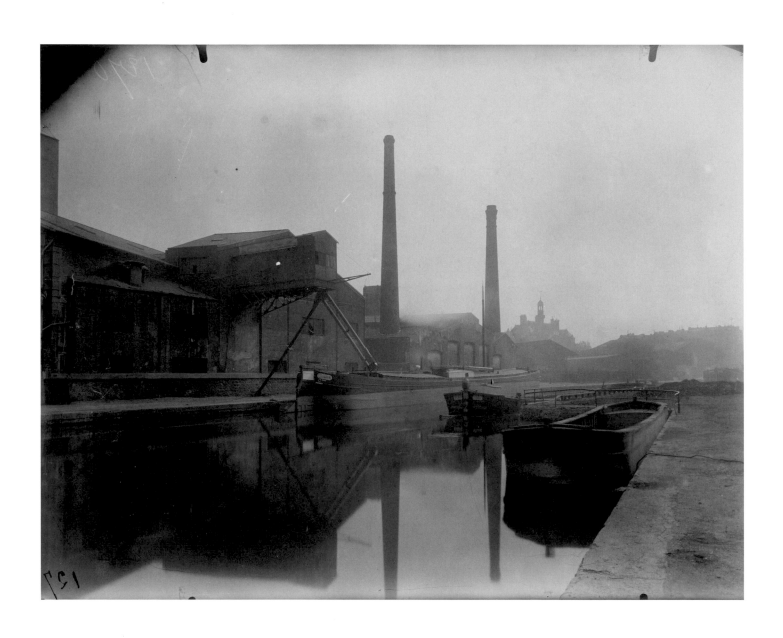

128. Eugène Atget
Saint-Denis, canal, ca. 1925–27
Gold-toned printing-out paper print
7 x 8 ¾ in. (17.8 x 22.2 cm)

129. **Eugène Atget**
Saules, 1921
Gold-toned printing-out paper print
8 1/2 x 7 in. (21.6 x 17.8 cm)

PROGRESS AND ITS DISCONTENTS

Though photography was invented near the peak of the industrial revolution, the earliest photographic processes were more closely related to craft than to industry. For years after the medium's invention, photographic prints remained handmade objects, and a photographer's success was often dependent on trial and error. By the 1880s, however, the forces of industrialization had brought dramatic changes in the medium. The commercial manufacture of standardized photographic paper and mass-produced dry plates enabled vast numbers of professional photographers to satisfy the public's demand for portraits, stereographs, and souvenir views, and by 1888, amateur photographers could purchase a Kodak No. 1 camera, the first to be mass-marketed. Eastman Dry Plate Company not only sold the cameras but also provided full-service processing of the film and prints. "You press the button," their ads urged; "we do the rest."

The resultant explosion of commercially produced glossy prints and amateur snapshots led to the emergence of Pictorialism, the first concerted movement to promote photography as a fine art. Dismayed by the glut of technically competent but unsophisticated images flooding the market, pictorialist photographers rejected the vulgar materialism of both commercial and amateur practice and advocated an aesthetic that suppressed the medium's mechanical origins. Using soft-focus lenses and heavily manipulated printing processes, they battled the camera's tendency to describe the world in unsparing detail, aspiring to make prints that more closely resembled paintings than hard-edged documents. Art, they argued, was a sensitive process of selection and translation from nature, not the product of mindless button-pushing.

Running through the Pictorialists' antipopulist and anti-industrial rhetoric was a self-conscious alignment with the values of more traditional forms of visual art. The movement's adherents were particularly influenced by the ideals of the symbolist painters and poets and the contemporary Arts and Crafts movement. The Symbolists advocated nonnarrative art that eschewed the representation of the material world and sought instead to express subjective interior states. The Arts and Crafts movement deplored the growing industrialization of Western culture, extolling the value of the artisanal, the handmade, and the nobility of honest labor. Looking at Robert Demachy's photograph of an idyllic cottage (*pl. 114*), we would be hard pressed to identify either the geographic location or the time period to which it belongs. Demachy, one of the leading advocates of pictorialist photography in France, perfected the gum bichromate print, an elaborate process in which pigmented layers of emulsion were hand-applied to textured paper and then heavily worked with a brush to achieve a painterly quality. Edward Steichen, who trained as both a painter and a photographer, spent his formative years in Paris, where he was profoundly influenced by the harmonies of form and color in James McNeill Whistler's paintings and by the emotional intensity of Auguste Rodin's sculpture. In *Rock Hill, Oyster Bay, Long Island (pl. 117)*, Steichen's intricate, hand-worked printing process lends the dark trees and bushes the appearance of charcoal smudges against the snowy field, dissolving their forms into near abstraction. Photographed at twilight, Steichen's atmospheric landscape is a study in tone and mood, much like the Whistler nocturnes he so admired.

The Pictorialists' distaste for the mass-produced photograph and their celebration of the craftsman as creative hero must be seen within a larger cultural critique of industrialization at the end of the nineteenth century. The rapid replacement of agrarian communities by a technology-driven, urban-based society had profound political and social consequences, uprooting families and transforming class relations. John Thomson's photographs of lower-class Londoners were published in the 1877 volume *Street Life in*

London to publicize the plight of the poor. *Workers on the "Silent Highway"* (*pl. 109*) portrays two Thames bargemen whose time-honored trade had been nearly eradicated by new forms of mechanized transportation, while *Public Disinfectors* (*pl. 110*) documents the emergence of an extremely dangerous occupation necessitated by the epidemics of smallpox resulting from close urban living conditions. In New York, Jacob August Riis similarly used photographs to fight for social reform, exposing the squalid living and working conditions of the poor, many of them recent immigrants (*see pl. 108*). Riis's effective use of pictures and text to inform and sway public opinion would prove a powerful model for photographers such as Dorothea Lange and Arthur Rothstein, whose emotionally compelling photographs for the Farm Security Administration (*pls. 133–34, 136*) revealed the desperate plight of the American farmer during the Great Depression. To many minds, technology had not lived up to its promise of liberating the worker, but instead had proved to be extremely effective in extracting ever more human labor.

Some artists and writers sought an antidote to the spiritual emptiness of industrial society by looking to cultures seemingly untouched by modernity. In the American popular imagination, Native Americans embodied a traditional way of life that was rooted in nature and spiritually authentic. By the end of the nineteenth century, however, these cultures had almost completely disappeared: those populations that had survived decimation by Anglo diseases and warfare were largely confined to reservations. Adam Clark Vroman is but one of the many photographers who visited the reservations in the early 1900s to document the vestiges of an indigenous culture and to record its architecture, ceremonies, and crafts. Such photographs (*see pls. 102, 104*) fueled a national mythology that saw the vanishing Indian as a romantic symbol of the country's preindustrial history. This potent mythology continued to grow well into the 1920s: to artists and bohemians in search of artistic freedom, the American Southwest beckoned like a modern Eden. Painter Georgia O'Keeffe and photographers Laura Gilpin and Ansel Adams all found spiritual refuge and visual inspiration in the "primitive"—for example, in the pure shapes and massive volumes of Taos Pueblo's sturdy adobe architecture (*pls. 140, 145*). Though they abandoned the soft-focus aesthetic of pictorialist photography for a sharp-edged, descriptive style, their works convey a similar distrust of the industrial and a desire to retreat from the modern world.

To a society as deeply dependent on technology and as immersed in photographic imagery as our own, the Pictorialists' stance now seems quaint and historically remote. Indeed, by the end of the twentieth century's first decade, the romantic ideals and painterly aesthetic of many pictorialist photographers—including their most vocal advocate, Alfred Stieglitz—suddenly appeared reactionary and deeply antimodern. The outbreak of World War I made it clear that technology was an inescapable, if sometimes destructive, part of the modern experience. Nonetheless, the Pictorialists' stylistic approach had ensured the acceptance of photography as a means of artistic expression. Photographers simply had to renegotiate their relationship to the camera and to modernity. Charles Sheeler's 1917 photograph of the side of an old Pennsylvania barn (*pl. 143*) speaks in the new stylistic idiom of sharp focus, but his subject still embodies the modernist enchantment with the primitive. His tightly framed view trains our attention on the building's rough-hewn construction, well-worn boards, and solid structure while flattening the facade into a geometric pattern of lines and rectangles that evokes the innovations of cubist painting. Just as the architect Le Corbusier turned to American grain elevators as paragons of aesthetic functionalism in the 1920s, photographers such as Edward Weston and Sheeler began to perceive the factory building and other forms of vernacular architecture as worthy of artistic consideration. Sheeler's photograph admits to a growing recognition of technology's vital role in modern life and, more importantly, photography's unique position to give voice to a new modern consciousness.

—C.K.

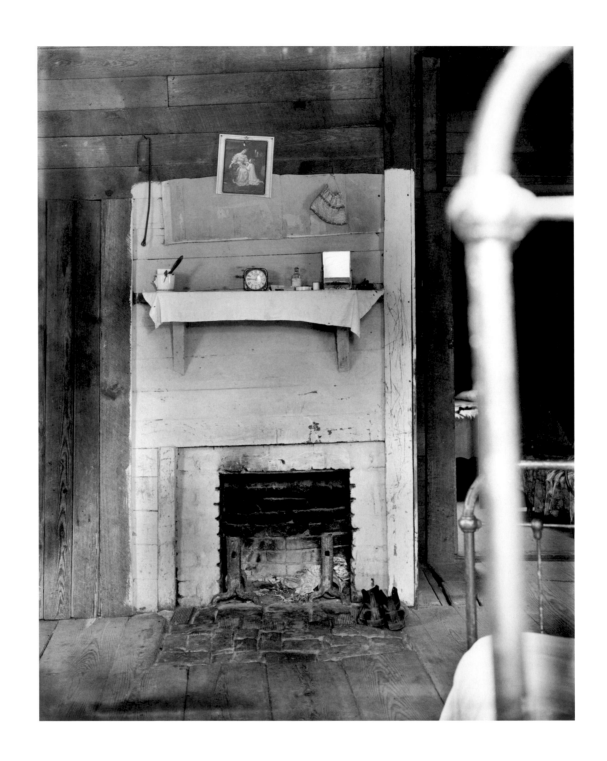

130. **Walker Evans**
Fireplace, Burroughs House, Hale County, Alabama, 1936
Gelatin silver print
9 5/8 x 7 5/8 in. (24.4 x 19.4 cm)

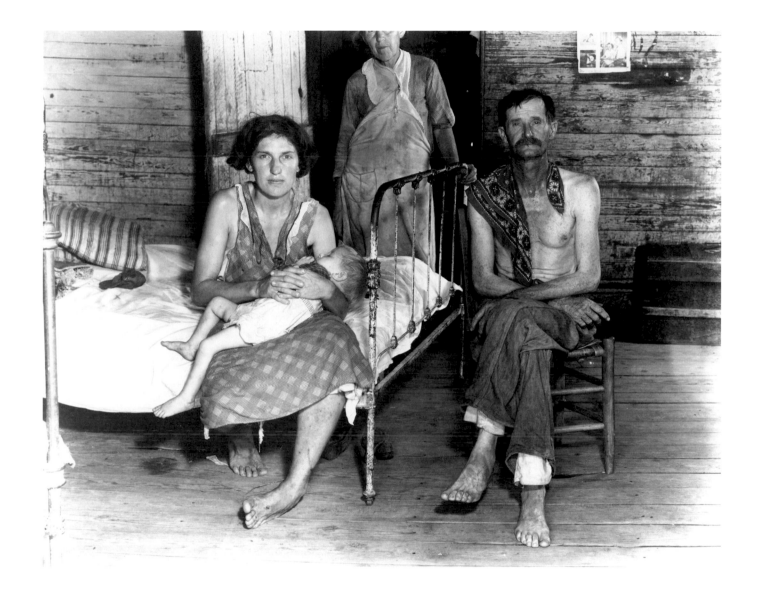

131. **Walker Evans**
Alabama Cotton Tenant Farmer Family, 1936
Gelatin silver print
7 9/16 x 9 9/16 in. (19.2 x 24.3 cm)

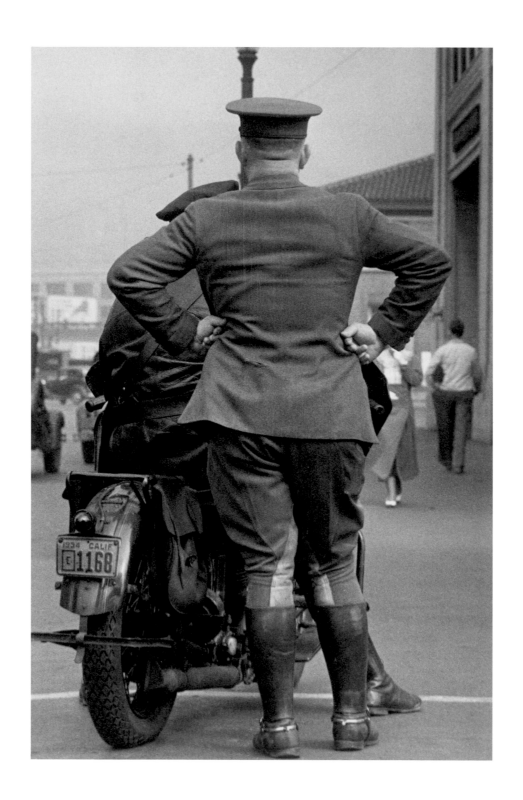

132. Dorothea Lange
Policeman on Street, San Francisco, 1934
Gelatin silver print
8 1/8 x 5 1/4 in. (20.6 x 13.3 cm)

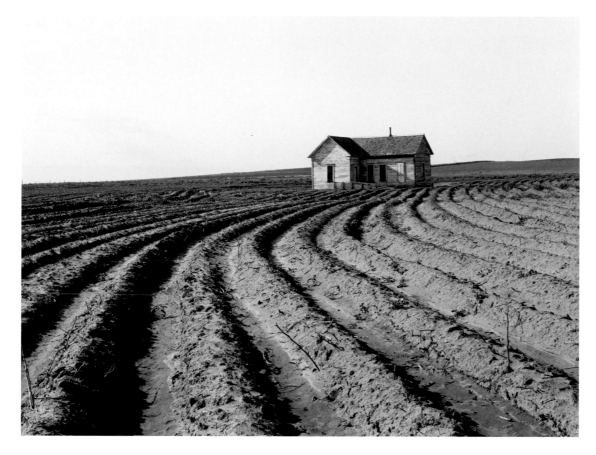

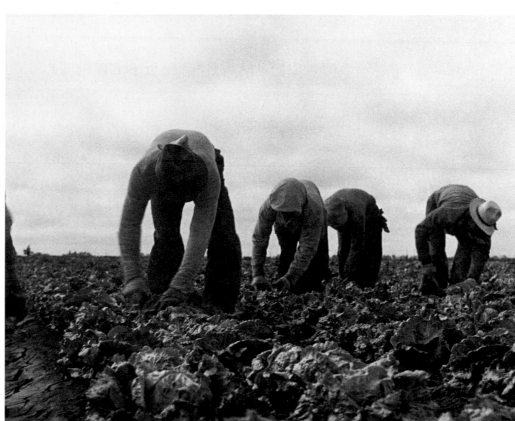

133. **Dorothea Lange**
Tractored Out, Childress County, Texas, 1938
Gelatin silver print
9 15/16 x 13 in. (25.2 x 33 cm)

134. **Dorothea Lange**
*Filipinos Cutting Lettuce, Salinas Valley,
California*, 1935
Gelatin silver print
7 3/4 x 9 1/2 in. (19.7 x 24.1 cm)

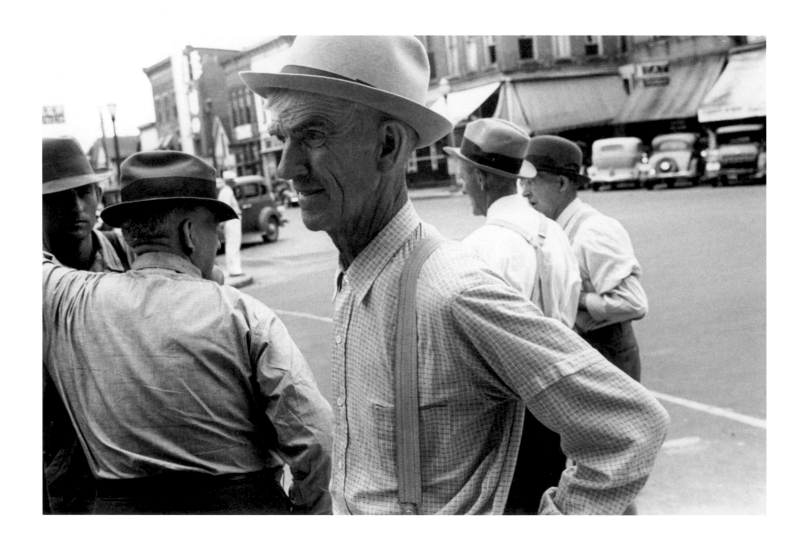

135. **Ben Shahn**
Street Scene, Marysville, Ohio, 1938
Gelatin silver print
6 3/8 x 9 5/8 in. (16.2 x 24.4 cm)

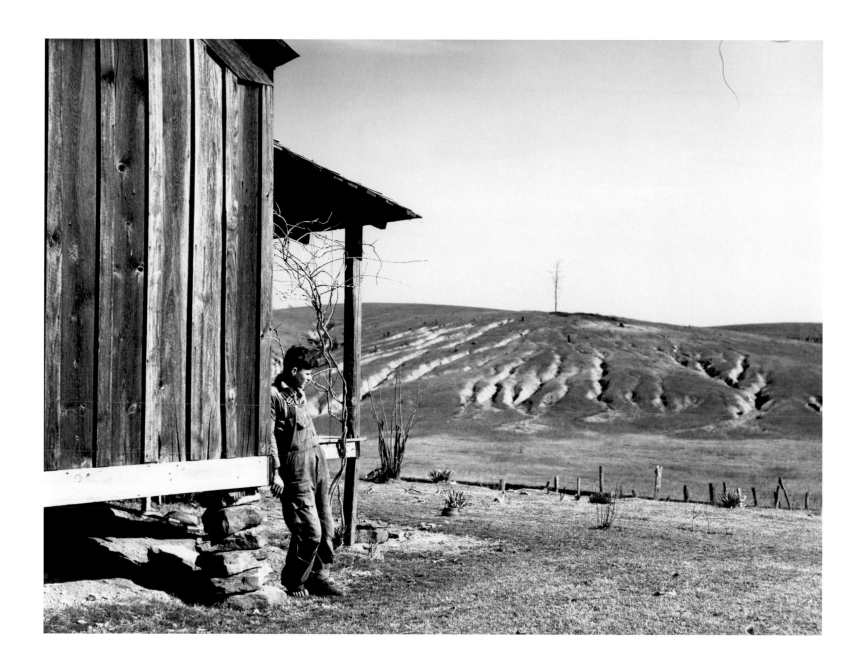

136. Arthur Rothstein
Soil Erosion, Alabama, 1937
Gelatin silver print
10 3/8 x 13 1/2 in. (26.4 x 34.3 cm)

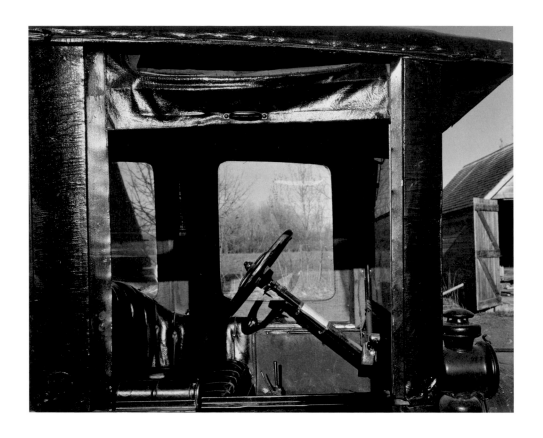

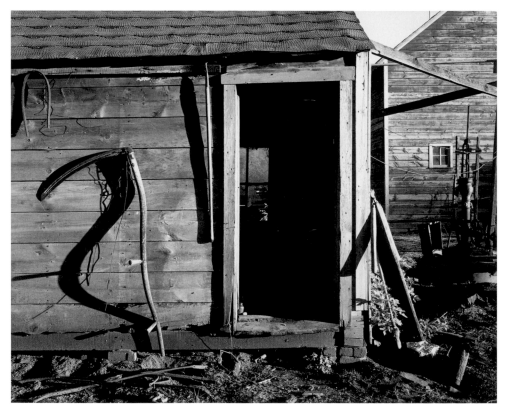

137. Wright Morris
Home Place [Model T Steering Wheel], 1947
Gelatin silver print
7 3/4 x 9 5/8 in. (19.7 x 24.4 cm)

138. Wright Morris
Untitled [Scythe by Shed], 1947
Gelatin silver print
7 3/4 x 9 5/8 in. (19.7 x 24.4 cm)

139. **Wright Morris**
Untitled [Interior through Screen Window], ca. 1947
Gelatin silver print
9 3/8 x 7 3/4 in. (23.8 x 19.7 cm)

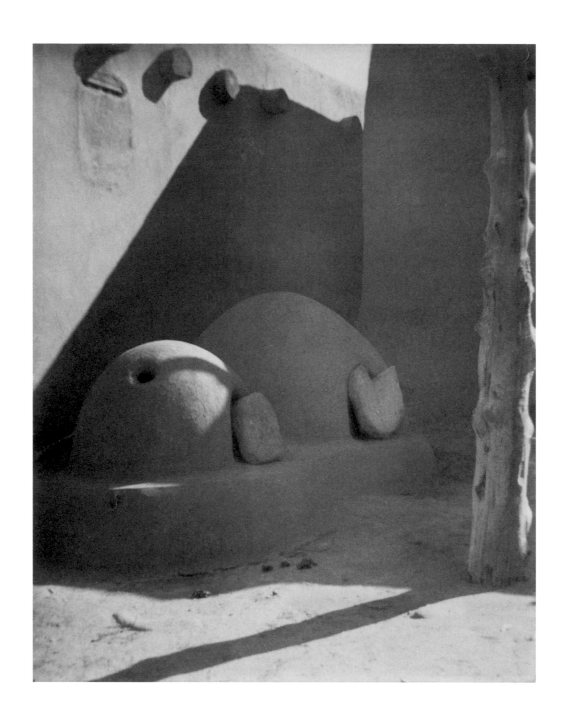

140. **Laura Gilpin**
Taos Ovens, New Mexico, 1926
Platinum print
8 5/8 x 6 13/16 in. (21.9 x 17.3 cm)

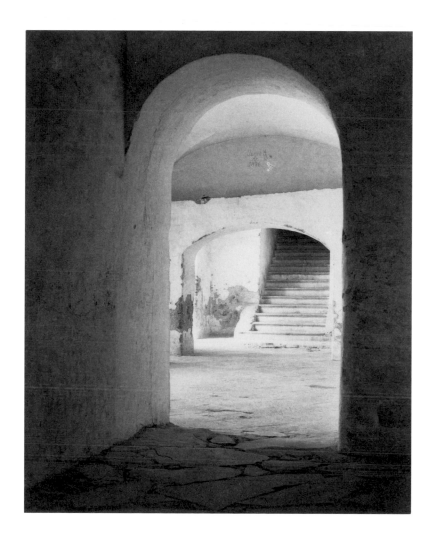

141. **Tina Modotti**
Convent of Tepotzotlán, Mexico, 1924
Platinum print
4⅝ x 3⅝ in. (11.7 x 9.2 cm)

142. **Paul Strand**
Barn, Gaspé, 1936
Gelatin silver print
4 11/16 x 5 7/8 in. (11.9 x 14.9 cm)

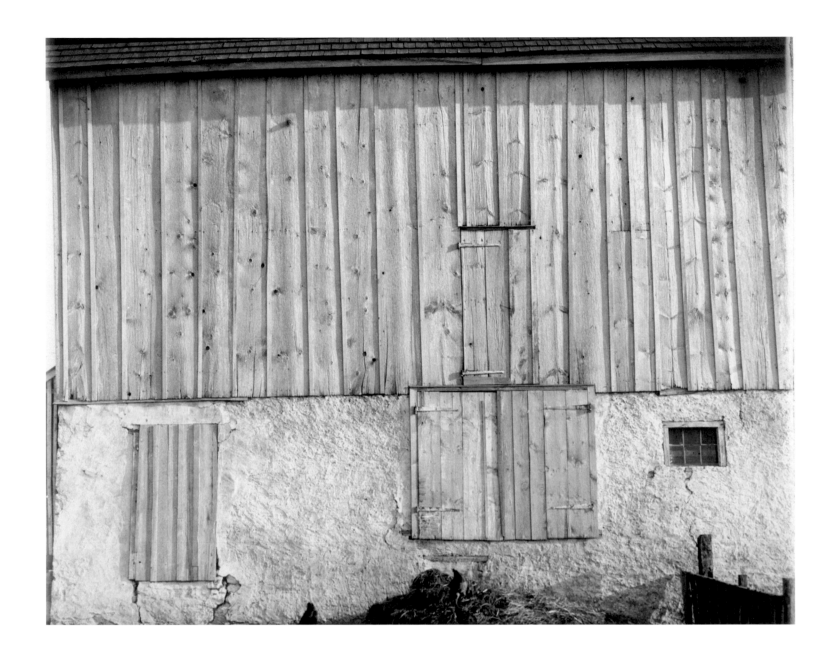

143. Charles Sheeler
Side of White Barn, 1917
Gelatin silver print
8 x 10 in. (20.3 x 25.4 cm)

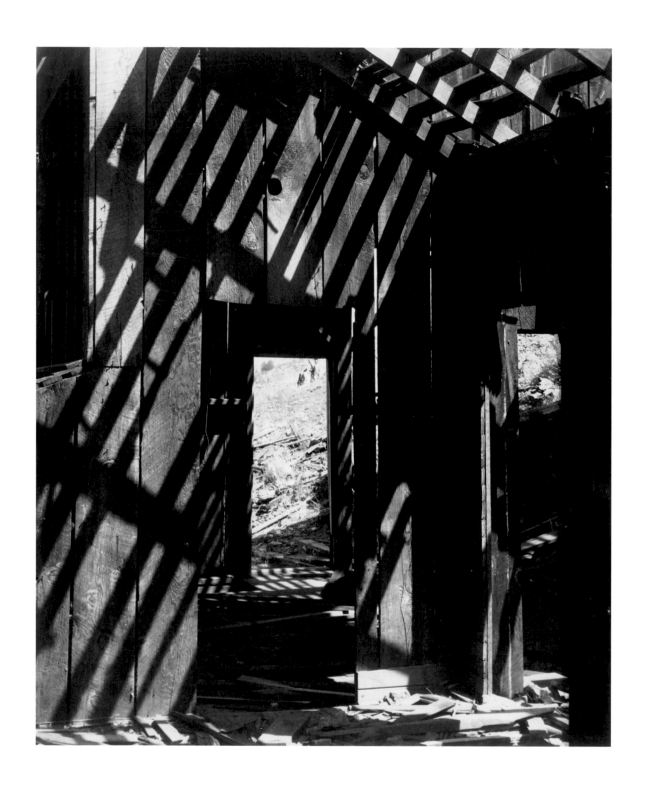

144. Imogen Cunningham
Yreka, 1929
Gelatin silver print
9 x 7½ in. (22.9 x 19.1 cm)

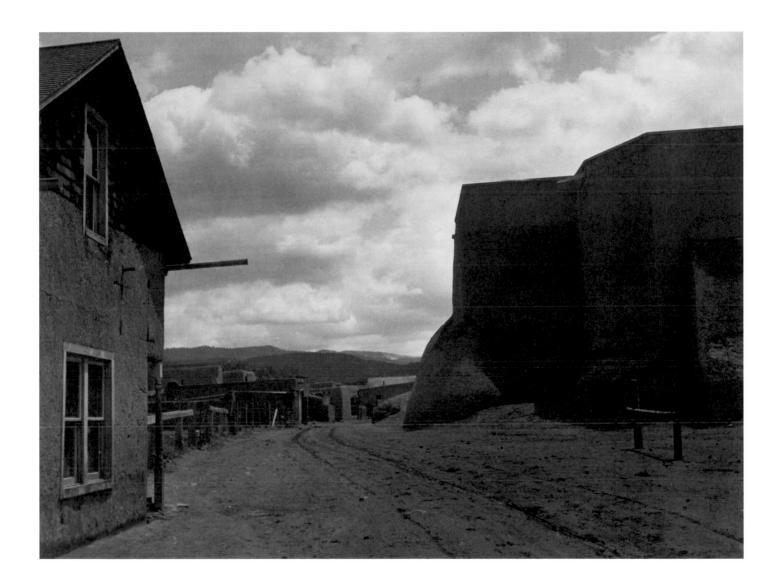

145. **Ansel Adams**
Taos, New Mexico, ca. 1929
Gelatin silver print
5⁷/₈ x 7⁷/₈ in. (14.9 x 20 cm)

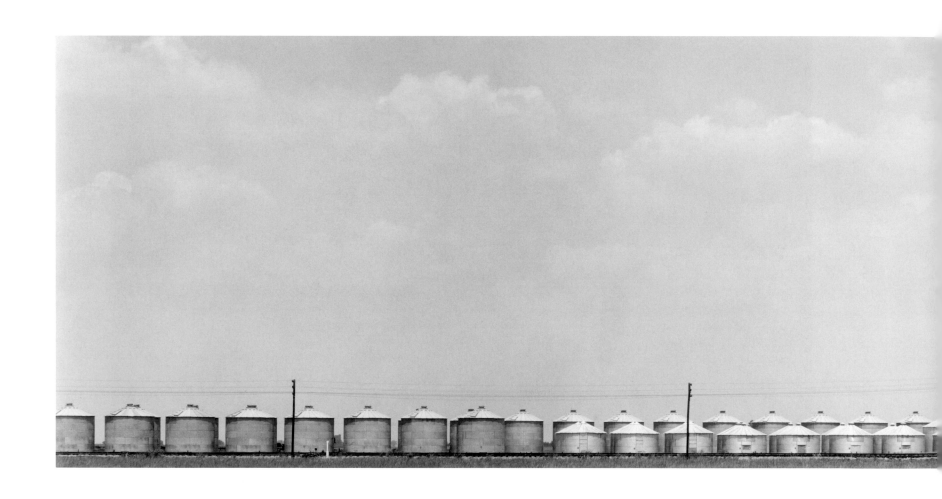

146. **Art Sinsabaugh**
Midwest Landscape #60, 1961
Gelatin silver print
4 5/8 x 19 3/8 in. (11.7 x 49.2 cm)

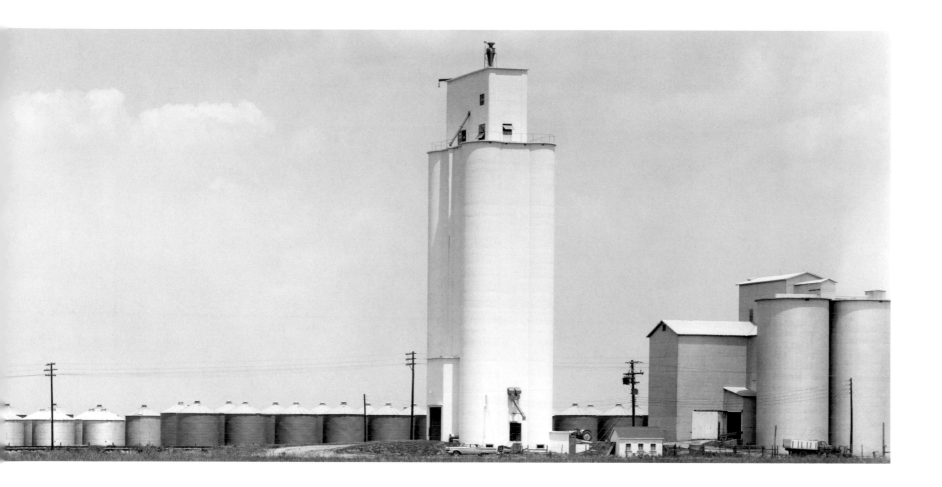

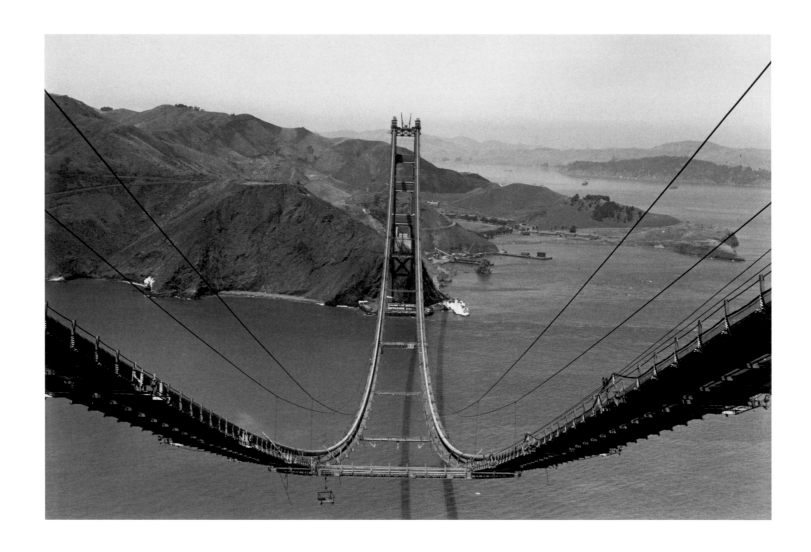

147. **Peter Stackpole**
Golden Gate Bridge, 1935
Gelatin silver print
5 7/8 x 8 7/8 in. (14.9 x 22.5 cm)

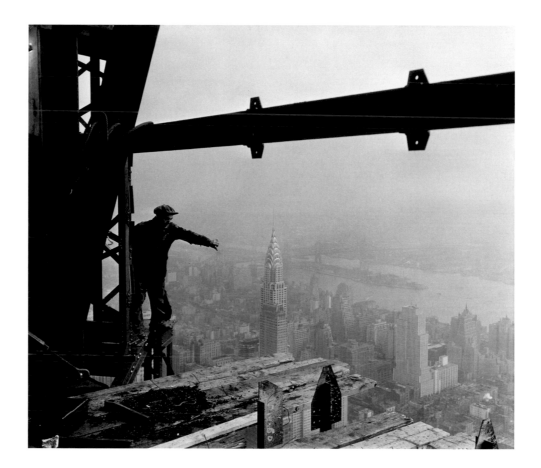

148. **Lewis Wickes Hine**
Empire State Building Construction, 1931
Gelatin silver print
3 3/4 x 4 3/8 in. (9.5 x 11.1 cm)

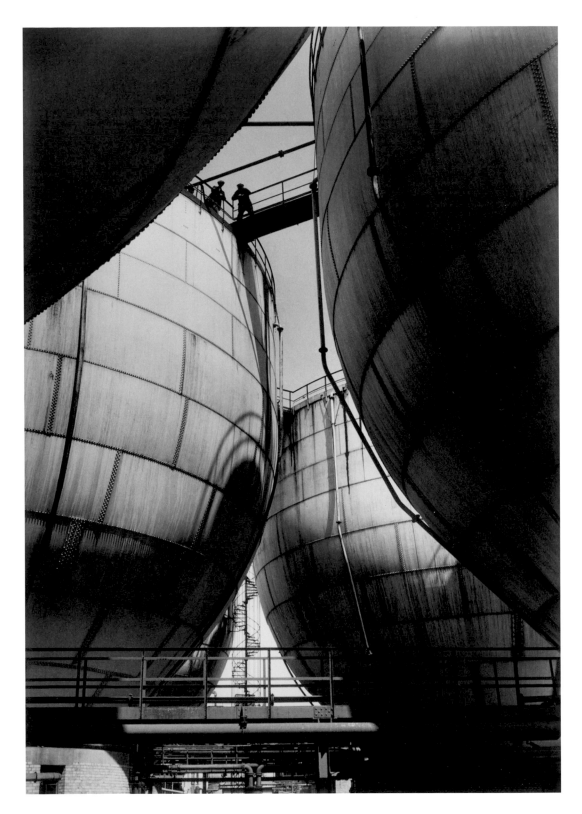

149. **Margaret Bourke-White**
Ammonia Storage Tanks, I. G. Farben, 1930
Gelatin silver print
13 x 9⅛ in. (33 x 23.2 cm)

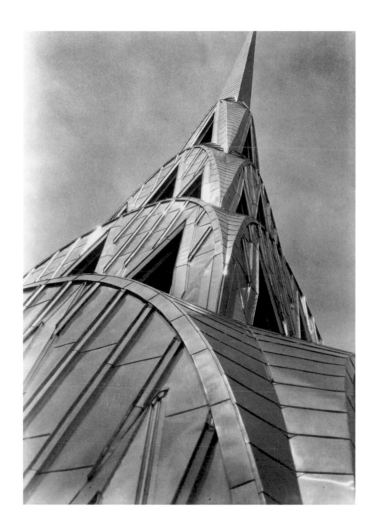

150. Margaret Bourke-White
Chrysler Building: Tower, 1931
Gelatin silver print
5 1/2 x 3 3/4 in. (14 x 9.5 cm)

151. **Berenice Abbott**
The Construction of Rockefeller Center, 1931
Gelatin silver print
7³/₈ x 9³/₈ in. (18.7 x 23.8 cm)

152. **Paul Outerbridge**
Semi-Abstraction of Columbus Circle, New York, 1923
Gelatin silver print
4 1/8 x 4 7/8 in. (10.5 x 12.4 cm)

153. **Imogen Cunningham**
Ventilators, Fageol Factory, Oakland, 1934
Gelatin silver print
7 x 9 in. (17.8 x 22.9 cm)

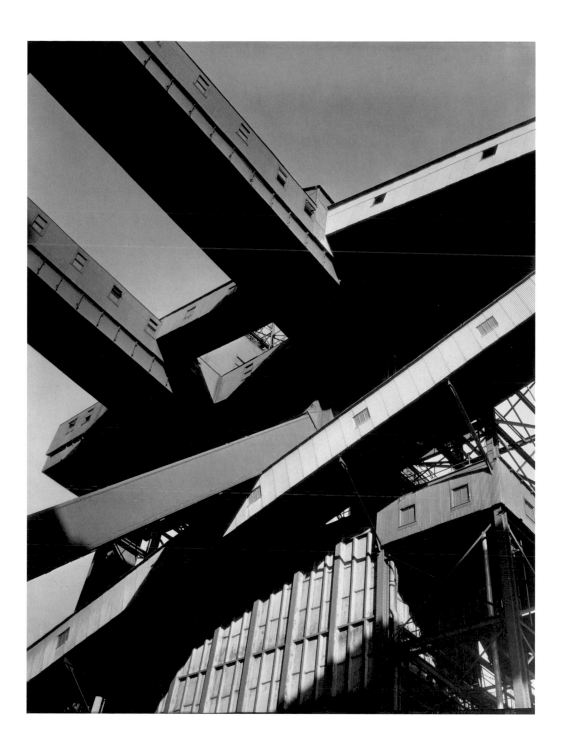

154. **Martin Bruehl**
Untitled [Grain Elevator], ca. 1932
Gelatin silver print
8 1/8 x 6 1/8 in. (20.6 x 15.6 cm)

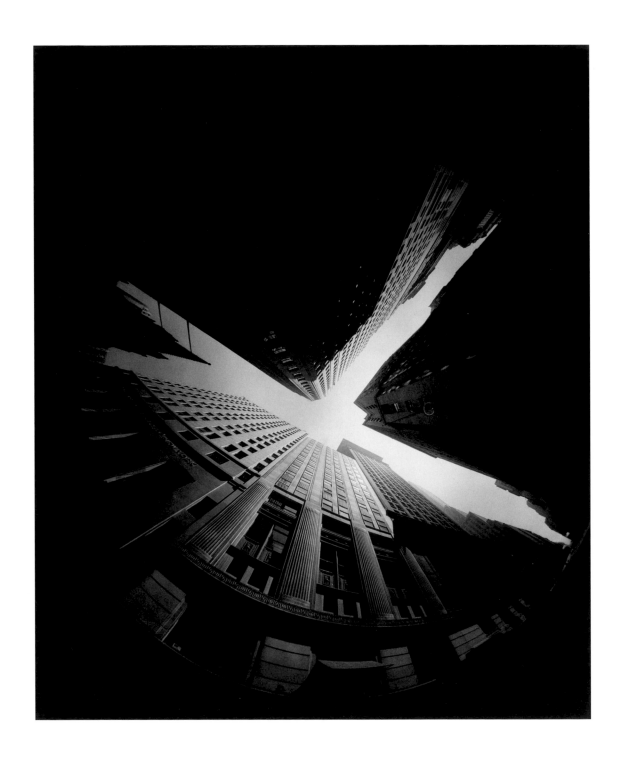

155. **Ralph Steiner**
Bank of New York, ca. 1926
Gelatin silver print
9 9/16 x 7 5/8 in. (24.3 x 19.4 cm)

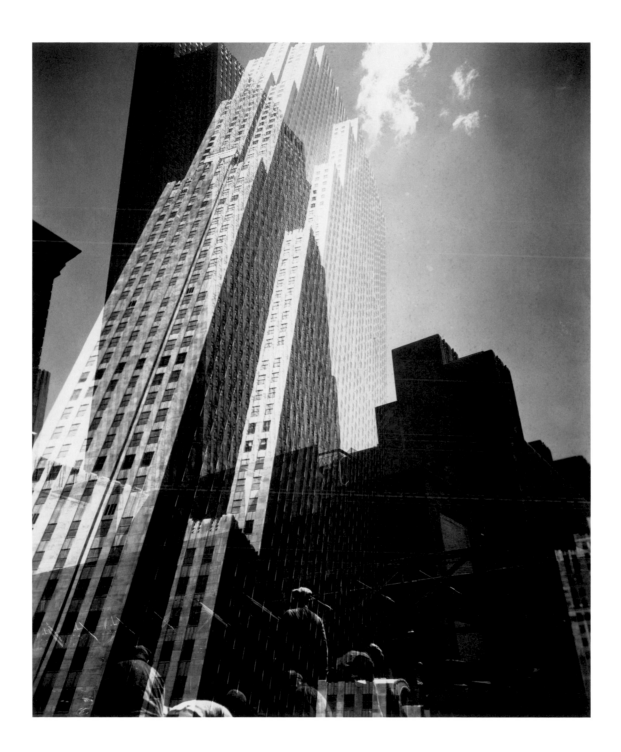

156. **Edward Steichen**
Untitled [Rockefeller Center Montage], 1932
Gelatin silver print
9 1/8 x 7 1/2 in. (23.2 x 19.1 cm)

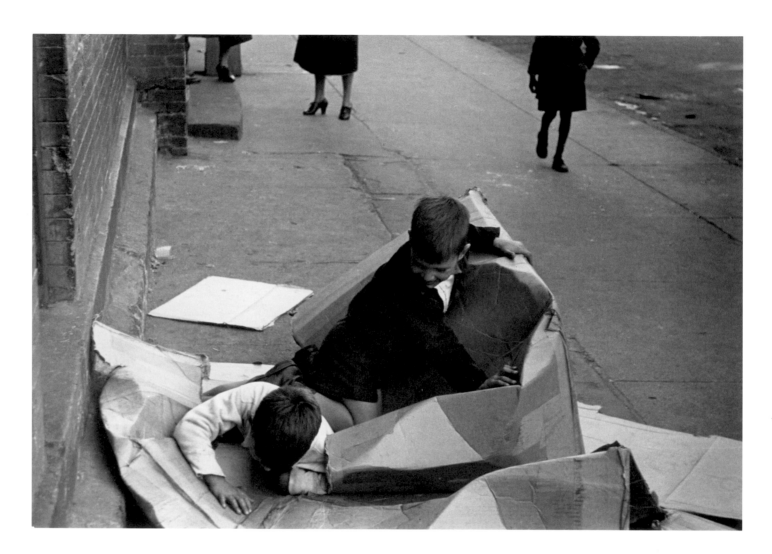

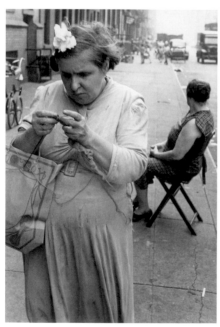

157. **Helen Levitt**
New York, ca. 1942
Gelatin silver print
6 5/8 x 9 1/2 in. (16.8 x 24.1 cm)

158. **Helen Levitt**
New York, ca. 1939
Gelatin silver print
3 1/4 x 2 1/8 in. (8.3 x 5.4 cm)

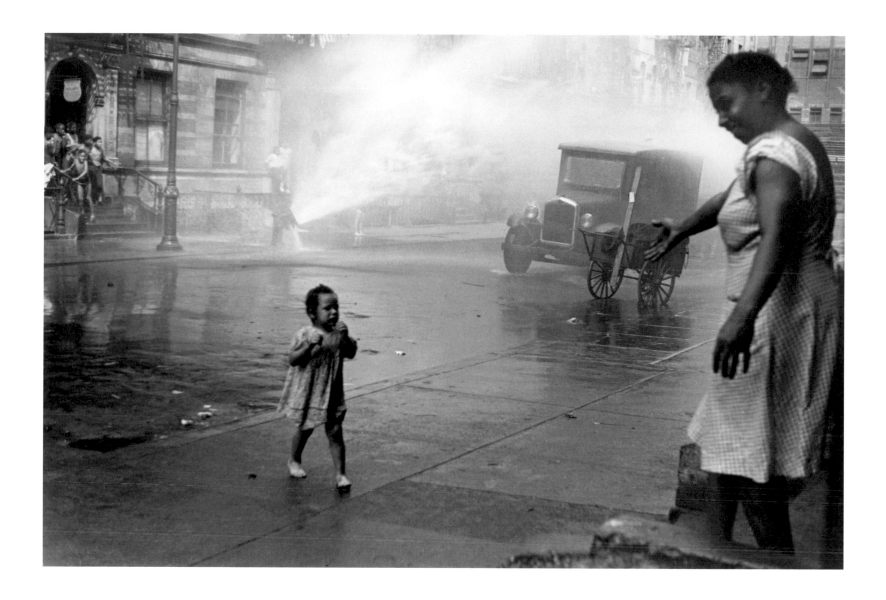

159. **Helen Levitt**
New York, 1939
Gelatin silver print
5 15/16 x 8 13/16 in. (15.1 x 22.4 cm)

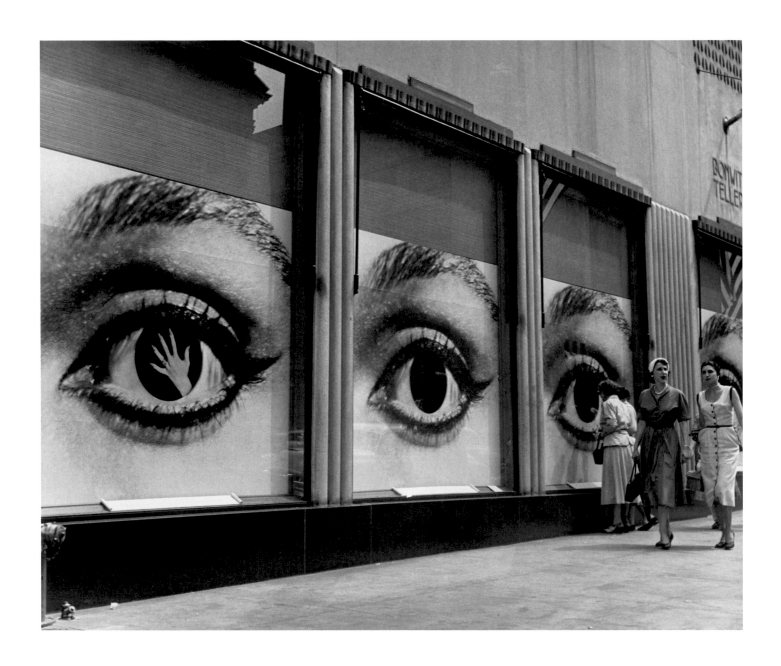

160. Morris Huberland
Bonwit Teller, Fifth Avenue, New York City, ca. 1950
Gelatin silver print
7 1/2 x 8 15/16 in. (19.1 x 22.7 cm)

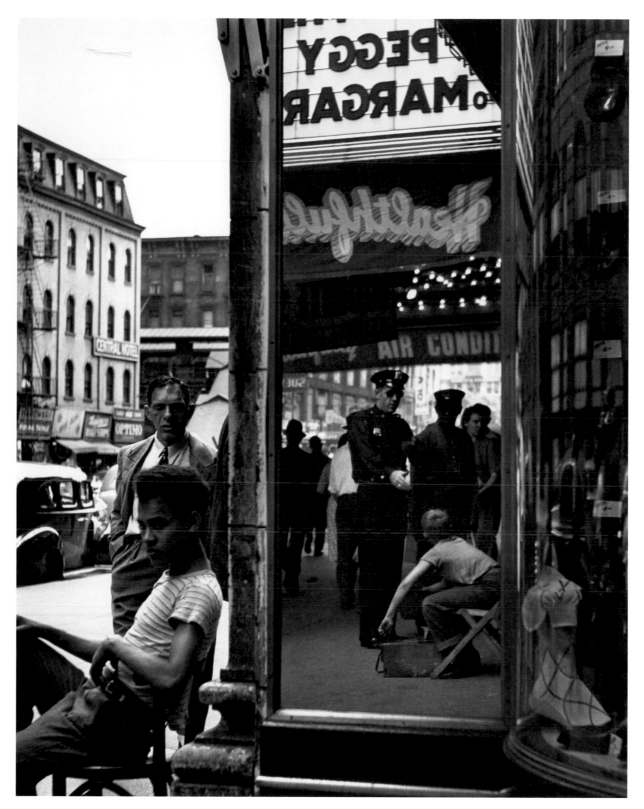

161. **Morris Engel**
Shoeshine Boy with Cop, 1947
Gelatin silver print
13 3/8 x 10 3/8 in. (34 x 26.4 cm)

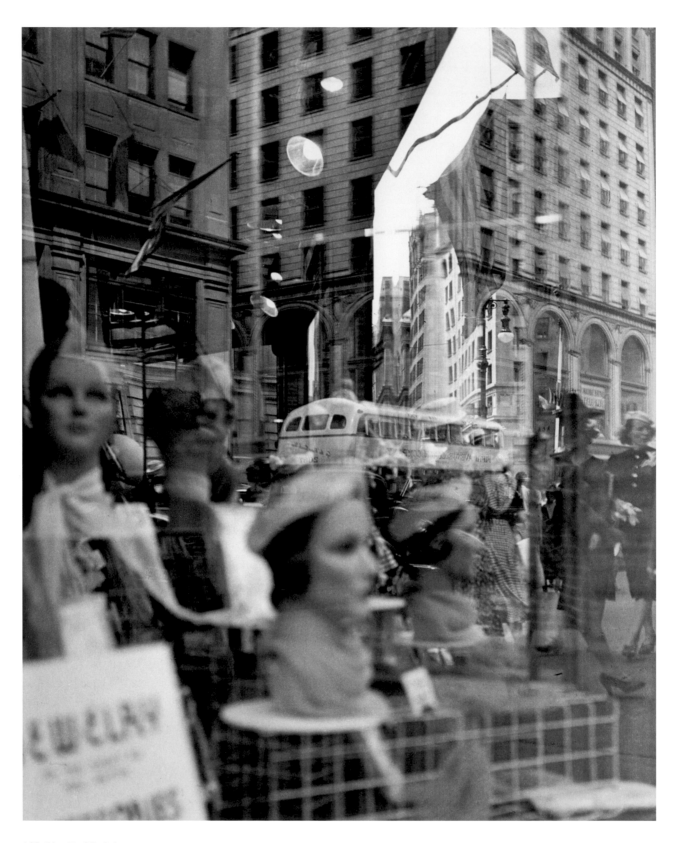

162. **Lisette Model**
Fifth Avenue, 1950s
Gelatin silver print
13 9/16 x 10 13/16 in. (34.5 x 27.5 cm)

THE MODERN EYE

In the simplest terms, a camera is a machine for making pictures. Over the course of the medium's history, this essential fact has conditioned the reception of the photographic image; indeed, the cultural status of photography is often a sensitive barometer of broader attitudes toward technology in general. In the waves of industrialization that followed World War I, the machine emerged as a powerful symbol of progress, a "new God," as photographer Paul Strand described it. Though earlier practitioners had wrestled with the medium's mechanical nature, Strand and other like-minded "straight" photographers celebrated the camera's objectivity and precision, arguing that these characteristics set photography apart from any other medium. In the years between the two world wars, a new generation of modernist photographers embraced the camera's stark mechanical vision, finding in its melding of the material and the subjective a fitting expression for the modern condition.

In Europe, where the impact of technology had been experienced in direct and often brutal ways during World War I and the Russian Revolution, there was a certain political urgency to the adoption of the camera on artistic grounds. Machines had proved to be great forces of destruction, but the hope still lingered that they might be

the path to redemption: that society might be rebuilt, even revolutionized, through technology. Photography was a technological process, but it was also a new artistic medium, free of the academic traditions and ossified conventions of painting. Many artists agreed with Russian Constructivist Alexander Rodchenko when he pronounced that easel painting was dead and anointed the new mass media as its modern successors. The explosion of the illustrated press between the world wars gave rise to a society that was accustomed to photographs and adept at reading them. László Moholy-Nagy intended no hyperbole when he claimed, in 1936, "The illiterates of the future will be ignorant of the use of camera and pen alike." Socially engaged artists understood that photography had the potential not only to communicate with a broad public but also to instruct them in a new way of seeing.

The camera's mobile mechanical eye offered a new model for the modern observer. The development of the compact, lightweight 35-millimeter camera afforded photographers an unprecedented freedom and gave birth to a radical formal vocabulary intended to shake the public out of its reflexive viewing habits. Using extreme close-ups, unusual angles, and vertiginous points of view, avant-garde artists trans-

formed the landscape of the everyday into an unfamiliar visual experience. In Rodchenko's *Courtyard* (*pl. 168*), for example, the skewed horizon disorients the viewer and undercuts the tranquillity of the snow-covered square, while Umbo's extremely low vantage point and fish-eye lens dramatically distort the regimented architecture of Berlin's Potzdamer Platz (*pl. 176*). The European avant-garde also drew inspiration from other forms of mechanically enhanced vision, including cinematic film and X-ray photography, and adopted such radical strategies as photomontage and photograms to explore the perceptual possibilities that these technologies suggested. By juxtaposing disparate images and layering multiple negatives, works such as El Lissitzky's design for the Soviet political journal *SSSR na stroike* (USSR under Construction; *pl. 175*) propose a revolutionary and visually complex alternative to traditional forms of representation.

Nowhere did the impact of technology manifest itself more directly than in the modern city. The man-made environment changed the way people lived: how they conducted business, behaved toward one another, moved around, communicated, ate, and slept. The spectacle of the

urban environment prompted a kaleido-scopic range of pictorial responses, from Paul Outerbridge's cool formal study of blocky New York buildings (*pl. 152*) to Martin Munkacsi's radically flattened aerial view of Budapest (*pl. 177*). The photographs in the Sack Collection speak above all to the way industry transformed the architecture and consequently the experience of the urban landscape. In New York, skyscrapers reached improbable heights: the shimmering tower of the Chrysler Building (*pl. 150*) was completed in 1930, outstripped merely months later by the Empire State Building at a record-breaking 102 stories. Photographs such as Ralph Steiner's *Bank of New York* (*pl. 155*), taken from deep within the shad-owy canyons of Wall Street—the towering skyscrapers framing a mere sliver of sky—describe the invention of an industrial sublime, just as Berenice Abbott's view of the excavation of Rockefeller Center (*pl. 151*) celebrates the triumph of modern engineering over the inhospitable bedrock of Manhattan island. Most of these pictures tell us less about the geography of a particu-lar city—whether Paris, Berlin, or New York—than about the city as a modern experience. Photographers such as Helen Levitt (*pls. 157–59*) and Morris Engel (*pl. 161*) viewed the transformed public spaces of the city not only as stage sets for an unfolding human comedy but also as living, dynamic subjects themselves.

Not all artists celebrated technolog-ical progress. Particularly in France, the Surrealists took a more elegiac view of the relentless quest for the new and its inevitable companion, obsolescence. They turned their attention to modernity's edges, to the sites where memories were stored and history archived. In the city, the present was not a stable condition but in a persistent state of flux, where the past might irrupt, unexpectedly, as in Ilse Bing's picture of a Parisian building, where a disintegrating old movie poster reveals an archaeology of outdated advertising beneath it (*pl. 174*). Photographers took inspiration from the work of Eugène Atget (*pls. 124–29*), whose documentary studies of old Paris belong neither to the nineteenth century nor to modernity, and whose uninflected views of the city reveal the uncanny in the everyday. Armed with a camera, the surrealist flaneur plumbed the shadowy, ill-defined, and rapidly eroding zones of the city where the old and the new, the reputable and the transgressive were permitted to cohabit.

The rich international dialogue among artists as well as the dissemination of the illustrated press during the 1920s and 1930s meant that experimental photographs were widely seen and their innovative style liberally adopted, often without the social and political agendas that originally engen-dered them. What began as an avant-garde critique emerged as an instantly recogniz-able visual idiom for modernity and secured photography's status as the modern lingua franca. In their self-conscious examination of photography's relationship to technology, mass media, and traditional forms of repre-sentation, photographers on both sides of the Atlantic laid out the terms that continue to inform the discussion of photographically based art today.

—C.K.

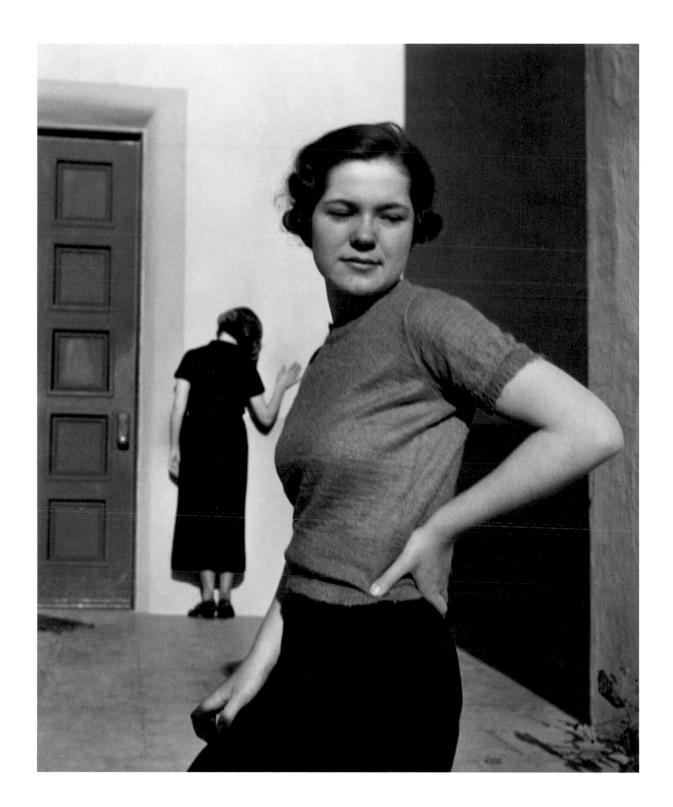

163. **John Gutmann**
Two Girls, 1935
Gelatin silver print
9 7/16 x 7 11/16 in. (24 x 19.5 cm)

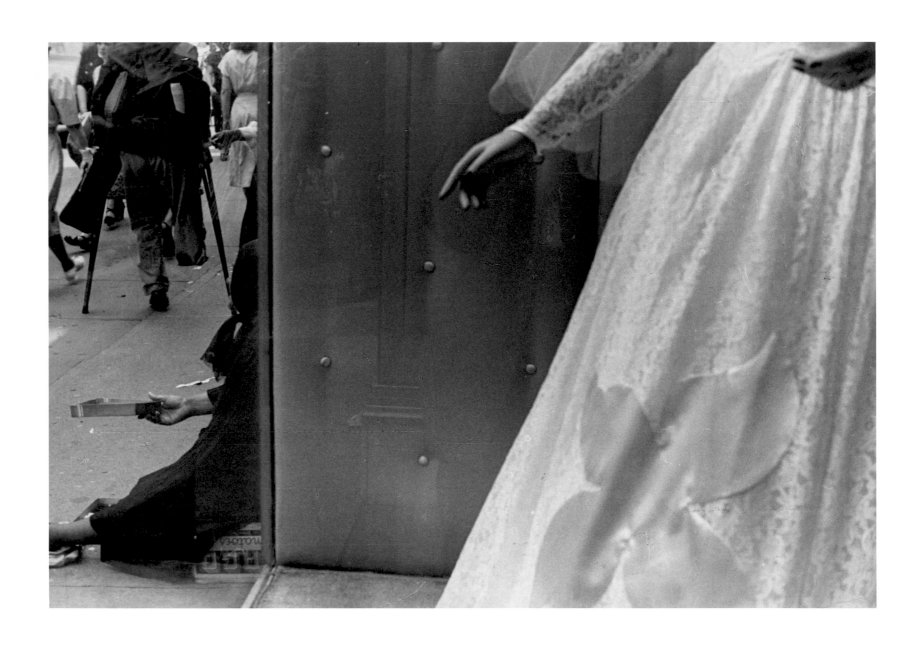

164. Louis Faurer
Untitled [Street Scene], 1940
Gelatin silver print
9 x 13 1/8 in. (22.9 x 33.3 cm)

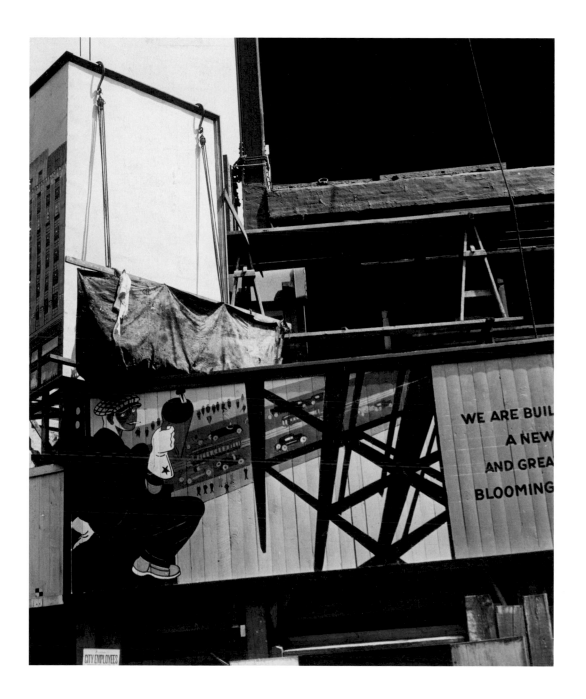

165. **Walker Evans**
We Are Building a New and Greater Bloomingdale's, ca. 1929–30
Gelatin silver print
9 7/8 x 8 1/8 in. (25.1 x 20.6 cm)

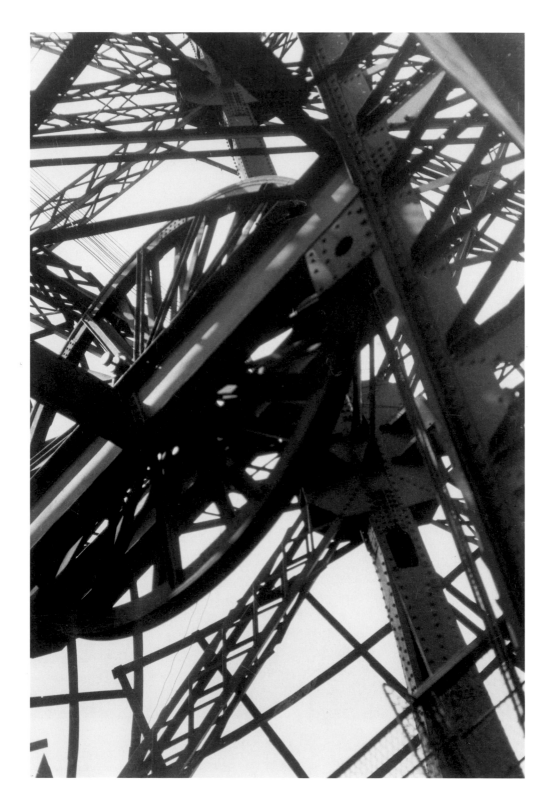

166. Germaine Krull
La Tour Eiffel (The Eiffel Tower), ca. 1928
Gelatin silver print
9 1/8 x 6 1/16 in. (23.2 x 15.4 cm)

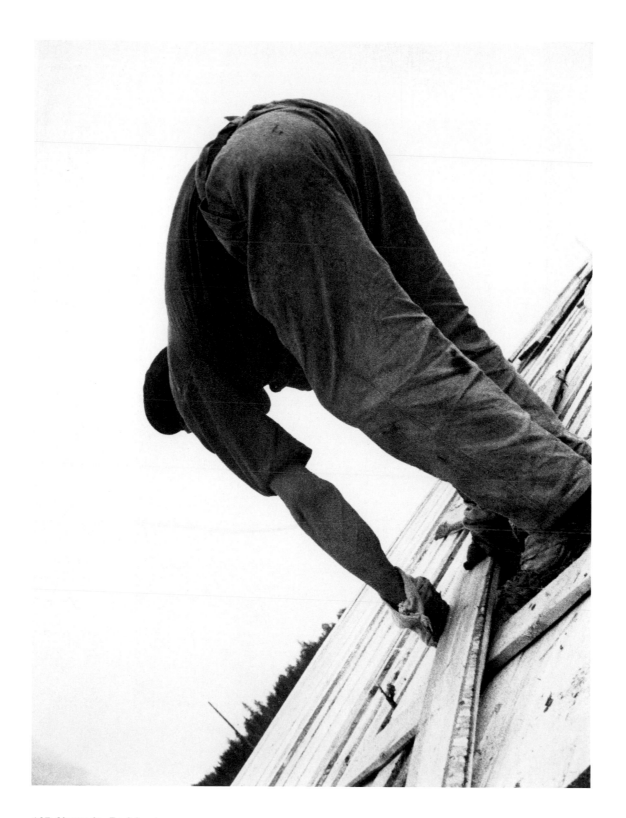

167. Alexander Rodchenko
Sawmill Worker, 1930
Gelatin silver print
9 5/8 x 7 1/8 in. (24.4 x 18.1 cm)

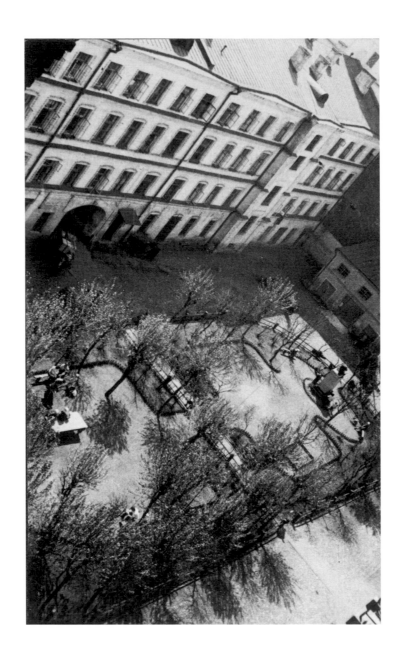

168. **Alexander Rodchenko**
Courtyard, ca. 1928–30
Gelatin silver print
5 3/8 x 3 3/8 in. (13.7 x 8.6 cm)

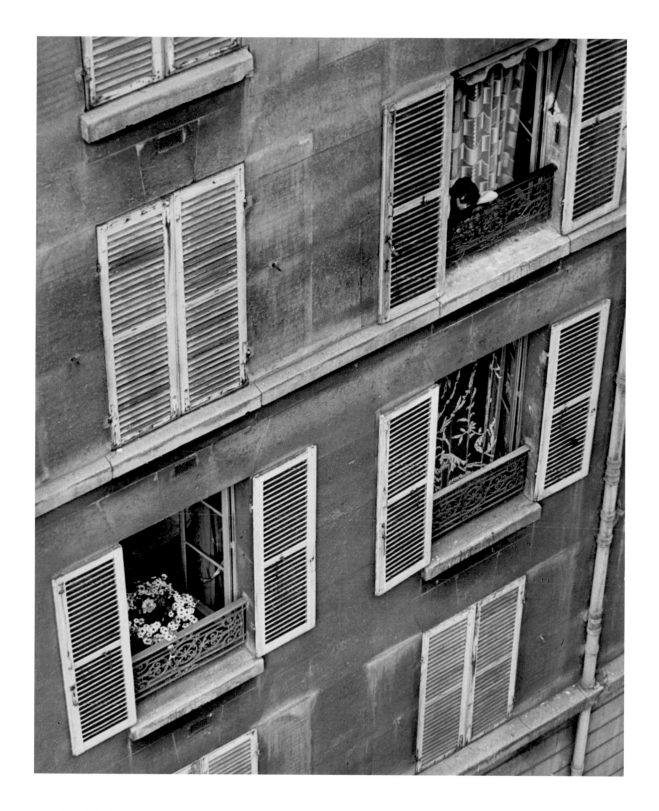

169. **André Kertész**
Rue Vavin, Paris, 1925
Gelatin silver print
9¹⁵/₁₆ x 7⅞ in. (25.2 x 20 cm)

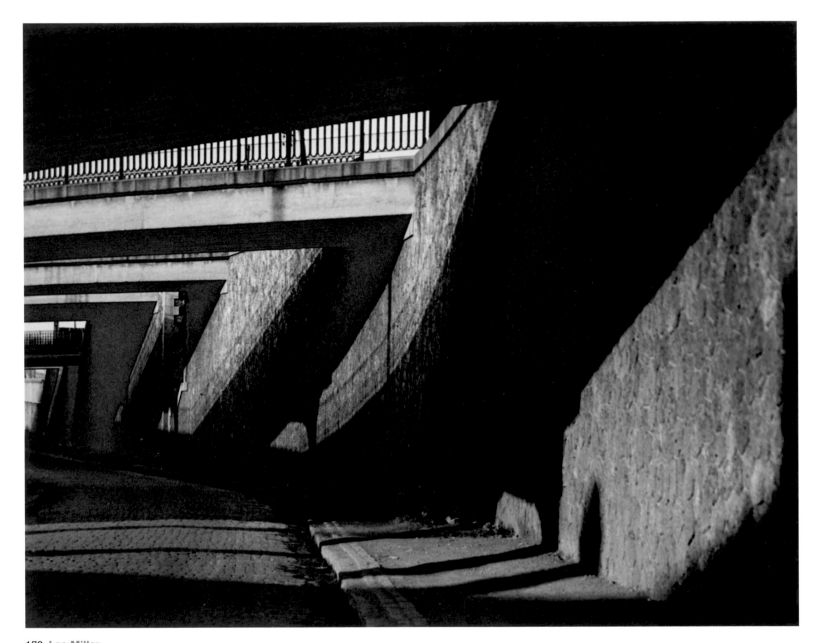

170. **Lee Miller**
Walkway, Paris, ca. 1929
Gelatin silver print
9 x 11⅝ in. (22.9 x 29.5 cm)

171. **Werner Mantz**
*Siedlung Köln-Kalkerfeld, Wohnblöcke in der
Heidelberger Strasse* (Cologne-Kalkerfeld Housing Project,
Residential Blocks on Heidelberger Strasse), 1930
Gelatin silver print
15¼ x 11⅜ in. (38.7 x 28.9 cm)

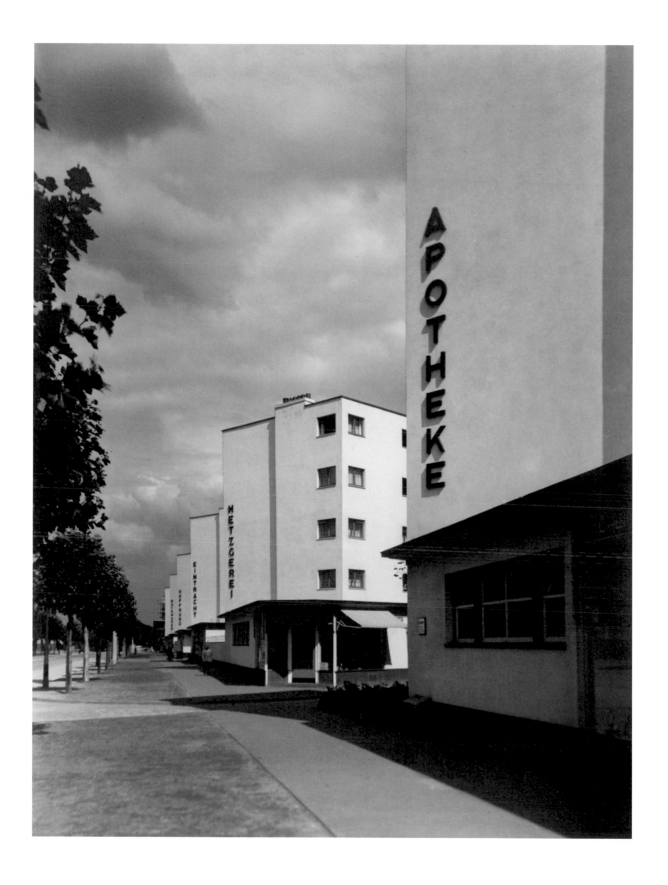

172. Florence Henri
Paris, 1930
Gelatin silver print
9 x 6¹³/₁₆ in. (22.9 x 17.3 cm)

173. **Man Ray**
Untitled, 1926
Gelatin silver print
5¹/₄ x 6 in. (13.3 x 15.2 cm)

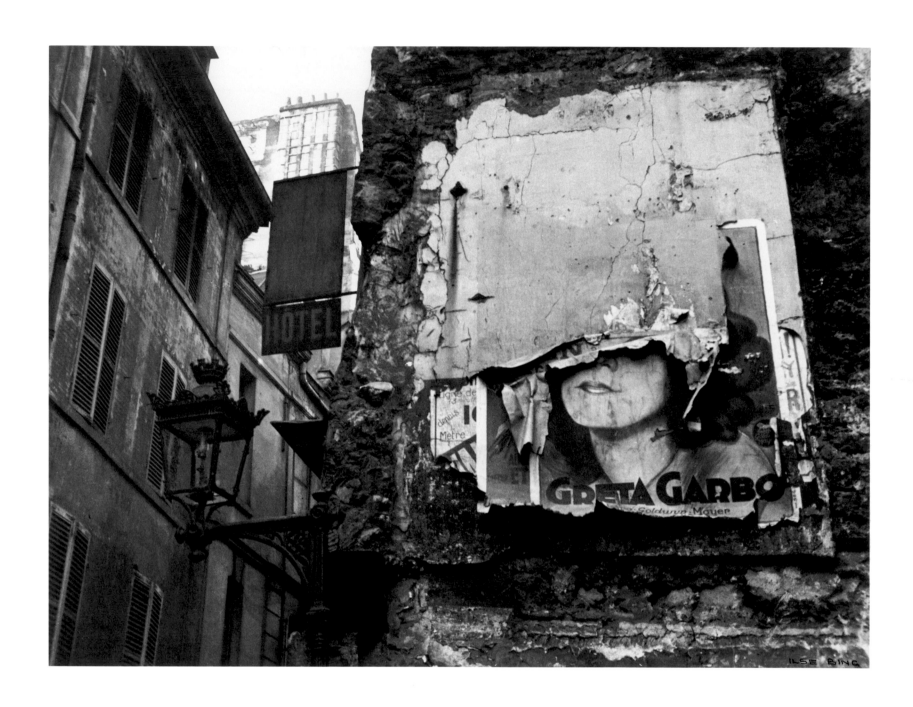

174. Ilse Bing
Greta Garbo Poster, Paris, 1932
Gelatin silver print
10³/₁₆ x 13³/₈ in. (25.9 x 34 cm)

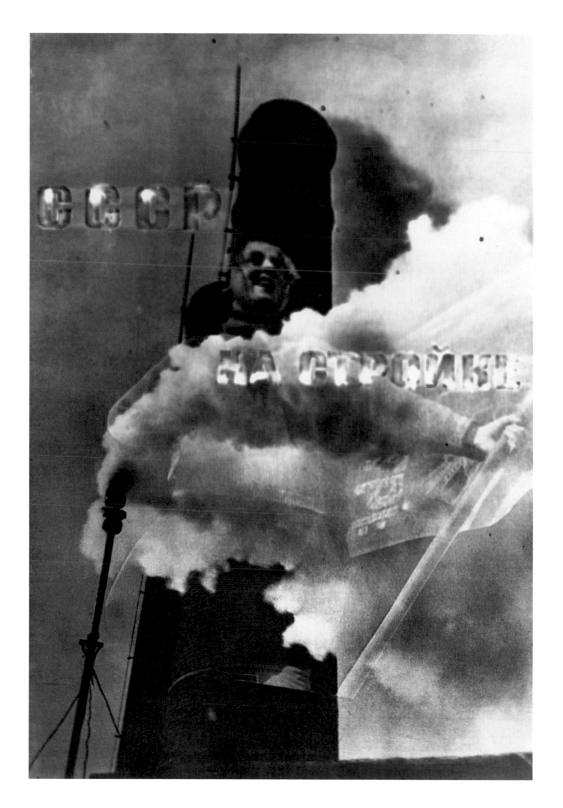

175. El Lissitzky
Design for *SSSR na stroike* (USSR under Construction), ca. 1930
Gelatin silver print
10 5/8 x 7 1/8 in. (27 x 18.1 cm)

176. **Umbo** (Otto Umbehr)
Potsdamer Platz, Berlin, 1935
Gelatin silver print
8¹⁵/₁₆ x 8¹⁵/₁₆ in. (22.7 x 22.7 cm)

177. Martin Munkacsi
Aerial View of Pest, 1926
Gelatin silver print
12 x 8 1/4 in. (30.5 x 21 cm)

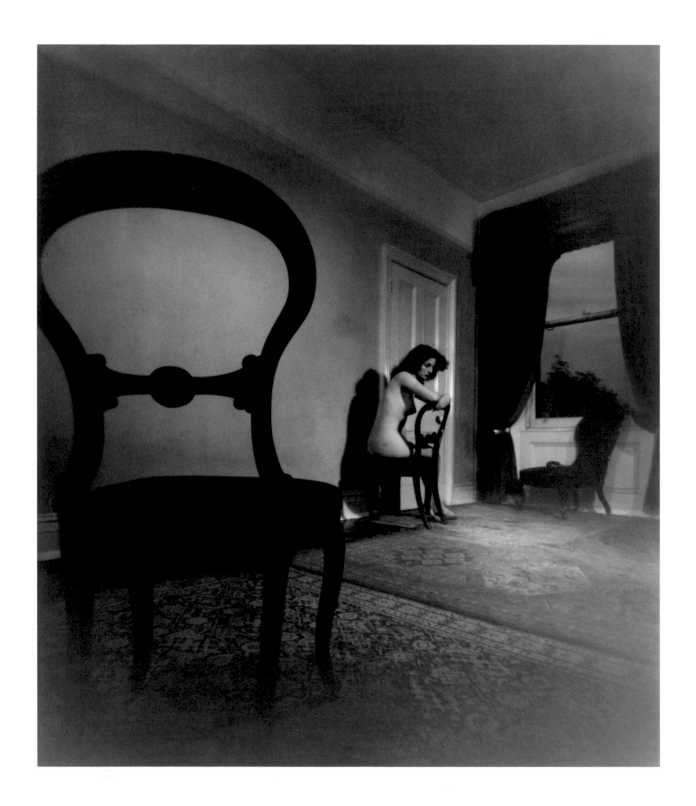

178. **Bill Brandt**
Camden Hill, London, 1947
Gelatin silver print
9 x 7⁵/₈ in. (22.9 x 19.4 cm)

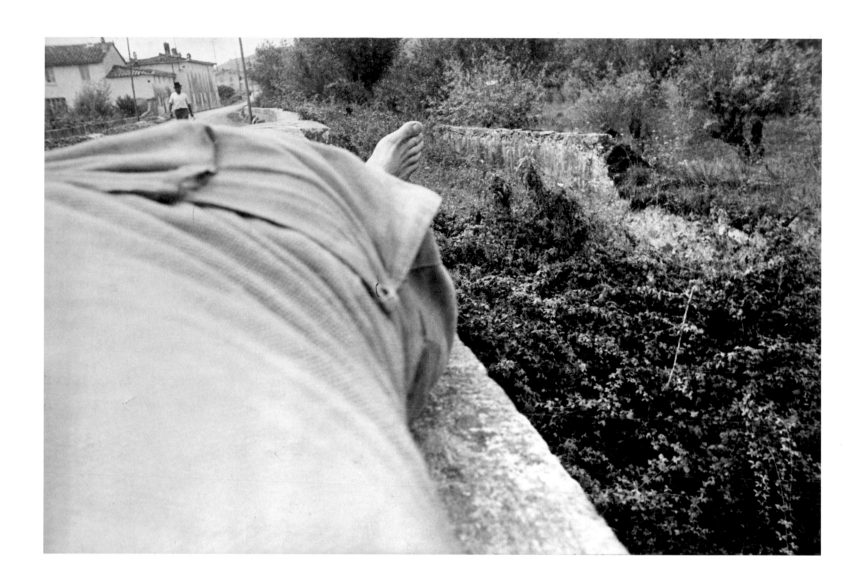

179. **Henri Cartier-Bresson**
Self-Portrait, 1933
Gelatin silver print
6 5/8 x 9 7/8 in. (16.8 x 25.1 cm)

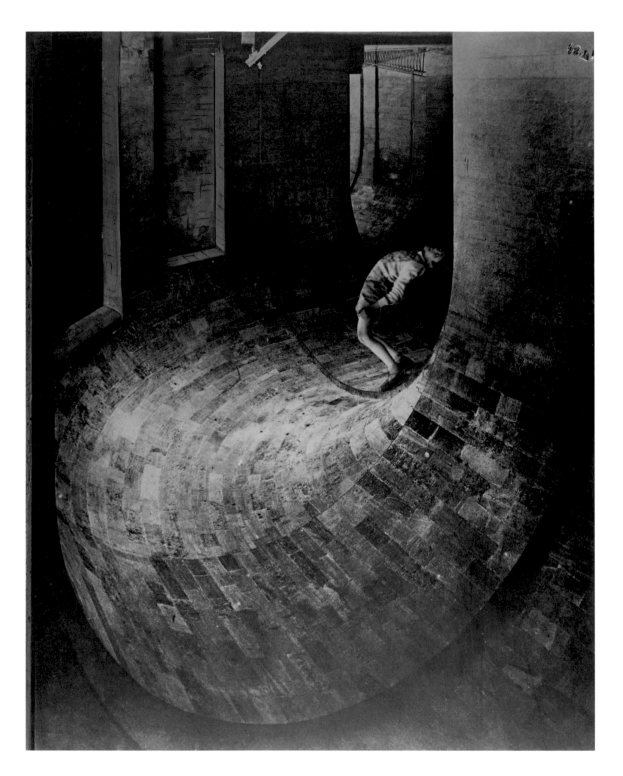

180. **Dora Maar**
Le simulateur (The Pretender), 1936
Gelatin silver print
11 1/2 x 9 in. (29.2 x 22.9 cm)

181. **László Moholy-Nagy**
Helsinki, 1930
Gelatin silver print
15 1/8 x 11 1/4 in. (38.4 x 28.6 cm)

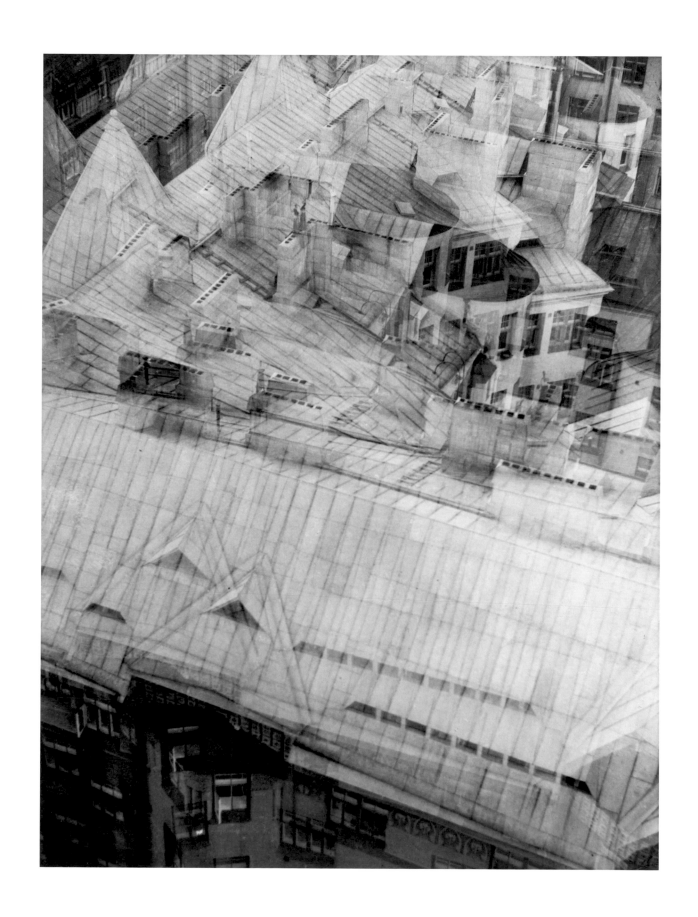

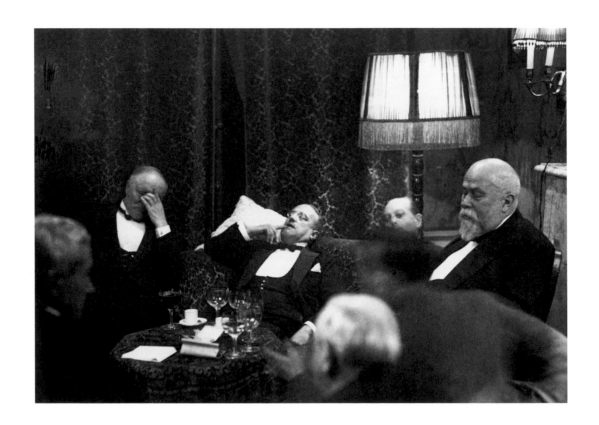

182. **Erich Salomon**
Hague Conference, 1930
Gelatin silver print
4 1/4 x 6 in. (10.8 x 15.2 cm)

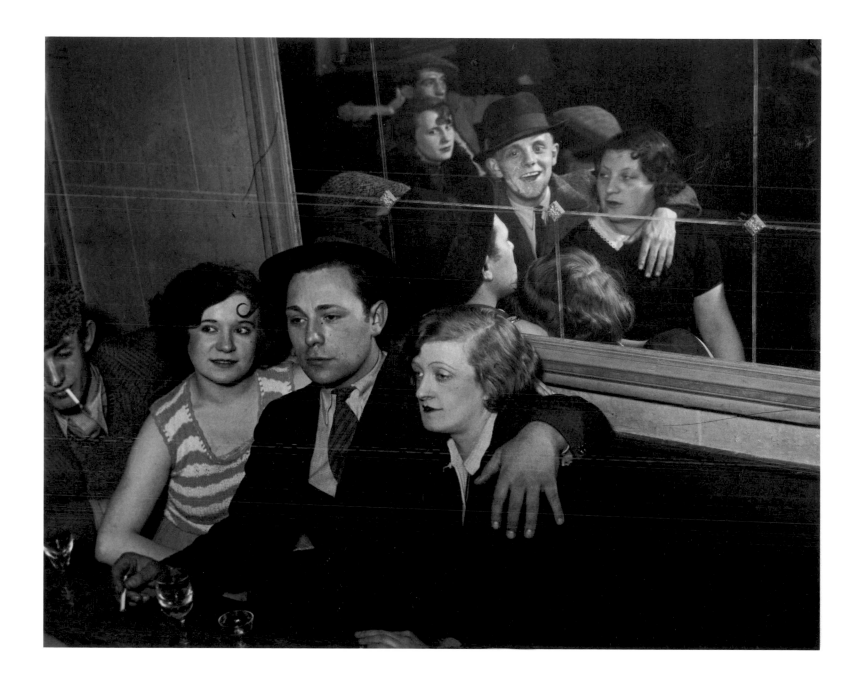

183. **Brassaï** (Gyula Halász)
Groupe joyeux au bal musette des Quatre Saisons,
rue de Lappe (Happy Group at the Four Seasons Ball,
rue de Lappe), ca. 1932, printed ca. 1948–55
Gelatin silver print
9 3/8 x 11 13/16 in. (23.8 x 30 cm)

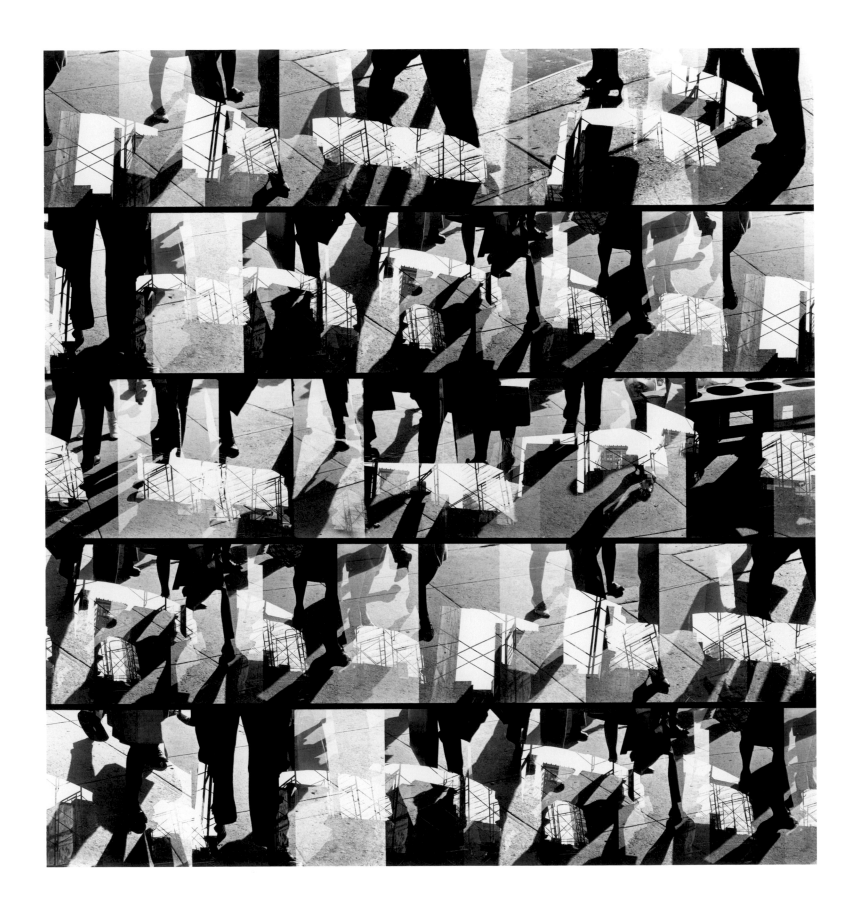

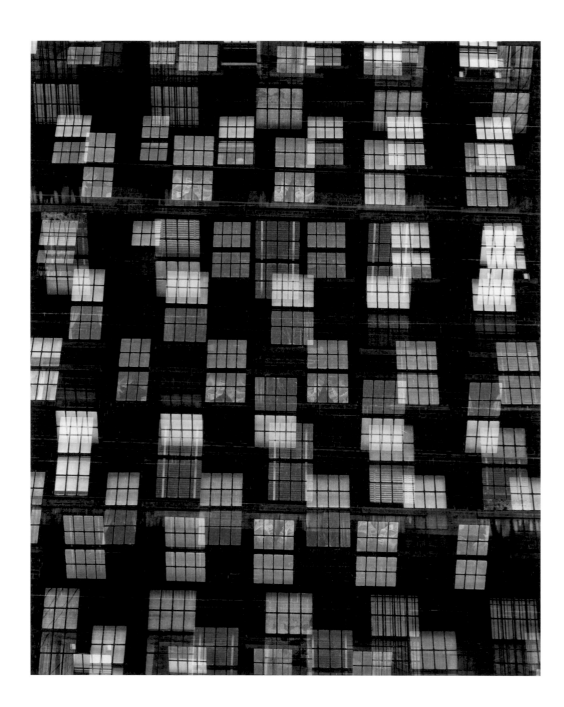

184. **Ray K. Metzker**
Philly Walk, 1965
Five gelatin silver prints
17 3/8 x 16 5/16 in. (44.1 x 41.4 cm) overall

185. **Harry Callahan**
Chicago, ca. 1948, printed ca. 1965
Gelatin silver print
9 5/8 x 7 5/8 in. (24.4 x 19.4 cm)

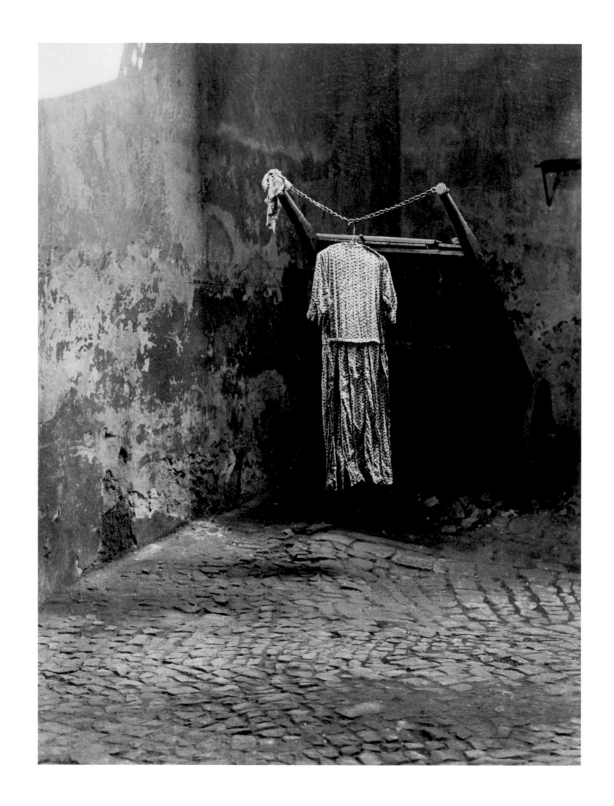

186. **Miroslav Hak**
Ve dvore (In the Courtyard), 1942
Gelatin silver print
9 1/8 x 6 7/8 in. (23.2 x 17.5 cm)

187. Roman Vishniac
Entrance to the Old Ghetto, Kraków, 1937
Gelatin silver print
9 15/16 x 7 11/16 in. (25.2 x 19.5 cm)

188. W. Eugene Smith
Dance of the Flaming Coke, 1955
Gelatin silver print
8 3/4 x 13 3/4 in. (22.2 x 34.9 cm)

189. Bruce Davidson
Untitled, 1965
Gelatin silver print
6 x 9 in. (15.2 x 22.9 cm)

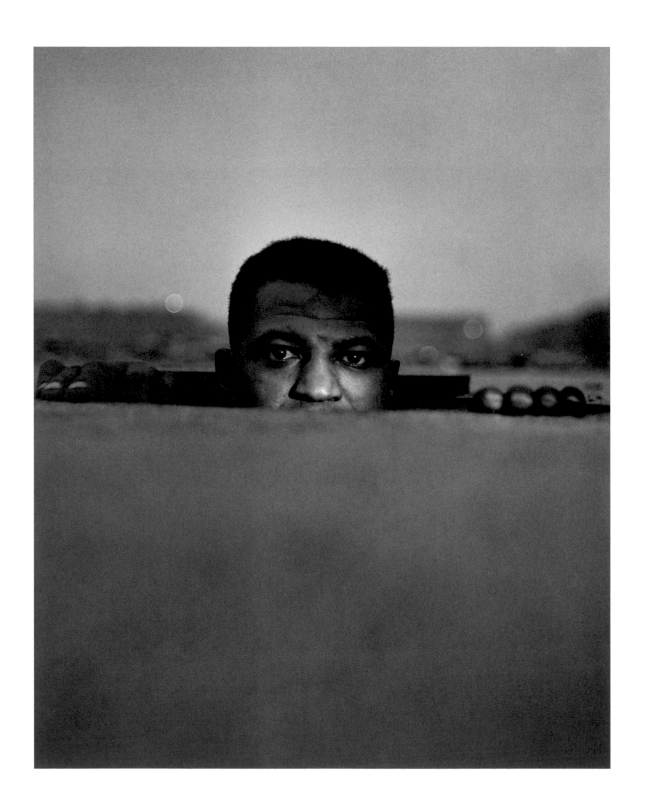

190. **Gordon Parks**
Emerging Man, 1952
Gelatin silver print
13^{7}/$_{16}$ x 10^{11}/$_{16}$ in. (34.1 x 27.1 cm)

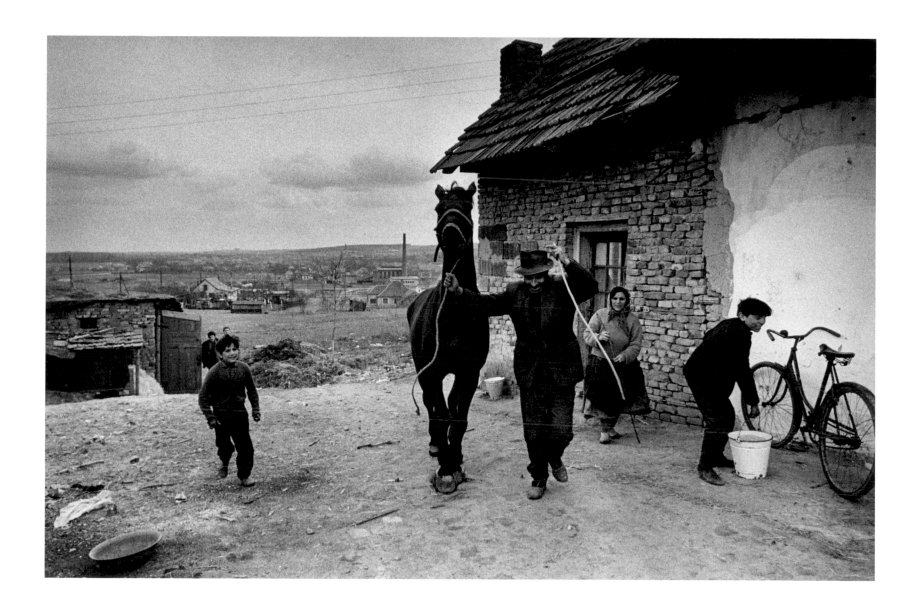

191. Josef Koudelka
Nitra, 1968
Gelatin silver print
8 7/16 x 12 13/16 in. (21.4 x 32.5 cm)

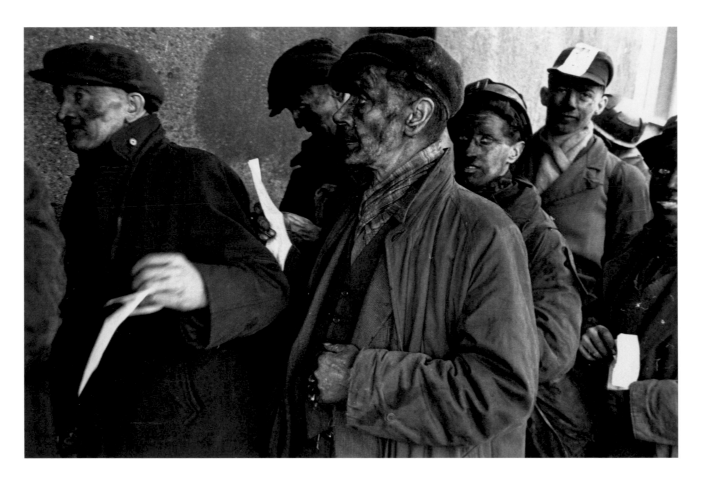

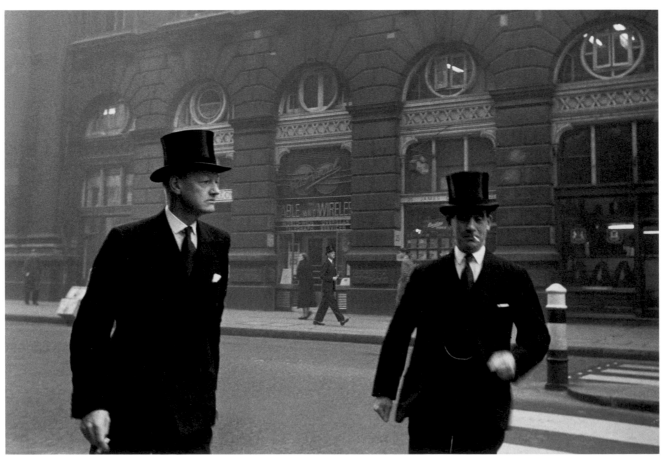

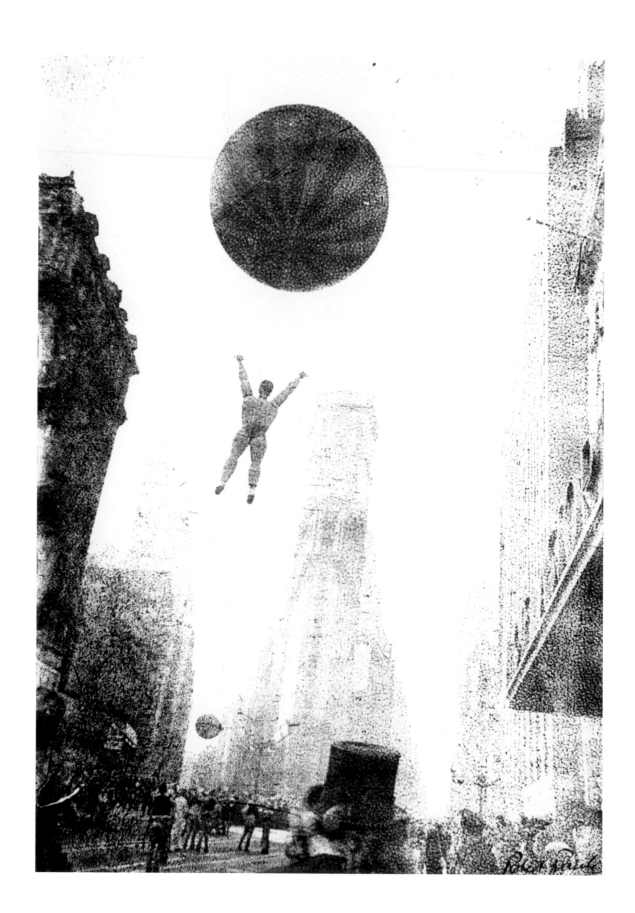

192. **Robert Frank**
Wales, Ben James, 1953
Gelatin silver print
9 1/8 x 13 1/2 in. (23.2 x 34.3 cm)

193. **Robert Frank**
London Bankers, 1951
Gelatin silver print
8 3/4 x 12 5/8 in. (22.2 x 32.1 cm)

194. **Robert Frank**
Men of Air, New York, 1947
Gelatin silver print
13 1/2 x 9 1/4 in. (34.3 x 23.5 cm)

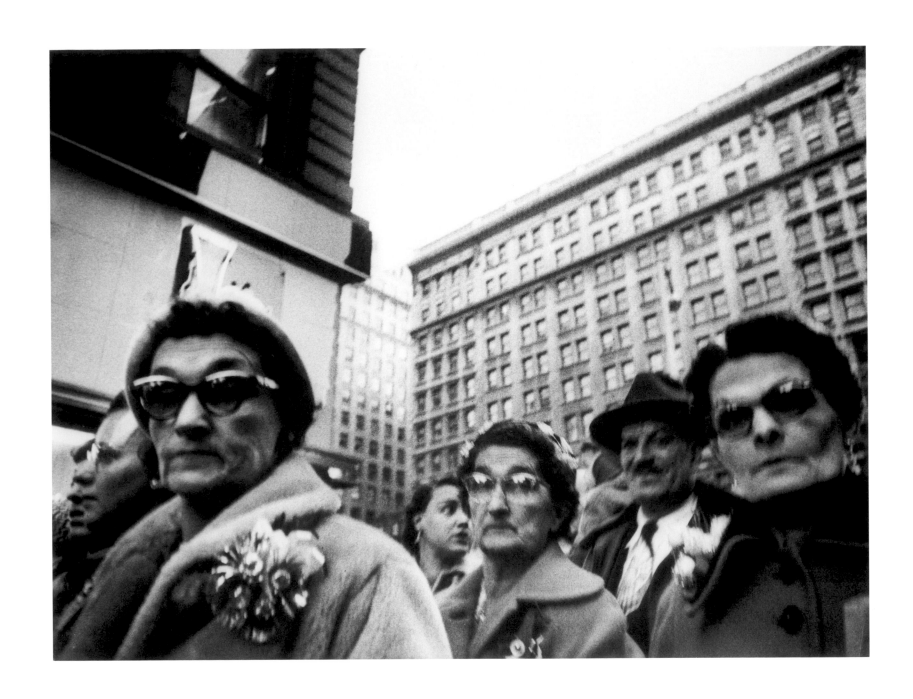

195. William Klein
Xmas Shopping near Macy's, New York, 1954, printed 1956
Gelatin silver print
11 3/4 x 15 3/4 in. (29.8 x 40 cm)

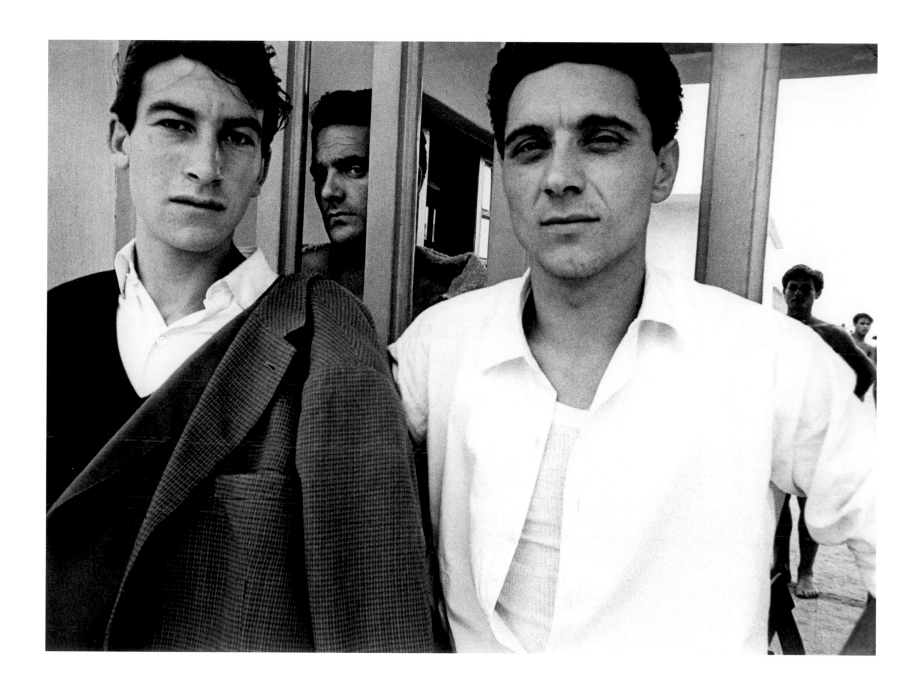

196. **William Klein**
Entrance, Ostia Beach, near Rome, 1956
Gelatin silver print
10 7/8 x 14 5/8 in. (27.6 x 37.1 cm)

INHABITANTS

The pictures in the Sack Collection made after 1945 manifest a subtle shift in focus. If many of the earlier photographs are concerned with the architecture of the built environment and its impact on human relationships, it is the inhabitants of such spaces who take center stage in the later works. That this shift occurred in the immediate aftermath of the economic and physical devastation and unprecedented loss of human life in World War II is not insignificant. In the United States, where most of the postwar photographs in the Sack Collection were made, the situation was complicated by the country's headlong descent into an anticommunist hysteria.

In 1955 the Museum of Modern Art, New York, opened the most well-attended exhibition of photography in the medium's history, *The Family of Man*. Organized by Edward Steichen, the unorthodox installation brought together nearly five hundred photographs from around the world to construct a picture-story about the "essential oneness" of humanity. The exhibition reassured its audiences that despite the divisiveness of Cold War politics, certain human values and concerns are innate and immutable, transcending cultural and national differences. Above all, the exhibition professed Steichen's deep-seated faith in photography as a universal humanistic language.

That same year the young Swiss photographer Robert Frank was awarded a Guggenheim fellowship to document the American social landscape. For two years Frank traveled by car across his adopted homeland with his wife and young child, constructing what he described as a "visual study of a civilization." Frank's raw, soulful photographs exposed America's hollow patriotic rituals and symbols, the puffery of politicians, and the gaping social chasms of race and class. He was moved by the freedom of American society but deplored the emptiness of its commodity-driven culture. A photograph of a parade (*pl. 194*), made on his first trip to America in 1947, subtly conveys this ambivalence: Frank's knowing title, *Men of Air, New York,* inflects the soaring balloon's exuberant gesture with irony. Frank's photographs cut through the rosy mass-media imagery of postwar affluence to tell a more personally truthful story: his America is gritty and fragmented, alienating and lonesome. When Frank completed his maquette for *The Americans* in 1957, no publisher in the United States would touch it.

Frank's vision could not have been more different from Steichen's, but it was widely shared by a generation of artists.

Like the abstract expressionist painter Jackson Pollock or the iconoclastic, improvisational jazz musician Miles Davis, American photographers of the 1950s and 1960s combated postwar anomie with a fiercely individualistic approach. Despite *The Family of Man*'s unprecedented popular success, the exhibition betrayed a willful naïveté about the irreparable social fractures of the atomic age and the diversity of global culture. Moreover, Steichen's idealized view of photography as the medium of the masses no longer held true: television, not photography, was to be the twentieth century's eyewitness. Many photographers turned their backs on politics and social issues altogether, convinced that their ideas were better served by private rather than programmatic campaigns. Frank—like the Beat poets who embraced his work—subscribed to no particular creed; his nonconformist view of America was spontaneous, innovative, and above all personal.

This existentialist sensibility is typified in the work of William Klein, who, like Frank, approached his subject as an outsider and defied the rules of "good" photographic composition. Klein's street pictures are bluntly confrontational; in *Entrance, Ostia Beach, near Rome* (*pl. 196*), for example, the wide-angle lens transforms the young men's

stony faces into an impenetrable barrier across the picture plane. This aggressive stance is underscored by the brutality of his aesthetic: if Frank's pictures derived something of their spontaneity from the quick-footedness of photojournalism, Klein's approach recalls the belligerent determination of the paparazzi. Louis Stettner's *Irene* (*pl. 201*) creates a similar sense of psychological remove in somewhat cooler tones. The camera's physical distance from the scene isolates the woman's figure within the composition; her aloneness is underscored not only by the picture's geometry but also by the starkness of her dark form against the white wall. The view is not altogether bleak, however: the sly cropping of the words painted on the wall relieves the scene's melancholy with black humor. In very different ways, Klein's and Stettner's pictures evoke a similarly powerful emotional response, each without overt symbolism or explicit narrative.

The loneliness that pervades the public spaces in these pictures is balanced by moments of great intimacy, as in Bruce Davidson's view of a wedding in Welsh mining country (*pl. 189*). The couple stands alone on a windswept hillside, the smoke-veiled chimneys in the background a reminder of the region's economy. The ritual takes place not in a church but in the open air, a private communion witnessed by none but the photographer. Though their view is no longer outward and encompassing, but rather inward-looking and insular, many of the pictures in the Sack Collection retain a little of Steichen's hopeful idealism. Elliott Erwitt's tender and languorous portrait of his wife and child (*pl. 197*), for example, shows us an entirely private world: a self-contained system of physical and emotional sustenance.

Ralph Eugene Meatyard's enigmatic *Family Album of Lucybelle Crater,* published two years after his death in 1972, is an ironic counterpoint to Steichen's *Family of Man.* Throughout the series, the photographer's wife, Madelyn, wears a grotesque rubber mask in the guise of the title character, Lucybelle Crater. In each picture she is paired with a second figure, also masked and also named Lucybelle Crater. The identity of the subjects is made clear only through their relationship to each other; in *Lucybelle Crater and her charmingly youthful mother-in-law Lucybelle* (*pl. 215*), for example, it is the photographer's mother who stands beside his wife. By suppressing the two most basic indices of his subjects' individuality—name and face—Meatyard might seem to subscribe to the same universalism that Steichen imagined. But Meatyard's carefully staged fictions instead reveal the extent to which the family photograph has become ritualized: a cache of stock poses to be imitated and appropriated. Meatyard's project revels in an ambiguity that Steichen's heavily ideological installation simply could not admit.

During the latter half of the twentieth century, the photograph's status as metaphor for objectivity and truth gradually withered. The generation of postwar practitioners who borrowed the style of documentary photography in order to create deeply personal work called attention to the complexity and constructedness of photographic representation. By 1975, Steichen's instrumentalized use of the medium would be unthinkable; indeed, the one concern that unites the diverse pictorial practices of the late twentieth century is a critical appreciation for the open-endedness of photographic meaning and for the ways in which photography functions in society. If the invention of photography in the 1800s demanded a new kind of viewer, by the late twentieth century the medium had become ubiquitous. Photography is now not only one of the dominant modes of recording human experience, but also one of our primary vehicles for making sense of the world around us.

—C.K.

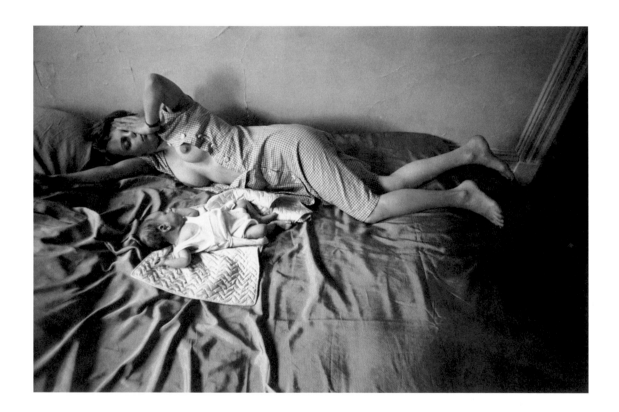

197. **Elliott Erwitt**
New York City, 1953
Gelatin silver print
4 ⅝ x 6 ⅝ in. (11.7 x 16.8 cm)

198. **William Gedney**
Kentucky, 1964
Gelatin silver print
10 ¾ x 7 ¼ in. (27.3 x 18.4 cm)

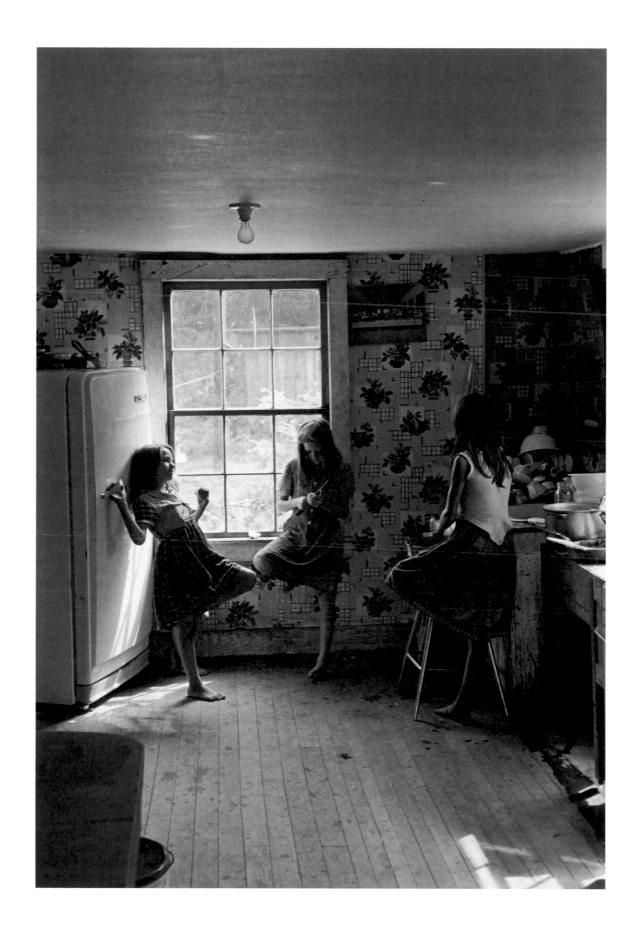

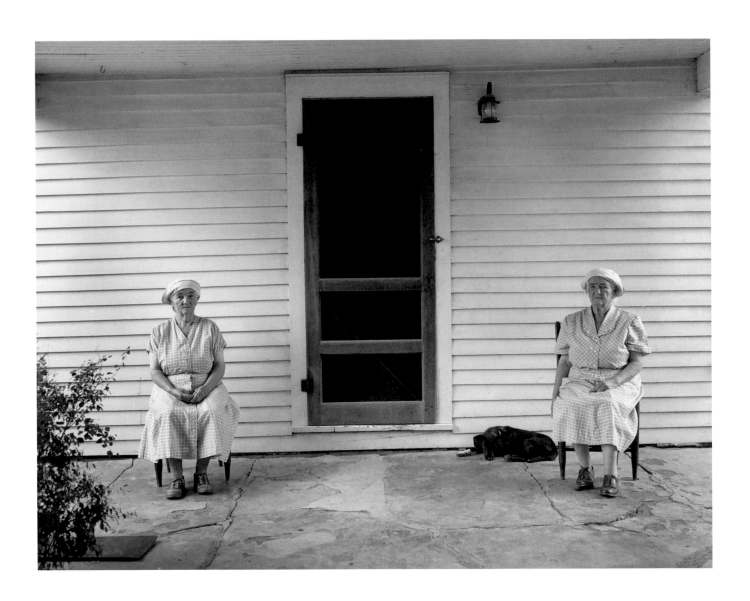

199. **Jack Warren Welpott**
The Farmer Twins, Stinesville, Indiana, 1959
Gelatin silver print
7 5/8 x 9 3/8 in. (19.4 x 23.8 cm)

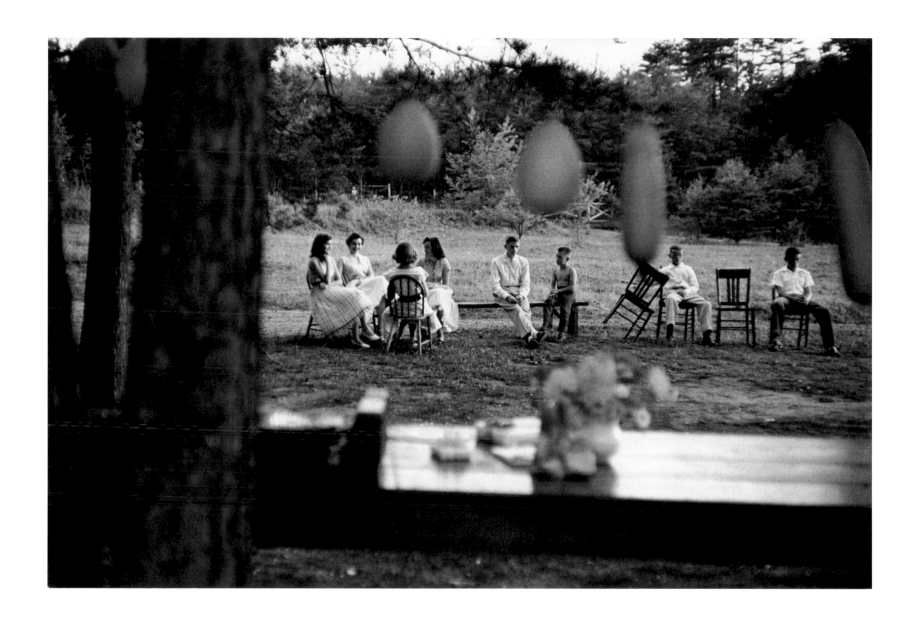

200. **Dan Weiner**
Teenage Party, Greenville, South Carolina, 1957
Gelatin silver print
9 1/8 x 13 1/2 in. (23.2 x 34.3 cm)

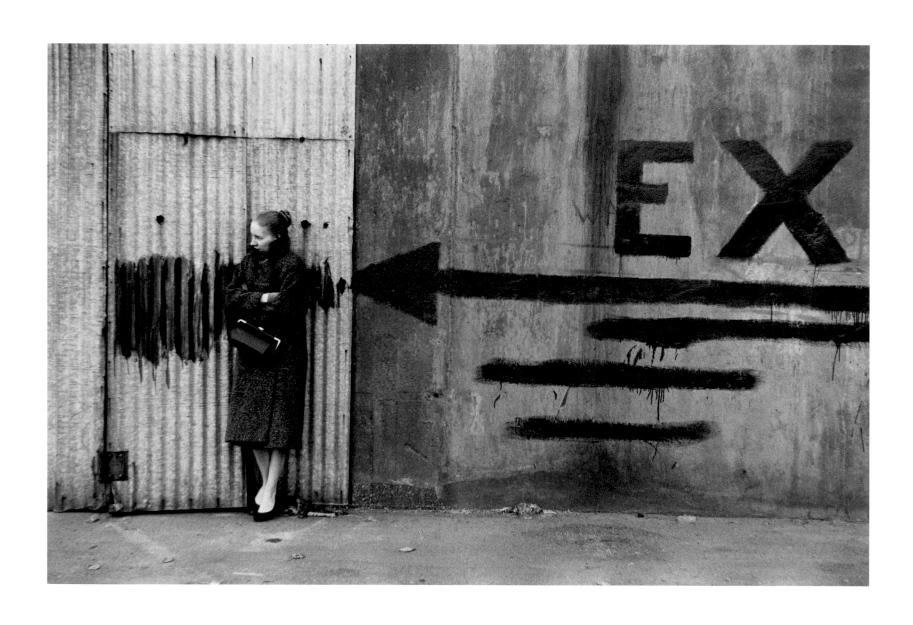

201. **Louis Stettner**
Irene, 1952
Gelatin silver print
9 x 13⅝ in. (22.9 x 34.6 cm)

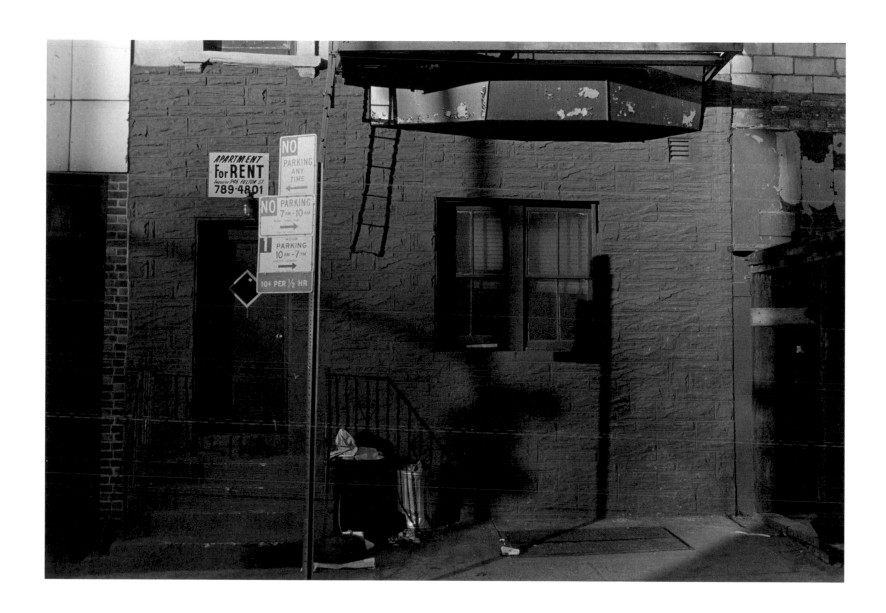

202. **Roy De Carava**
Apartment for Rent, 1977
Gelatin silver print
8 15/16 x 8 3/16 in. (22.7 x 20.8 cm)

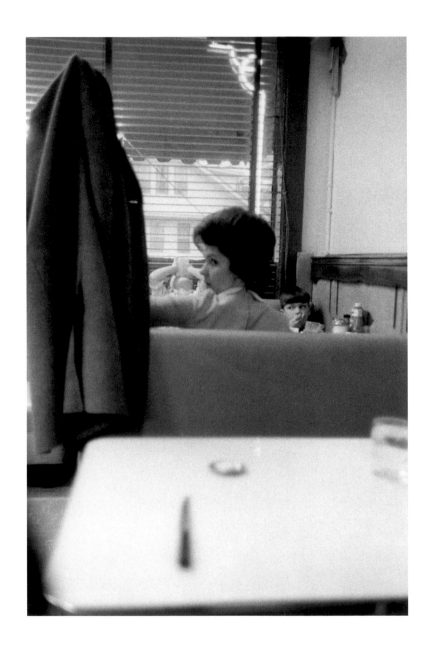

203. **William Eggleston**
Untitled, the Southwestern Grill, 1967
Gelatin silver print
8 1/2 x 5 1/2 in. (21.6 x 14 cm)

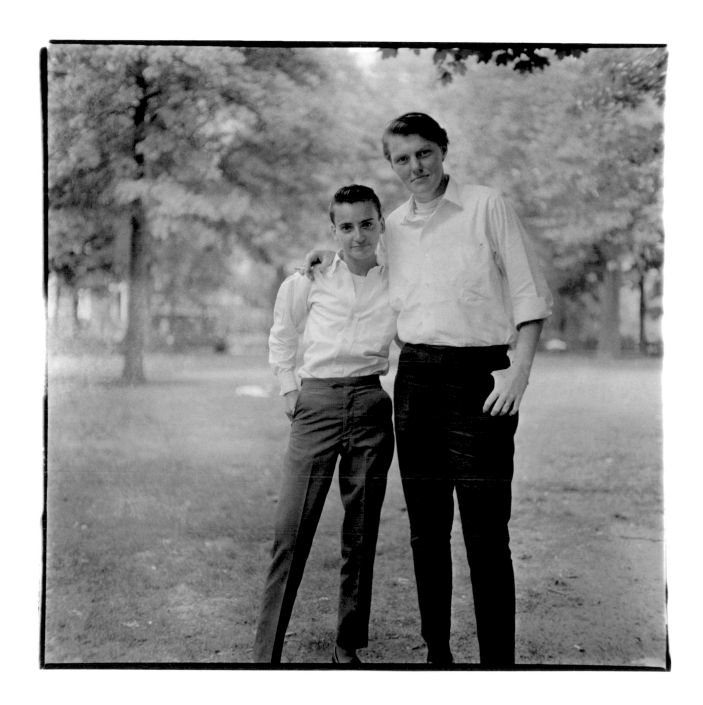

204. **Diane Arbus**
Two Friends in the Park, N.Y.C., 1965
Gelatin silver print
9 1/4 x 9 5/8 in. (23.5 x 24.4 cm)

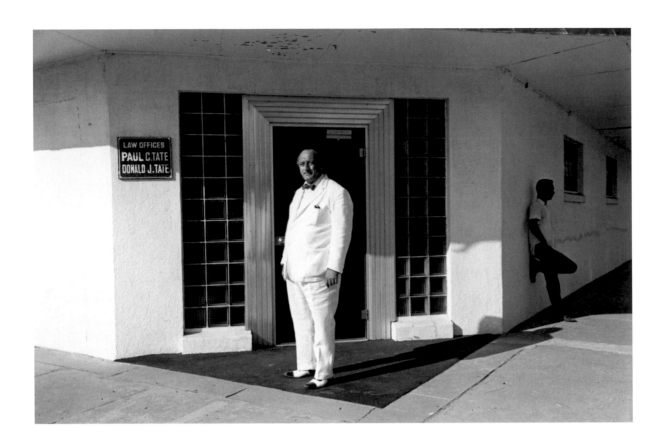

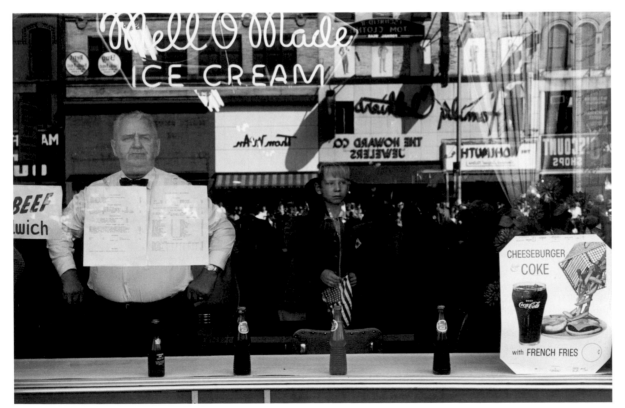

205. **Lee Friedlander**
Paul Tate, Lafayette, Louisiana, 1968
Gelatin silver print
5 1/2 x 8 1/4 in. (14 x 21 cm)

206. **Lee Friedlander**
Newark, New Jersey, 1962
Gelatin silver print
5 5/8 x 8 1/2 in. (14.3 x 21.6 cm)

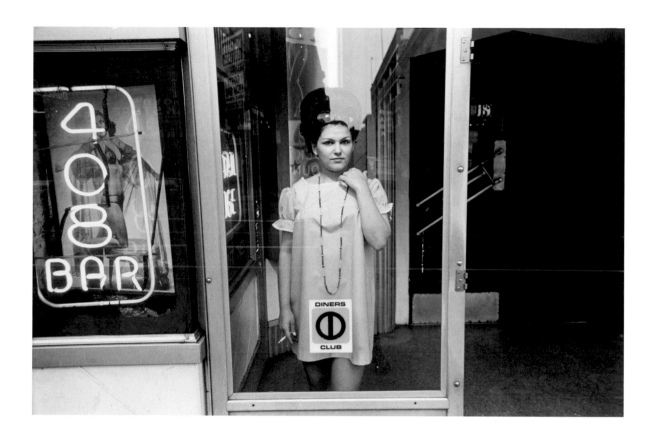

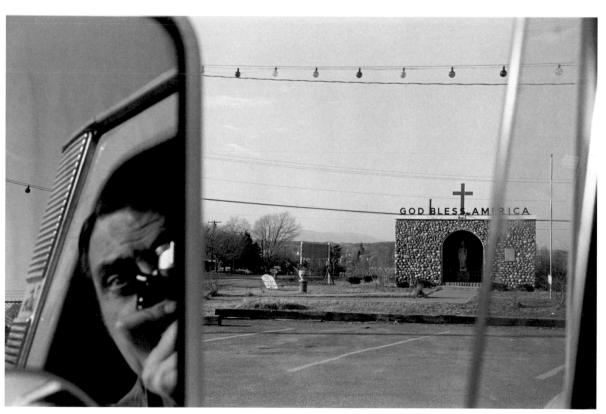

207. **Lee Friedlander**
Baltimore, 1968
Gelatin silver print
6 x 9 1/8 in. (15.2 x 23.2 cm)

208. **Lee Friedlander**
Route 9W, New York, 1969
Gelatin silver print
7 x 10 1/2 in. (17.8 x 26.7 cm)

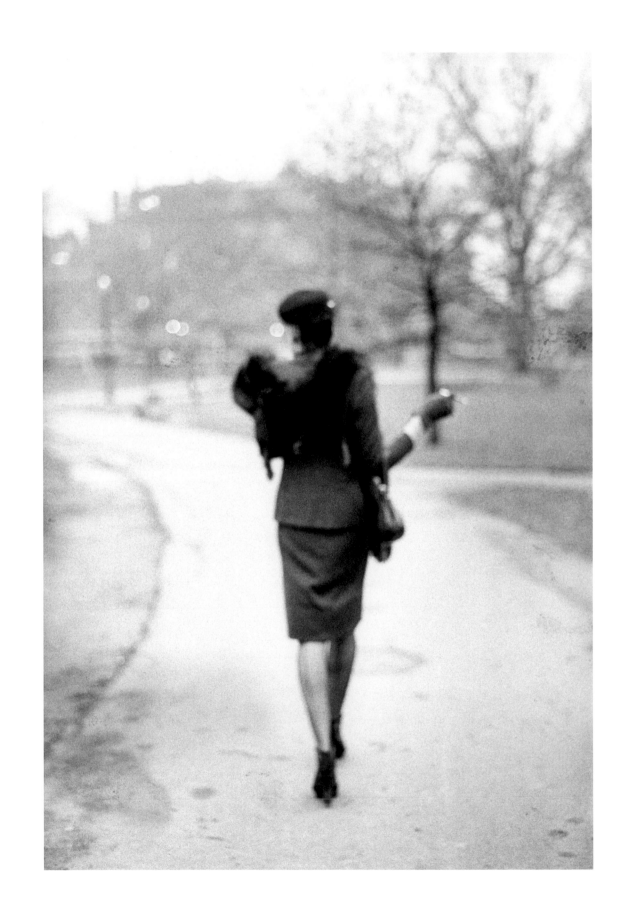

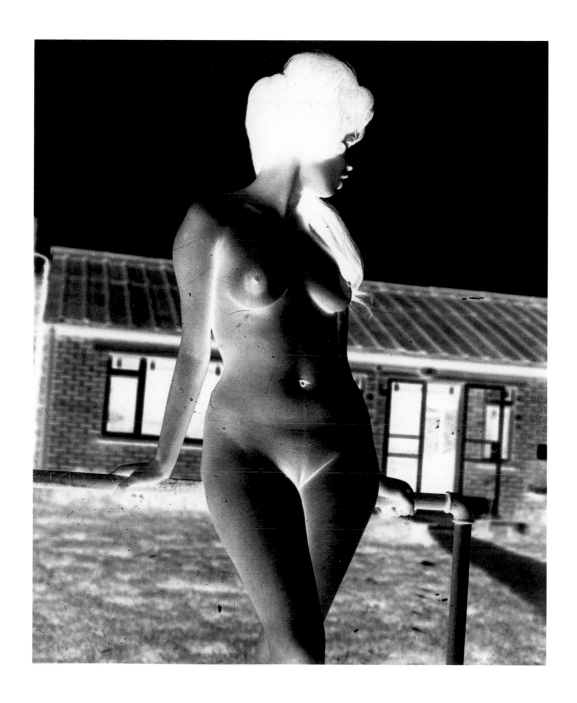

209. **Nan Goldin**
Ivy in the Garden; back. Boston, 1973, printed later
Gelatin silver print
18 11/16 x 12 7/16 in. (47.5 x 31.6 cm)

210. **Weegee** (Arthur H. Fellig)
Woman, New Jersey Nudist Camp, ca. 1960
Gelatin silver negative print
8 7/8 x 7 1/4 in. (22.5 x 18.4 cm)

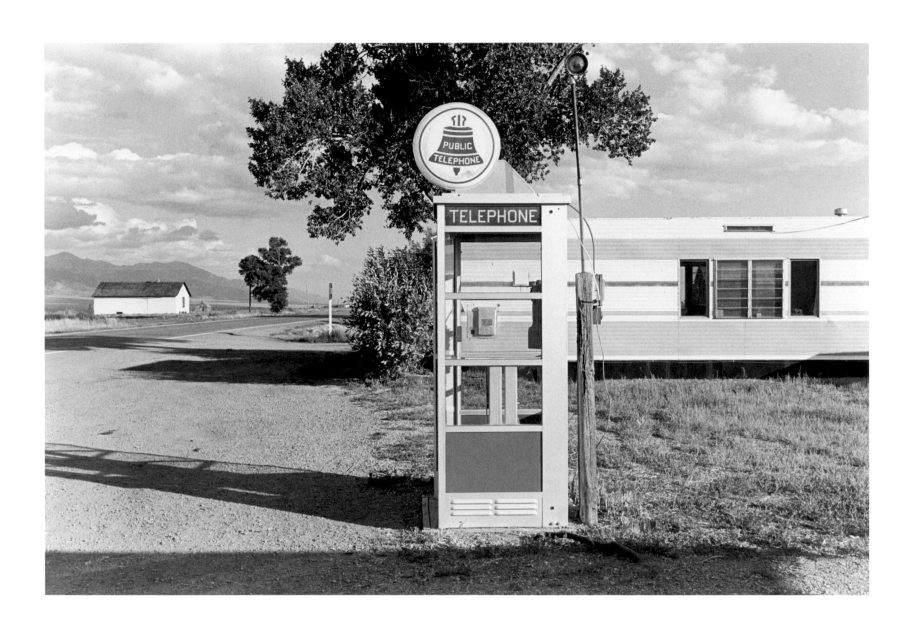

211. **Henry Wessel Jr.**
Buena Vista, Colorado, 1973
Gelatin silver print
10 x 14⁷/₈ in. (25.4 x 37.8 cm)

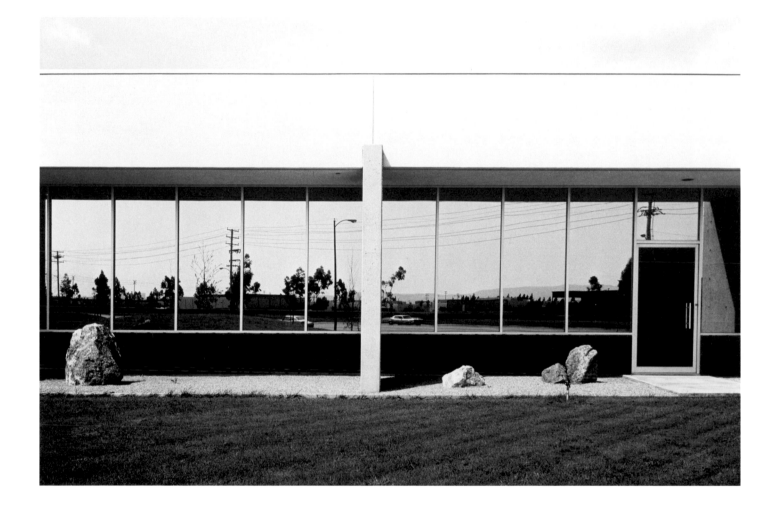

212. **Lewis Baltz**
South Wall, Mazda Motors, 2121 East Main Street, Irvine, 1974
Gelatin silver print
6 x 9 in. (15.2 x 22.9 cm)

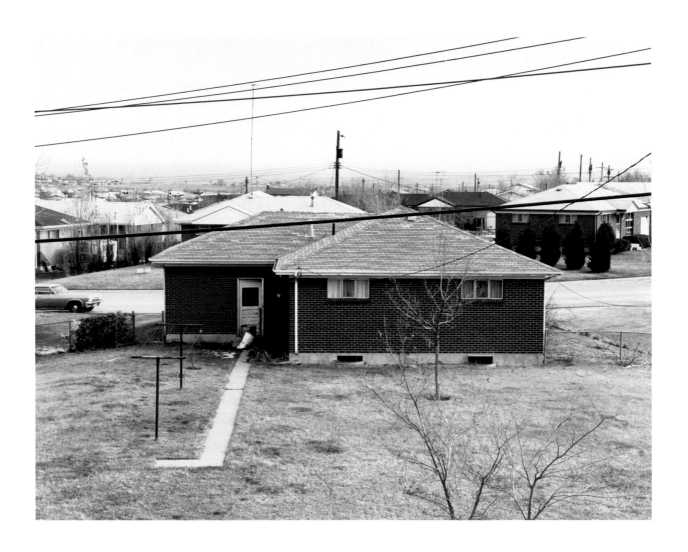

213. **Robert Adams**
Northglenn, Colorado, 1973
Gelatin silver print
6 x 7⁵/₈ in. (15.2 x 19.4 cm)

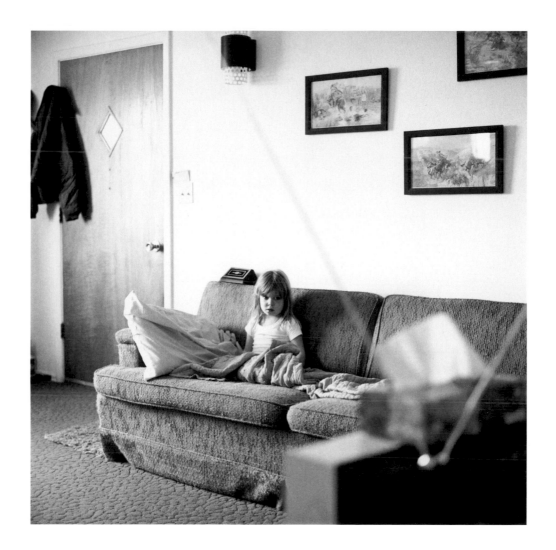

214. **Robert Adams**
Longmont, Colorado, 1973
Gelatin silver print
6 x 6 in. (15.2 x 15.2 cm)

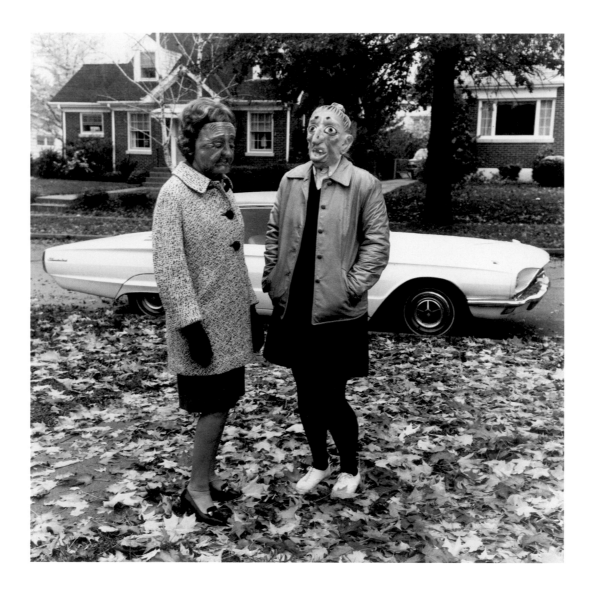

215. **Ralph Eugene Meatyard**
*Lucybelle Crater and her charmingly youthful
mother-in-law Lucybelle,* ca. 1970–72
Gelatin silver print
7 9/16 x 7 5/8 in. (19.2 x 19.4 cm)

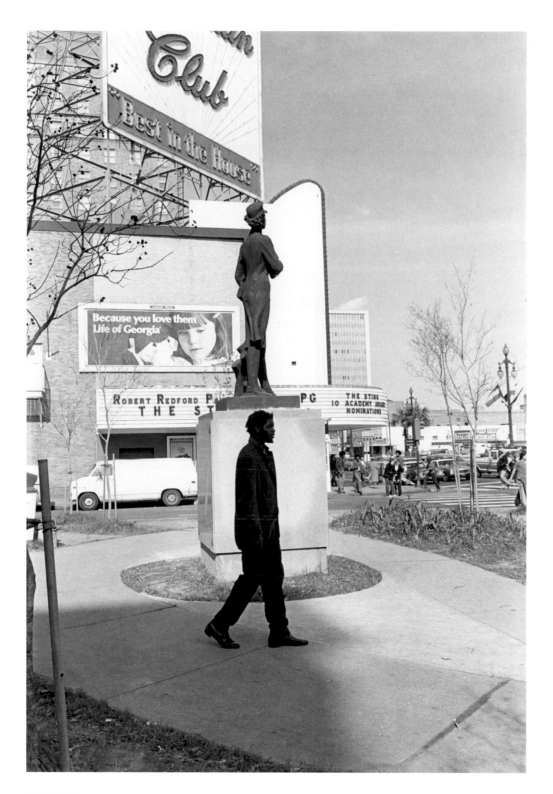

216. **Bill Dane**
New Orleans, 1974
Gelatin silver print
12 7/8 x 8 5/8 in. (32.7 x 21.9 cm)

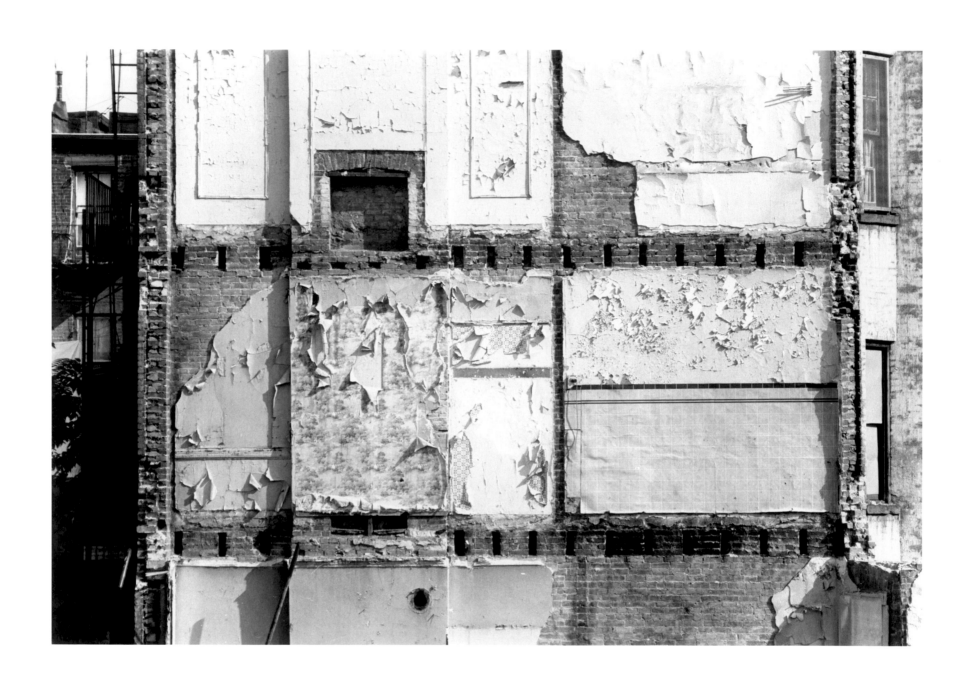

217. Gordon Matta-Clark
New York City, 1972
Gelatin silver print
16 x 22⁷/₈ in. (40.6 x 58.1 cm)

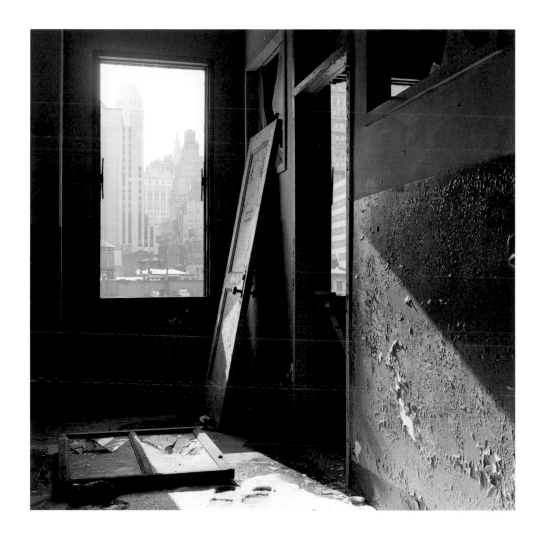

218. **Danny Lyon**
Untitled, 1968
Gelatin silver print
7 7/16 x 7 7/16 in. (18.9 x 18.9 cm)

219. **Paul Kwilecki**
Ms. Tomlinson in the House of Tomatoes, 1974
Gelatin silver print
12 1/2 x 8 5/8 in. (31.8 x 21.9 cm)

220. **Bill Owens**
4th of July Parade, Livermore, California, 1970s
Gelatin silver print
8 1/2 x 6 in. (21.6 x 15.2 cm)

SUGGESTIONS FOR FURTHER READING

Beginnings

Jammes, André, and Eugenia Parry Janis. *The Art of French Calotype: With a Critical Dictionary of Photographers, 1845–1870*. Princeton, N.J.: Princeton University Press, 1983.

Pare, Richard, ed. *Photography and Architecture, 1839–1939*. Montreal: Centre canadien d'architecture/Canadian Centre for Architecture; New York: Callaway Editions, 1982.

Wolf, Sylvia. *Julia Margaret Cameron's Women*. Chicago: Art Institute of Chicago; New Haven, Conn.: Yale University Press, 1998.

Territories

Baldwin, Gordon, et al. *All the Mighty World: The Photography of Roger Fenton, 1852–60*. New Haven, Conn.: Yale University Press, 2004.

Daniel, Malcolm. *The Photographs of Édouard Baldus*. New York: Metropolitan Museum of Art, 1994.

Nickel, Douglas R. *Francis Frith in Egypt and Palestine: A Victorian Photographer Abroad*. Princeton, N.J.: Princeton University Press, 2004.

North and South, East and West

Hales, Peter B. *Silver Cities: The Photography of American Urbanization, 1839–1915*. Philadelphia: Temple University Press, 1984.

Harris, David. *Eadweard Muybridge and the Photographic Panorama of San Francisco, 1850–1880*. Montreal: Centre Canadien d'Architecture/Canadian Centre for Architecture; Cambridge, Mass.: MIT Press, 1993.

Phillips, Sandra S. *Crossing the Frontier: Photographs of the Developing West, 1849 to the Present*. San Francisco: San Francisco Museum of Modern Art, 1996.

Sandweiss, Martha A., ed. *Photography in Nineteenth-Century America*. New York: Harry N. Abrams, 1991.

Progress and Its Discontents

Bunnell, Peter C., ed. *A Photographic Vision: Pictorial Photography, 1889–1923*. Salt Lake City: Peregrine Smith, 1980.

Fleischhauer, Carl, and Beverly W. Brannan, eds. *Documenting America, 1935–1943*. Berkeley: University of California Press, 1989.

Riis, Jacob. *How the Other Half Lives: Studies Among the Tenements of New York*. 1890. Reprint, New York: Penguin Books, 1997.

Smith, Joel. *Edward Steichen: The Early Years*. New York: Metropolitan Museum of Art; Princeton, N.J.: Princeton University Press, 1999.

The Modern Eye

Dabrowski, Magdalena, Leah Dickerman, and Peter Galassi. *Aleksandr Rodchenko*. New York: Museum of Modern Art, 1998.

Hambourg, Maria Morris, and Christopher Phillips. *The New Vision: Photography Between the World Wars*. New York: Metropolitan Museum of Art, 1989.

Hight, Eleanor M. *Picturing Modernism: Moholy-Nagy and Photography in Weimar Germany*. Cambridge, Mass.: MIT Press, 1995.

Teitelbaum, Matthew, ed. *Montage and Modern Life, 1919–1942*. Cambridge, Mass.: MIT Press, 1992.

Inhabitants

Frank, Robert. *The Americans*. 1958. Reprint, Millerton, N.Y.: Aperture, Inc., 1978.

Livingston, Jane. *The New York School: Photographs 1936–1963*. New York: Stewart, Tabori & Chang, 1992.

Sandeen, Eric J. *Picturing an Exhibition: The Family of Man and 1950s America*. Albuquerque: University of New Mexico Press, 1995.

Szarkowski, John. *Mirrors and Windows: American Photography since 1960*. New York: Museum of Modern Art, 1978.

CATALOGUE OF THE EXHIBITION

Collection credits for the photographs listed below are indicated as follows:

① *Promised gift of Prentice and Paul Sack to the Prentice and Paul Sack Photographic Trust*

② *Collection of the Prentice and Paul Sack Photographic Trust*

③ *Collection of the San Francisco Museum of Modern Art, fractional gift of Prentice and Paul Sack, and collection of the Prentice and Paul Sack Photographic Trust*

④ *Collection of the San Francisco Museum of Modern Art, Margaret Weston Collection, fractional gift of Margaret Weston and Paul Sack, and collection of the Prentice and Paul Sack Photographic Trust*

⑤ *Promised gift of Prentice and Paul Sack to the Prentice and Paul Sack Photographic Trust and collection of the San Francisco Museum of Modern Art, Accessions Committee Fund purchase*

Berenice Abbott American, 1898–1991
The Construction of Rockefeller Center, 1931.
Gelatin silver print. 7³/₈ x 9³/₈ in. (18.7 x 23.8 cm).
*Plate 151*②

Murray Hill Hotel from Park Avenue and 40th Street, 1935. Gelatin silver print. 9⁷/₁₆ x 7⁹/₁₆ in. (24 x 19.2 cm)②

Flam and Flam, New York City, 1936. Gelatin silver print. 9⁹/₁₆ x 7⁵/₈ in. (24.3 x 19.4 cm). *Plate 33*①

Ansel Adams American, 1902–1984
Taos, New Mexico, ca. 1929. Gelatin silver print.
5⁷/₈ x 7⁷/₈ in. (14.9 x 20 cm). *Plate 145*②

Robert Adams American, born 1937
Longmont, Colorado, 1973. Gelatin silver print.
6 x 6 in. (15.2 x 15.2 cm). *Plate 214*②

Northglenn, Colorado, 1973. Gelatin silver print.
6 x 7⁵/₈ in. (15.2 x 19.4 cm). *Plate 213*②

Gioacchino Altobelli Italian, ca. 1820–ca. 1879
Fontana dell'Accademia di Francia—Villa Medici (Fountain of the French Academy—Villa Medici), ca. 1859–64. Albumen print from a glass negative.
10¹/₁₆ x 14⁷/₈ in. (25.6 x 37.8 cm). *Plate 65*②

James Anderson British, 1813–1877
Tombeau de Cécilia Metella, via Appia Antica, Rome (Tomb of Cecilia Metella, via Appia Antica, Rome), ca. 1857. Albumen print from a glass negative.
13⁹/₁₆ x 12⁷/₁₆ in. (34.4 x 31.6 cm). *Plate 29*②

Diane Arbus American, 1923–1971
Two Friends in the Park, N.Y.C., 1965. Gelatin silver print. 9¹/₄ x 9⁵/₈ in. (23.5 x 24.4 cm). *Plate 204*①

Transvestite on a couch, N.Y.C., 1966. Gelatin silver print. 14⁷/₈ x 14⁷/₈ in. (37.8 x 37.8 cm)①

George Armistead and Henry White
American, active 1860s; British, 1819–1903
Group of Confederates Killed by a Shell, Vicksburg, July 3, 1863, 1863. Salt print from a glass negative.
5¹⁵/₁₆ x 8 in. (15.1 x 20.3 cm). *Plate 4*②

Eugène Atget French, 1857–1927
Route, Amiens, ca. 1895. Gold-toned printing-out paper print. 8 x 6⁵/₈ in. (20.3 x 16.8 cm)②

Au Griffon, 10, rue de Buci (At the Griffon, 10 rue de Buci), 1911. Gold-toned printing-out paper print.
8⁵/₈ x 7 in. (21.9 x 17.8 cm)②

Saules, 1921. Gold-toned printing-out paper print.
8¹/₂ x 7 in. (21.6 x 17.8 cm). *Plate 129*②

Coin rue Valette (Corner of rue Valette), 1923.
Albumen print from a glass negative. 8⁵/₈ x 7 in.
(21.9 x 17.8 cm)②

Nôtre-Dame, 1923. Arrowroot print. 9 x 6⁷/₈ in.
(22.9 x 17.5 cm)②

Rue des Chantres, 1923. Gold-toned printing-out paper print. 8⁵/₈ x 7 in. (21.9 x 17.8 cm). *Plate 126*②

Boutique—Fleurs—rue de Vaugirard (Shop—Flowers—rue de Vaugirard), ca. 1923–24.
Arrowroot print. 9 x 6⁷/₈ in. (22.9 x 17.5 cm).
*Plate 127*②

Rue du Mont-Cenis, maison de musette (Rue du Mont-Cenis, Dance Hall), 1924. Gold-toned printing-out paper print. 8³/₄ x 6³/₄ in. (22.2 x 17.2 cm)②

Château de la Reine Blanche, rue des Gobelins, 1925.
Gold-toned printing-out paper print. 6⁷/₈ x 8⁷/₈ in.
(17.5 x 22.5 cm)②

La Marne, La Varenne, 1925. Gold-toned printing-out paper print. 6⁵/₈ x 8⁷/₈ in. (16.8 x 22.5 cm).
*Plate 125*②

Pont Neuf, 1925. Gold-toned printing-out paper print. 6¹⁵/₁₆ x 8⁷/₈ in. (17.6 x 22.5 cm). *Plate 124*②

Saint-Denis, canal, ca. 1925–27. Gold-toned printing-out paper print. 7 x 8³/₄ in. (17.8 x 22.2 cm).
*Plate 128*②

Édouard Baldus French, born Germany,
1813–1889
Amiens (vue générale) (Amiens [General View]), 1855.
Salt print from a paper negative. 12¹/₈ x 17⁵/₁₆ in.
(30.8 x 44 cm). *Plate 59*③

Creil, 1855. Salt print from a paper negative.
12¹¹/₁₆ x 17⁷/₁₆ in. (32.2 x 44.3 cm). *Plate 58*②

Gare de Longueau (Longueau Station), 1855.
Salt print from a paper negative. 13¹/₄ x 17¹/₄ in.
(33.7 x 43.8 cm)③

Viaduc de La Voulte (Viaduct at La Voulte), from the album *Chemins de Fer de Paris à Lyon et à la Méditerranée* (Railroads from Paris to Lyon and to the Mediterranean), 1861 or later. Albumen print from a glass negative. 9³/₄ x 16¹/₂ in. (24.8 x 41.9 cm)④

Lewis Baltz American, born 1945
South Wall, Mazda Motors, 2121 East Main Street, Irvine, from the series *The New Industrial Parks near Irvine, California*, 1974. Gelatin silver print. 6 x 9 in.
(15.2 x 22.9 cm). *Plate 212*①

George N. Barnard American, 1819–1902
Destruction of Hood's Ordnance Train and Ruins of Rolling Mill, Atlanta, Georgia, plate forty-four from the album *Photographic Views of Sherman's Campaign*, 1864. Albumen print. 10¹/₁₆ x 14¹/₁₆ in. (25.6 x 35.7 cm)②

Rebel Works in Front of Atlanta, Georgia, no. 1, plate thirty-nine from the album *Photographic Views of Sherman's Campaign*, 1864. Albumen print.
10¹/₈ x 14¹/₈ in. (25.7 x 35.9 cm). *Plate 86*②

Ruins of the Railroad Depot, Charleston, South Carolina, plate sixty-one from the album *Photographic Views of Sherman's Campaign*, 1865. Albumen print.
10¹/₈ x 14¹/₄ in. (25.7 x 36.2 cm). *Plate 30*②

Ruins in Charleston, South Carolina, plate sixty from the album *Photographic Views of Sherman's Campaign*, ca. 1865–66. Albumen print. 10¹/₈ x 14¹/₈ in.
(25.7 x 35.9 cm). *Plate 87*③

Hippolyte Bayard French, 1801–1887
Église à Louviers (Church, Louviers), 1851. Salt print.
7⁵/₈ x 10¹/₄ in. (19.4 x 26 cm). *Plate 54*①

Ilse Bing American, born Germany, 1899–1998
Champ-de-Mars, vue de la Tour Eiffel (Champ-de-Mars, View from the Eiffel Tower), 1931. Gelatin silver print. 8³/₄ x 11¹/₈ in. (22.2 x 28.3 cm). *Plate 31*①

Greta Garbo Poster, Paris, 1932. Gelatin silver print.
10³/₁₆ x 13³/₈ in. (25.9 x 34 cm). *Plate 174*②

Félix Bonfils French, 1831–1885
Piscine probatique, Jerusalem (Pool of Bethesda, Jerusalem), 1870s. Albumen print from a glass negative. 11³/₈ x 15³/₈ in. (28.9 x 39.1 cm). *Plate 63*①

Henry P. Bosse American, 1844–1903
DeSoto, Wisconsin, from the album *Views of the Mississippi River,* 1891. Cyanotype. 10 5/8 x 13 7/16 in. (27 x 34.1 cm) ②

Margaret Bourke-White American, 1904–1971
Ammonia Storage Tanks, I. G. Farben, 1930. Gelatin silver print. 13 x 9 1/8 in. (33 x 23.2 cm). *Plate 149* ①

Chrysler Building: Tower, 1931. Gelatin silver print. 5 1/2 x 3 3/4 in. (14 x 9.5 cm). *Plate 150* ②

Mathew B. Brady American, 1823–1896
View of Richmond, Virginia, ca. 1865. Albumen stereo view. 3 15/16 x 9 3/4 in. (10 x 24.8 cm). *Plate 85* ②

Bill Brandt British, 1904–1983
Northern Suburb, 1933. Gelatin silver print. 9 x 7 3/4 in. (22.86 x 19.7 cm) ②

Camden Hill, London, 1947. Gelatin silver print. 9 x 7 5/8 in. (22.9 x 19.4 cm). *Plate 178* ①

Brassaï (Gyula Halász) French, born Hungary, 1899–1984
Groupe joyeux au bal musette des Quatre Saisons, rue de Lappe (Happy Group at the Four Seasons Ball, rue de Lappe), ca. 1932, printed ca. 1948–55. Gelatin silver print. 9 3/8 x 11 13/16 in. (23.8 x 30 cm). *Plate 183* ②

Plane Tree, Paris, 1945. Gelatin silver print. 11 5/8 x 8 in. (29.5 x 20.3 cm) ②

Martin Bruehl American, born Australia, 1895–1980
Untitled [Grain Elevator], ca. 1932. Gelatin silver print. 8 1/8 x 6 1/8 in. (20.6 x 15.6 cm). *Plate 154* ②

David W. Butterfield American, 1844–1933
Untitled [New England Houses], 1870s. Albumen print from a glass negative. 16 1/4 x 20 5/16 in. (41.3 x 51.6 cm). *Plate 92* ②

Harry Callahan American, 1912–1999
Detroit, 1943. Gelatin silver print. 3 5/8 x 5 1/4 in. (9.2 x 12.7 cm) ①

Chicago, ca. 1948, printed ca. 1965. Gelatin silver print. 9 5/8 x 7 5/8 in. (24.4 x 19.4 cm). *Plate 185* ②

Eleanor and Barbara, Chicago, ca. 1954. Gelatin silver print. 7 5/8 x 10 in. (19.4 x 25.4 cm) ①

Julia Margaret Cameron British, 1815–1879
After Perugino; the Annunciation, 1865. Albumen print from a glass negative. 13 1/4 x 11 in. (33.7 x 27.9 cm). *Plate 53* ①

Annie Chinery Cameron, 1873. Albumen print. 12 3/4 x 10 7/8 in. (32.4 x 27.6 cm) ①

Lewis Carroll British, 1832–1898
Brook and Hugh Kitchin, 1876. Albumen print from a glass negative. 5 13/16 x 4 11/16 in. (14.8 x 11.9 cm). *Plate 51* ①

Henri Cartier-Bresson French, 1908–2004
Self-Portrait, 1933. Gelatin silver print. 6 5/8 x 9 7/8 in. (16.8 x 25.1 cm). *Plate 179* ②

Désiré Charnay French, 1828–1915
Maison du curé — Mitla, Oaxaca (Priest's House — Mitla, Oaxaca), 1859. Albumen print from a glass negative. 10 5/8 x 15 3/4 in. (27 x 40 cm). *Plate 79* ②

Charles Clifford British, 1819–1863
Sevilla: Torre del Oro (Seville: Tower of Gold), 1862. Albumen print from a glass negative. 11 1/4 x 16 3/4 in. (28.6 x 42.5 cm). *Plate 69* ③

Alvin Langdon Coburn British, born United States, 1882–1966
Untitled [Twilight Study], ca. 1910. Platinum print. 6 5/16 x 7 13/16 in. (16 x 19.8 cm). *Plate 113* ①

Ralston Crawford American, born Canada, 1906–1978
Grain Elevators, Buffalo, 1942. Gelatin silver print. 6 5/16 x 9 3/16 in. (16 x 23.3 cm) ②

Imogen Cunningham American, 1883–1976
Yreka, 1929. Gelatin silver print. 9 x 7 1/2 in. (22.9 x 19.1 cm). *Plate 144* ①

Ventilators, Fageol Factory, Oakland, 1934. Gelatin silver print. 7 x 9 in. (17.8 x 22.9 cm). *Plate 153* ①

Bill Dane American, born 1938
New Orleans, 1974. Gelatin silver print. 12 7/8 x 8 5/8 in. (32.7 x 21.9 cm). *Plate 216* ①

William Edward Dassonville American, 1879–1957
The Russ Building, San Francisco, 1925. Gelatin silver print. 10 x 8 in. (25.4 x 20.3 cm). *Plate 121* ①

Bruce Davidson American, born 1933
Untitled, from the series *Welsh Miners,* 1965. Gelatin silver print. 6 x 9 in. (15.2 x 22.9 cm). *Plate 189* ②

Gustave de Beaucorps French, 1825–1906
Ponte Vecchio, Florence, 1856. Paper negative. 11 1/2 x 14 7/8 in. (29.2 x 37.8 cm) ②

Ernest de Caranza French, born 1837 (death date unknown)
Untitled [Harbor Scene, Turkey], 1854. Salt print from a paper negative. 6 11/16 x 8 13/16 in. (17 x 22.4 cm). *Plate 64* ③

Roy De Carava American, born 1919
Apartment for Rent, 1977. Gelatin silver print. 8 15/16 x 8 3/16 in. (22.7 x 20.8 cm). *Plate 202* ①

Louis De Clercq French, 1836–1901
Kalaat el Hosn, première enceinte midi (Krak of the Knights, First Southern Enclosure), 1859. Albumen print from a paper negative. 8 5/16 x 22 1/4 in. (21.1 x 56.5 cm). *Plate 66* ③

Robert Demachy French, 1859–1937
Untitled [French Cottage], ca. 1910. Oil transfer print. 6 5/8 x 9 in. (16.8 x 22.9 cm). *Plate 114* ②

André Adolphe-Eugène Disdéri French, 1819–1889
Paris Commune, 1871. Albumen print from a glass negative. 8 5/8 x 11 3/8 in. (21.9 x 28.9 cm) ①

Louis-Emile Durandelle French, 1839–1917
Construction of Sacré-Coeur, 1879. Albumen print from a glass negative. 13 1/2 x 17 1/8 in. (34.3 x 43.5 cm). *Plate 5* ③

Eugène Durieu French, 1800–1874
Untitled [Female Nude], 1850s. Albumen print from a glass negative. 8 x 5 1/8 in. (20.3 x 13 cm). *Plate 52* ①

Thomas Eakins American, 1844–1916
The Crowell Children at Saint Peter's Village, ca. 1880–83. Albumen print. 5 x 3 3/4 in. (12.7 x 9.5 cm) ①

Robert Eaton British, 1819–1871
Roman Forum, 1853. Salt print from a glass negative. 10 x 7 3/8 in. (25.4 x 18.7 cm). *Plate 75* ①

William Eggleston American, born 1939
Untitled, the Southwestern Grill, 1967. Gelatin silver print. 8 1/2 x 5 1/2 in. (21.6 x 14 cm). *Plate 203* ①

Peter Henry Emerson British, born Cuba, 1856–1936
Cutting the Gladdon, plate XXXII from the book *Life and Landscape on the Norfolk Broads,* 1886. Platinum print. 7 7/16 x 9 7/16 in. (18.9 x 24 cm). *Plate 112* ②

A Rushy Shore, plate XXXV from the book *Life and Landscape on the Norfolk Broads,* 1886. Platinum print. 7 1/2 x 11 3/16 in. (19.1 x 28.4 cm). *Plate 111* ②

Morris Engel American, born 1918
Shoeshine Boy with Cop, 1947. Gelatin silver print. 13 3/8 x 10 3/8 in. (34 x 26.4 cm). *Plate 161* ②

Elliott Erwitt American, born 1928
New York City, 1953. Gelatin silver print. 4 5/8 x 6 5/8 in. (11.7 x 16.8 cm). *Plate 197* ①

Walker Evans American, 1903–1975
New York City, ca. 1928–29. Gelatin silver print.
3 9/16 x 2 1/4 in. (9.1 x 5.7 cm)②

We Are Building a New and Greater Bloomingdale's,
ca. 1929–30. Gelatin silver print. 9 7/8 x 8 1/8 in.
(25.1 x 20.6 cm). *Plate 165*②

South Street, New York City, 1934. Gelatin silver print.
7 3/16 x 5 1/2 in. (18.3 x 14 cm). *Plate 16*②

Alabama Cotton Tenant Farmer Family, 1936. Gelatin
silver print. 7 9/16 x 9 9/16 in. (19.2 x 24.3 cm).
*Plate 131*②

Fireplace, Burroughs House, Hale County, Alabama,
1936. Gelatin silver print. 9 5/8 x 7 5/8 in. (24.4 x
19.4 cm). *Plate 130*①

George R. Fardon British, 1806–1886
East Side of Montgomery Street, from *San Francisco
Album: Photographs of the Most Beautiful Views and Public
Buildings of San Francisco*, 1856. Salt print from a glass
negative. 6 1/4 x 7 1/2 in. (15.9 x 19.1 cm). *Plate 97*①

Louis Faurer American, 1916–2001
Untitled [Street Scene], 1940. Gelatin silver print.
9 x 13 1/8 in. (22.9 x 33.3 cm). *Plate 164*①

Andreas Feininger American, born France,
1906–1999
*New York, South Street, Corner of Roosevelt Street
and Brooklyn Bridge*, 1940. Gelatin silver print.
9 3/4 x 7 5/8 in. (24.8 x 19.4 cm). *Plate 23*②

Roger Fenton British, 1819–1869
On the Wye, ca. 1855. Salt print from a glass negative.
7 1/4 x 9 1/8 in. (18.4 x 23.2 cm). *Plate 60*②

L'entente cordiale (The Cordial Agreement), 1856.
Salt print. 6 3/8 x 6 1/2 in. (16.2 x 16.5 cm)②

Head of Harbour, Balaklava, 1856. Salt print from
a glass negative. 8 x 10 1/16 in. (20.3 x 25.6 cm).
*Plate 70*②

Robert Frank American, born Switzerland, 1924
Men of Air, New York, 1947. Gelatin silver print.
13 1/2 x 9 1/4 in. (34.3 x 23.5 cm). *Plate 194*②

London Bankers, 1951. Gelatin silver print.
8 3/4 x 12 5/8 in. (22.2 x 32.1 cm). *Plate 193*②

London, ca. 1951–52. Gelatin silver print.
10 3/8 x 11 9/16 in. (26.4 x 29.4 cm)②

Wales, Ben James, 1953. Gelatin silver print.
9 1/8 x 13 1/2 in. (23.2 x 34.3 cm). *Plate 192*①

Jean Baptiste Frénet French, 1814–1889
Untitled [Man on Horseback], 1855. Salt print.
6 7/8 x 9 1/4 in. (17.5 x 23.5 cm). *Plate 41*①

Lee Friedlander American, born 1934
Newark, New Jersey, 1962. Gelatin silver print.
5 5/8 x 8 1/2 in. (14.3 x 21.6 cm). *Plate 206*②

Baltimore, 1968. Gelatin silver print. 6 x 9 1/8 in.
(15.2 x 23.2 cm). *Plate 207*②

Paul Tate, Lafayette, Louisiana, 1968. Gelatin silver
print. 5 1/2 x 8 1/4 in. (14 x 21 cm). *Plate 205*②

Route 9W, New York, 1969. Gelatin silver print.
7 x 10 1/2 in. (17.8 x 26.7 cm). *Plate 208*②

Francis Frith British, 1822–1898
The Rameseum of El-Kurneh, Thebes — First View,
ca. 1857. Albumen print from a glass negative.
15 3/8 x 17 3/4 in. (39.1 x 45.1 cm). *Plate 72*③

The Hypaethral Temple, Philae, 1858. Albumen print
from a glass negative. 15 x 19 in. (38.1 x 48.3 cm)②

Pyramids of El-Geezah from the Southwest, 1858.
Albumen print from a glass negative. 13 x 19 in.
(33 x 48.3 cm)③

The Second Pyramid from the Southeast, 1858.
Albumen print from a glass negative. 15 x 18 7/8 in.
(38.1 x 47.9 cm). *Plate 71*②

Alexander Gardner American, born Scotland,
1821–1882
Ruins of Arsenal, Richmond, Virginia, from the album
Photographic Sketchbook of the Civil War, 1865.
Albumen print. 6 13/16 x 8 7/8 in. (17.3 x 22.5 cm).
*Plate 89*①

William Gedney American, 1933–1989
Kentucky, 1964. Gelatin silver print. 10 3/4 x 7 1/4 in.
(27.3 x 18.4 cm). *Plate 198*①

Arnold Genthe American, born Germany,
1869–1942
Vegetable Peddler, Old Chinatown, San Francisco,
ca. 1895–1906. Gelatin silver print. 8 5/8 x 12 1/2 in.
(21.9 x 31.8 cm). *Plate 123*②

Laura Gilpin American, 1891–1979
Taos Ovens, New Mexico, 1926. Platinum print.
8 5/8 x 6 13/16 in. (21.9 x 17.3 cm). *Plate 140*②

Nan Goldin American, born 1953
Ivy in the Garden; back, Boston, 1973, printed later.
Gelatin silver print. 18 11/16 x 12 7/16 in. (47.5 x
31.6 cm). *Plate 209*②

John Beasley Greene American, born France,
1832–1856
Untitled [Clifftop Town], 1850s. Salt print.
9 3/8 x 12 in. (23.8 x 30.5 cm). *Plate 76*②

John Gutmann American, born Germany,
1905–1998
Two Girls, 1935. Gelatin silver print. 9 7/16 x 7 11/16 in.
(24 x 19.5 cm). *Plate 163*②

The Monkey, San Francisco, 1938. Gelatin silver print.
9 5/16 x 6 15/16 in. (23.7 x 17.6 cm). *Plate 17*②

Johan Hagemeyer American, 1884–1962
Cypress Trees, Telegraph Hill, San Francisco, 1925.
Gelatin silver print. 9 1/16 x 6 9/16 in. (23 x 16.7 cm).
*Plate 120*②

Miroslav Hak Czech, 1911–1977
Ve dvore (In the Courtyard), 1942. Gelatin silver
print. 9 1/8 x 6 7/8 in. (23.2 x 17.5 cm). *Plate 186*②

**Sergeant Harrold and the Royal Corps of
Engineers** British, active 1860s
Abyssinian Dwellings, 1868. Albumen print from a
glass negative. 7 5/8 x 10 1/8 in. (19.4 x 25.7 cm).
*Plate 62*①

Frank Jay Haynes American, 1853–1921
Gloster Mill, 60 Stamps, 24 Pans, 12 Settlers, ca. 1885.
Albumen print from a glass negative. 17 1/8 x 21 13/16 in.
(43.5 x 55.4 cm). *Plate 96*②

Granite Silver Mine, Montana Territory, 1887.
Albumen print from a glass negative. 16 7/8 x 21 1/2 in.
(42.9 x 54.6 cm). *Plate 26*③

Florence Henri Swiss, born United States,
1893–1982
Paris, 1930. Gelatin silver print. 9 x 6 13/16 in.
(22.9 x 17.3 cm). *Plate 172*②

David Octavius Hill and Robert Adamson
Scottish, 1802–1870; Scottish, 1821–1848
The Artist and the Gravedigger [Greyfriars'
Churchyard, the Dennistoun Monument with D. O.
Hill, His Nieces the Misses Watson, and an Unknown
Man], ca. 1843–47. Salt print from a paper negative.
8 3/8 x 6 1/2 in. (21.3 x 16.5 cm). *Plate 1*③

*Bonaly Towers with a Group of Ten, Including John
Henning, Mrs. Cockburn, Mrs. Cleghorn, and D. O. Hill*,
ca. 1843–47. Salt print from a paper negative.
8 1/4 x 6 1/8 in. (21 x 15.6 cm)②

Miss Crampton of Dublin, ca. 1843–47. Salt print
from a paper negative. 8 1/16 x 6 in. (20.5 x 15.2 cm).
*Plate 40*③

Misses Grierson, ca. 1843–47. Salt print from a paper
negative. 8 x 6 1/8 in. (20.3 x 15.6 cm)①

*Professor Alexander Campbell Fraser, Reverend James
Walker, Reverend Robert Taylor, Reverend John Murray,
Reverend Doctor William Welsh, and Reverend Doctor
John Nelson*, ca. 1843–47. Salt print from a paper neg-
ative. 9 1/2 x 12 7/8 in. (24.1 x 32.7 cm). *Plate 42*①

Humphrey Lloyd Hime Canadian, born Ireland, 1833–1903
Birch Bark Tents, West Bank of Red River, Middle Settlement, 1858. Albumen print. 5 3/8 x 6 13/16 in. (13.7 x 17.3 cm). *Plate 100* ②

Lewis Wickes Hine American, 1874–1940
Italian Family Looking for Lost Baggage, Ellis Island, New York, 1905. Gelatin silver print. 9 1/4 x 6 1/2 in. (23.5 x 16.5 cm) ②

Italian Immigrant, East Side, New York City, 1910. Gelatin silver print. 4 7/8 x 6 13/16 in. (12.4 x 17.3 cm). *Plate 107* ②

A Waif in Orphan Asylum near Pittsburgh, 1910. Gelatin silver print. 7 x 5 in. (17.8 x 12.7 cm) ②

Empire State Building Construction, 1931. Gelatin silver print. 3 3/4 x 4 3/8 in. (9.5 x 11.1 cm). *Plate 148* ①

Morris Huberland American, born 1909
Bonwit Teller, Fifth Avenue, New York City, ca. 1950. Gelatin silver print. 7 1/2 x 8 15/16 in. (19.1 x 22.7 cm). *Plate 160* ②

Louis-Adolphe Humbert de Molard French, 1800–1874
Untitled [Men Dressing a Hog], ca. 1846. Paper negative. 9 x 7 1/4 in. (22.9 x 18.4 cm) ①

Untitled [Two Men Sitting under a Pergola], ca. 1847. Paper negative. 9 1/2 x 7 1/8 in. (24.1 x 18.1 cm). *Plate 3* ①

William Henry Jackson American, 1843–1942
Pulpit Rock, Echo Canyon, Utah, ca. 1869. Albumen print from a glass negative. 7 x 9 3/8 in. (17.8 x 23.8 cm). *Plate 99* ②

Leadville, ca. 1880. Albumen print from a glass negative. 17 1/4 x 21 3/8 in. (43.8 x 54.3 cm). *Plate 103* ②

Thomas Johnson American, active 1860s
Inclined Plane, ca. 1865. Albumen print from a glass negative. 12 1/8 x 16 1/16 in. (30.8 x 40.8 cm). *Plate 94* ①

Calvert Richard Jones Welsh, 1802–1877
Colosseum, Rome, Second View, 1846. Salt print. 7 3/4 x 9 3/4 in. (19.7 x 24.8 cm). *Plate 24* ③

Street Scene in Valetta, Malta, 1846. Salt print from a paper negative. 8 5/16 x 5 15/16 in. (21.1 x 15.1 cm). *Plate 47* ②

Street Scene in Valetta, Malta, 1846. Paper negative. 8 5/16 x 5 15/16 in. (21.1 x 15.1 cm). *Plate 48* ②

André Kertész American, born Hungary, 1894–1985
Wine Cellars at Budafok, Hungary, 1919. Gelatin silver print. 1 1/2 x 2 1/8 in. (3.8 x 5.4 cm). *Plate 21* ②

Rue Vavin, Paris, 1925. Gelatin silver print. 9 15/16 x 7 7/8 in. (25.2 x 20 cm). *Plate 169* ②

William Klein American, born 1928
Xmas Shopping near Macy's, New York, 1954, printed 1956. Gelatin silver print. 11 3/4 x 15 3/4 in. (29.8 x 40 cm). *Plate 195* ②

Entrance, Ostia Beach, near Rome, 1956. Gelatin silver print. 10 7/8 x 14 5/8 in. (27.6 x 37.1 cm). *Plate 196* ①

Gustav Klutsis Russian, 1895–1944
Design for *My nash — my novi mir postroim* (We Will Build Our Own New World), 1930. Gelatin silver print. 4 5/8 x 3 3/8 in. (11.8 x 8.6 cm) ①

Josef Koudelka Czech, born 1938
Nitra, 1968. Gelatin silver print. 8 7/16 x 12 13/16 in. (21.4 x 32.5 cm). *Plate 191* ②

Germaine Krull Polish, 1897–1985
La Tour Eiffel (The Eiffel Tower), ca. 1928. Gelatin silver print. 9 1/8 x 6 1/16 in. (23.2 x 15.4 cm). *Plate 166* ②

Heinrich Kühn Austrian, 1866–1944
Landscape with Boat and Trees, 1897. Gum bichromate print. 5 1/2 x 13 1/4 in. (14 x 33.7 cm) ①

Mary and Lotte, Innsbruck-Tyrol, 1908. Gum bichromate print. 9 1/8 x 11 1/2 in. (23.2 x 29.2 cm). *Plate 115* ②

Paul Kwilecki American, born 1928
Ms. Tomlinson in the House of Tomatoes, 1974. Gelatin silver print. 12 1/2 x 8 5/8 in. (31.8 x 21.9 cm). *Plate 219* ①

Dorothea Lange American, 1895–1965
Policeman on Street, San Francisco, 1934. Gelatin silver print. 8 1/8 x 5 1/4 in. (20.6 x 13.3 cm). *Plate 132* ①

Filipinos Cutting Lettuce, Salinas Valley, California, 1935. Gelatin silver print. 7 3/4 x 9 1/2 in. (19.7 x 24.1 cm). *Plate 134* ①

Tractored Out, Childress County, Texas, 1938. Gelatin silver print. 9 15/16 x 13 in. (25.2 x 33 cm). *Plate 133* ②

Jacques Henri Lartigue French, 1894–1986
La mode — avenue du Bois (Fashion — avenue du Bois), 1915. Gelatin silver print. 4 1/2 x 4 15/16 in. (11.4 x 12.5 cm) ①. *Plate 9* ②

Renée Perle, Leaning on Motorcar, Le Mans, ca. 1930–32. Gelatin silver print. 3 1/4 x 5 in. (8.3 x 12.7 cm) ②

Clarence John Laughlin American, 1905–1985
The Oak Arch, Woodlawn Plantation, 1945. Gelatin silver print. 14 5/16 x 18 7/8 in. (36.4 x 47.9 cm). *Plate 11* ②

Gustave Le Gray French, 1820–1882
Maneuvers, Camp de Châlons, 1857. Albumen print from a glass negative. 11 5/8 x 13 7/16 in. (29.5 x 34.1 cm). *Plate 68* ③

The Steamer Saïd, *Sète,* 1857. Albumen print from a glass negative. 9 1/2 x 15 13/16 in. (24.1 x 40.2 cm). *Plate 67* ③

Henri Jean-Louis Le Secq French, 1818–1882
Untitled [Study of Chartres Cathedral], 1852. Salt print. 13 7/16 x 8 7/8 in. (34.1 x 22.5 cm). *Plate 43* ①

Helen Levitt American, born 1918
New York, ca. 1939. Gelatin silver print. 3 1/4 x 2 1/8 in. (8.3 x 5.4 cm). *Plate 158* ①

New York, 1939. Gelatin silver print. 5 15/16 x 8 13/16 in. (15.1 x 22.4 cm). *Plate 159* ②

New York, 1939. Gelatin silver print. 9 x 5 15/16 in. (22.9 x 15.1 cm). *Plate 18* ②

New York, ca. 1942. Gelatin silver print. 6 5/8 x 9 1/2 in. (16.8 x 24.1 cm). *Plate 157* ①

El Lissitzky Russian, 1890–1941
Der Läufer (Rekord) (The Runner [Record]), ca. 1926. Gelatin silver print. 4 3/4 x 3 7/8 in. (12.1 x 9.8 cm) ①

Design for *SSSR na stroike* (USSR under Construction), ca. 1930. Gelatin silver print. 10 5/8 x 7 1/8 in. (27 x 18.1 cm). *Plate 175* ①

Danny Lyon American, born 1942
Untitled, from the series *The Destruction of Lower Manhattan,* 1968. Gelatin silver print. 7 7/16 x 7 7/16 in. (18.9 x 18.9 cm). *Plate 218* ②

Dora Maar French, 1907–1997
Le simulateur (The Pretender), 1936. Gelatin silver print. 11 1/2 x 9 in. (29.2 x 22.9 cm). *Plate 180* ②

Robert MacPherson Scottish, 1811–1872
The Campagna near Rome, 1850s. Albumen print. 8 11/16 x 15 3/8 in. (22.1 x 39.1 cm) ①

Teatro di Marcello a Roma (Theater of Marcellus in Rome), ca. 1859. Albumen print. 15 3/4 x 10 7/8 in. (40 x 27.6 cm) ①

Rocca Pia, Tivoli, ca. 1860. Albumen print. 12 1/16 x 15 3/8 in. (30.6 x 39.1 cm). *Plate 73* ②

Man Ray American, 1890–1976
Untitled, from the film *Emak Bakia*, 1926. Gelatin silver print. 5 1/4 x 6 in. (13.3 x 15.2 cm). *Plate 173* ①

Mannequin de Man Ray (Man Ray's Mannequin), 1938. Gelatin silver print. 9 1/8 x 6 5/8 in. (23.2 x 16.8 cm) ①

Werner Mantz German, 1901–1983
Siedlung Köln-Kalkerfeld, Wohnblöcke in der Heidelberger Strasse (Cologne-Kalkerfeld Housing Project, Residential Blocks on Heidelberger Strasse), 1930. Gelatin silver print. 15 1/4 x 11 3/8 in. (38.7 x 28.9 cm). *Plate 171* ①

Charles Marville French, 1816–1879
Bois de Boulogne, ca. 1853–58. Albumen print from a paper negative. 13 13/16 x 10 5/16 in. (35.1 x 26.2 cm). *Plate 57* ①

Rue de la Montagne-Sainte-Geneviève. Vue prise vers l'église Saint-Étienne-du-Mont. À droite, la rue de l'École-Polytechnique (Rue de Montagne-Sainte-Geneviève. View Taken toward the Church of Saint-Étienne-du-Mont. On the Right, the rue de l'École-Polytechnique), 1868. Albumen print. 11 3/8 x 10 7/16 in. (28.9 x 26.5 cm). *Plate 56* ①

Gordon Matta-Clark American, 1943–1978
New York City, from the project *Wallspaper*, 1972. Gelatin silver print. 16 x 22 7/8 in. (40.6 x 58.1 cm). *Plate 217* ①

Ralph Eugene Meatyard American, 1925–1972
Lucybelle Crater and her charmingly youthful mother-in-law Lucybelle, ca. 1970–72. Gelatin silver print. 7 9/16 x 7 5/8 in. (19.2 x 19.4 cm). *Plate 215* ①

Susan Meiselas American, born 1948
Lena on the Bally Box, Essex Junction, Vermont, from the series *Carnival Strippers*, 1973. Gelatin silver print. 8 x 11 7/8 in. (20.3 x 30.2 cm) ①

Ray K. Metzker American, born 1931
Philly Walk, 1965. Five gelatin silver prints. 17 3/8 x 16 5/16 in. (44.1 x 41.4 cm) overall. *Plate 184* ①

Lee Miller American, 1907–1977
Walkway, Paris, ca. 1929. Gelatin silver print. 9 x 11 5/8 in. (22.9 x 29.5 cm). *Plate 170* ②

Lisette Model American, born Austria, 1901–1983
Fifth Avenue, 1950s. Gelatin silver print. 13 9/16 x 10 13/16 in. (34.5 x 27.5 cm). *Plate 162* ②

Tina Modotti American, born Italy, 1896–1942
Convent of Tepotzotlán, Mexico, 1924. Platinum print. 4 5/8 x 3 5/8 in. (11.7 x 9.2 cm). *Plate 141* ②

László Moholy-Nagy American, born Hungary, 1894–1946
Helsinki, 1930. Gelatin silver print. 15 1/8 x 11 1/4 in. (38.4 x 28.6 cm). *Plate 181* ③

Frederick Monsen American, born Norway, 1865–1929
Acoma Pueblo, ca. 1906. Gelatin silver print. 17 1/4 x 23 13/16 in. (43.8 x 60.5 cm) ②

Wright Morris American, 1910–1998
Home Place [Model T Steering Wheel], 1947. Gelatin silver print. 7 3/4 x 9 5/8 in. (19.7 x 24.4 cm). *Plate 137* ②

Untitled [Scythe by Shed], 1947. Gelatin silver print. 7 3/4 x 9 5/8 in. (19.7 x 24.4 cm). *Plate 138* ②

Untitled [Interior through Screen Window], ca. 1947. Gelatin silver print. 9 3/8 x 7 3/4 in. (23.8 x 19.7 cm). *Plate 139* ②

Martin Munkacsi Hungarian, 1896–1963
Aerial View of Pest, 1926. Gelatin silver print. 12 x 8 1/4 in. (30.5 x 21 cm). *Plate 177* ①

John Murray Scottish, 1809–1898
Kaiser Pasund, Lucknow, 1850s. Paper negative. 15 3/8 x 20 7/8 in. (39.1 x 53 cm) ②

Akbar's Tomb, Sikandra, ca. 1856. Paper negative. 14 1/2 x 18 3/16 in. (36.8 x 46.2 cm) ①

Eadweard Muybridge American, born England, 1830–1904
Panorama of San Francisco from California Street Hill, 1878. Thirteen albumen prints from glass negatives. Each: 20 x 15 1/2 in. (50.8 x 39.4 cm). *Plate 106* ①

Charles Nègre French, 1820–1880
Arles, remparts romains (Arles, Roman Ramparts), 1852. Salt print from a paper negative. 9 x 12 5/8 in. (22.9 x 32.1 cm) ①

Portrait d'une femme tenant un pot, au 21, quai de Bourbon (Woman Holding a Pot, 21 quai de Bourbon), 1852. Salt print from a paper negative. 7 1/4 x 5 1/8 in. (18.4 x 13 cm). *Plate 45* ①

Portrait d'une femme tenant un pot, au 21, quai de Bourbon (Woman Holding a Pot, 21 quai de Bourbon), 1852. Paper negative. 7 5/8 x 6 in. (19.4 x 15.2 cm). *Plate 46* ①

Timothy H. O'Sullivan American, born Ireland, 1840–1882
Fugitive Negro Family Fording Rappahannock River, near Farquier Court House, Virginia, 1862. Three albumen prints mounted to board. 10 1/16 x 12 in. (25.6 x 30.5 cm) overall. *Plate 84* ②

Ruins in Ancient Pueblo of San Juan, Colorado, 1874. Albumen print. 8 x 10 13/16 in. (20.3 x 27.5 cm). *Plate 101* ①

Paul Outerbridge American, 1896–1958
Semi-Abstraction of Columbus Circle, New York, 1923. Gelatin silver print. 4 1/8 x 4 7/8 in. (10.5 x 12.4 cm). *Plate 152* ①

Stores for Rent, 1923. Platinum print. 4 1/2 x 3 5/8 in. (11.4 x 9.2 cm) ②

Bill Owens American, born 1938
4th of July Parade, Livermore, California, 1970s. Gelatin silver print. 8 1/2 x 6 in. (21.6 x 15.2 cm). *Plate 220* ①

Gordon Parks American, born 1912
Emerging Man, 1952. Gelatin silver print. 13 7/16 x 10 11/16 in. (34.1 x 27.1 cm). *Plate 190* ①

William Herman Rau American, 1855–1920
Bellwood Station, Pennsylvania Railroad, ca. 1885. Platinum print. 17 1/2 x 21 1/8 in. (44.5 x 53.7 cm). *Plate 93* ②

South Plainfield Cold Storage, Capacity 100,000 Tons, 1890. Albumen print. 17 1/8 x 20 1/2 in. (43.5 x 52.1 cm) ①

Henri-Victor Regnault French, 1810–1878
Old House at Sèvres, ca. 1851. Salt print from a paper negative. 9 x 7 1/2 in. (22.9 x 19.1 cm). *Plate 55* ②

Untitled [View of Sèvres in Snow], ca. 1852. Salt print from a paper negative. 13 x 17 1/8 in. (33 x 43.5 cm) ①

André Philippe Alfred Regnier French, active 1850s–1860s
Château de Moncontour, ca. 1858. Albumen print from a paper negative. 14 3/8 x 18 7/8 in. (36.5 x 47.9 cm). *Plate 7* ②

Albert Renger-Patzsch German, 1897–1966
Essen-Bergeborbeck, from the series *Ruhrgebiet-Landschaften* (Ruhrgebiet Landscapes), 1929. Gelatin silver print. 6 5/8 x 9 in. (16.8 x 22.9 cm) ①

Vorstadt von Essen (Suburb of Essen), from the series *Ruhrgebiet-Landschaften* (Ruhrgebiet Landscapes), 1931. Gelatin silver print. 8 7/8 x 6 5/8 in. (22.5 x 16.8 cm). *Plate 8* ①

Jacob August Riis American, 1849–1914
Shooting Craps: The Game of the Street. Bootblacks and Newsboys, ca. 1895, printed ca. 1946 by Alexander Alland. Gelatin silver print. 7 7/8 x 9 3/4 in. (20 x 24.8 cm). *Plate 108* ②

Alexander Rodchenko Russian, 1891–1956
Courtyard, ca. 1928–30. Gelatin silver print.
5 3/8 x 3 3/8 in. (13.7 x 8.6 cm). *Plate 168* ②

Sawmill Worker, 1930. Gelatin silver print.
9 5/8 x 7 1/8 in. (24.4 x 18.1 cm). *Plate 167* ①

Winter, Teatralnaia Square, 1931. Gelatin silver print.
8 7/8 x 11 3/4 in. (22.5 x 29.9 cm). *Plate 13* ①

Pushkin Square, 1932. Gelatin silver print.
11 3/4 x 9 1/2 in. (29.8 x 24.1 cm). *Plate 13* ①

Arthur Rothstein American, 1915–1985
Soil Erosion, Alabama, 1937. Gelatin silver print.
10 3/8 x 13 1/2 in. (26.4 x 34.3 cm). *Plate 136* ②

Andrew Joseph Russell American, 1830–1902
Untitled [Railroad Bridge, Civil War], 1861. Albumen
print. 11 7/8 x 15 5/8 in. (30.2 x 39.7 cm). *Plate 88* ①

J. F. Ryder American, 1826–1904
Untitled [Train Tracks], 1862. Albumen print. 7 1/2 x
9 1/4 in. (19.1 x 23.5 cm). *Plate 98* ①

Erich Salomon German, 1886–1944
Hague Conference, 1930. Gelatin silver print.
4 1/4 x 6 in. (10.8 x 15.2 cm). *Plate 182* ①

Auguste Salzmann French, 1824–1872
Jérusalem, Vallée de Hinnom, Retraite des Apôtres
(Jerusalem: Valley of Hinnom, Refuge of the
Apostles), 1853. Salt print from a paper negative.
9 1/4 x 13 in. (23.5 x 33 cm) ①

Jérusalem, Vallée de Josaphat, Tombeau de Saint-Jacques
(Jerusalem: Valley of Jehoshaphat, Tomb of Saint
James), ca. 1854–56. Salt print from a paper nega-
tive. 9 3/16 x 12 11/16 in. (23.3 x 32.2 cm). *Plate 77* ②

August Sander German, 1876–1964
Der Arzt (The Doctor) [Carl Robert Schlayer], 1929.
Gelatin silver print. 9 1/4 x 6 1/4 in. (23.5 x 15.9 cm) ①

Trudpert Schneider and Soehne Ehrenstetten
German, active 1840s
Untitled [Workyard behind a Royal Residence],
ca. 1840. Stereo daguerreotype. 2 5/8 x 1 13/16 in.
(6.7 x 4.6 cm). *Plate 35* ①

George Henry Seeley American, 1880–1955
Untitled [Winter Landscape], 1917. Gelatin silver
print. 9 5/8 x 7 5/8 in. (24.4 x 19.4 cm). *Plate 116* ①

Ben Shahn American, born Lithuania, 1898–1969
Street Scene, Marysville, Ohio, 1938. Gelatin silver
print. 6 3/8 x 9 5/8 in. (16.2 x 24.4 cm). *Plate 135* ②

Charles Sheeler American, 1883–1965
Side of White Barn, 1917. Gelatin silver print.
8 x 10 in. (20.3 x 25.4 cm). *Plate 143* ①

Camille-Léon-Louis Silvy French, 1834–1910
Orléans House, Fête Champêtre [Cover Page], 1864.
Albumen print. 8 7/16 x 9 5/8 in. (21.4 x 24.5 cm) ⑤

Orléans House, Fête Champêtre [Page One], 1864.
Albumen print. 4 x 6 7/8 in. (10.2 x 17.5 cm) ⑤

Orléans House, Fête Champêtre [Page Four], 1864.
Albumen print. 3 15/16 x 6 9/16 in. (10 x 16.7 cm).
Plate 49 ⑤

Orléans House, Fête Champêtre [Page Seven], 1864.
Albumen print. 4 3/16 x 6 11/16 in. (10.6 x 17 cm) ⑤

Orléans House, Fête Champêtre [Page Eight], 1864.
Albumen print. 3 15/16 x 6 7/8 in. (10 x 17.5 cm) ⑤

Orléans House, Fête Champêtre [Page Twelve], 1864.
Albumen print. 4 1/16 x 6 7/8 in. (10.3 x 17.5 cm) ⑤

Art Sinsabaugh American, 1924–1983
Midwest Landscape #60, 1961. Gelatin silver print.
4 5/8 x 19 3/8 in. (11.7 x 49.2 cm). *Plate 146* ②

W. Eugene Smith American, 1918–1978
Dance of the Flaming Coke, from the essay *Pittsburgh,*
1955. Gelatin silver print. 8 3/4 x 13 3/4 in. (22.2 x
34.9 cm). *Plate 188* ①

Peter Stackpole American, 1913–1997
Golden Gate Bridge, 1935. Gelatin silver print. 5 7/8 x
8 7/8 in. (14.9 x 22.5 cm). *Plate 147* ①

Anton Stankowski German, 1906–1998
Untitled [Front Page of Advertisement for Zurich
Coal], 1931. Gelatin silver print. 4 1/4 x 6 1/4 in.
(10.8 x 15.9 cm) ①

Edward Steichen American, born Luxembourg,
1879–1973
Rock Hill, Oyster Bay, Long Island, 1920. Gum platinum
print. 3 9/16 x 4 9/16 in. (9 x 11.6 cm). *Plate 117* ①

Untitled [Rockefeller Center Montage], 1932.
Gelatin silver print. 9 1/8 x 7 1/2 in. (23.2 x 19.1 cm).
Plate 156 ①

Ralph Steiner American, 1899–1986
Untitled (Clothesline), 1923, printed 1930. Gelatin
silver print. 5 x 4 in. (12.7 x 10.2 cm) ②

Bank of New York, ca. 1926. Gelatin silver print.
9 9/16 x 7 5/8 in. (24.3 x 19.4 cm). *Plate 155* ①

Louis Stettner American, born 1922
Irene, 1952. Gelatin silver print. 9 x 13 5/8 in. (22.9 x
34.6 cm). *Plate 201* ②

Alfred Stieglitz American, 1864–1946
From My Window at the Shelton, West, 1931. Gelatin sil-
ver print. 9 7/8 x 7 3/4 in. (25.1 x 19.7 cm). *Plate 10* ②

William James Stillman American, 1828–1901
Untitled [Part of the Frieze of the Parthenon],
ca. 1868–69. Carbon print. 17 3/8 x 14 3/8 in.
(44.1 x 36.5 cm). *Plate 2* ③

Paul Strand American, 1890–1976
Buttress, Ranchos de Taos Church, New Mexico, 1932.
Platinum print. 6 x 4 5/8 in. (15.2 x 11.8 cm) ②

Barn, Gaspé, 1936. Gelatin silver print. 4 11/16 x
5 7/8 in. (11.9 x 14.9 cm). *Plate 142* ①

Village, Gaspé, 1936. Gelatin silver print. 4 11/16 x
5 15/16 in. (11.9 x 15.1 cm). *Plate 15* ②

Karl Struss American, 1886–1981
*Cables — Singer Building, Late Afternoon. Brooklyn
Bridge,* 1912. Platinum print. 8 1/2 x 7 in. (21.6 x
17.8 cm). *Plate 221* ②

Josef Sudek Czech, 1896–1976
Untitled [Street Vendors], ca. 1924–26. Gelatin silver
print. 8 7/8 x 10 7/8 in. (22.5 x 27.6 cm). *Plate 122* ①

Thomas Sutton British, 1819–1875
Souvenir of Jersey, 1854. Salt print from a paper nega-
tive. 8 7/16 x 10 7/8 in. (21.4 x 27.6 cm). *Plate 44* ①

Maurice Tabard French, 1897–1984
Untitled [Montage], 1929. Gelatin silver print. 9 1/4 x
6 7/8 in. (23.5 x 17.5 cm) ①

Isaiah West Taber American, 1830–1912
*Chinese Accountant, Chinatown, San Francisco,
California,* ca. 1880. Albumen print. 7 1/4 x 9 1/2 in.
(18.4 x 24.1 cm). *Plate 105* ①

William Henry Fox Talbot British, 1800–1877
Oxford, High Street, 1843. Salt print from a paper
negative. 7 3/8 x 6 13/16 in. (18.7 x 17.3 cm). *Plate 14* ③

Paris, 1843. Salt print from a paper negative. 6 5/8 x
6 13/16 in. (16.8 x 17.3 cm). *Plate 38* ③

Abbotsford Gate, 1844. Salt print from a paper nega-
tive. 6 1/2 x 8 3/16 in. (16.5 x 20.8 cm). *Plate 39* ①

Gate of Christchurch, ca. 1844–46. Salt print from
a paper negative. 6 5/8 x 7 3/4 in. (16.8 x 19.7 cm).
Plate 37 ①

Adolphe Terris French, 1820–1900
*Vue des chantiers prise du débouché de la rue de
l'Imperatrice sur la place centrale, Marseille* (View of
Construction Taken at the Outlet of rue de
l'Imperatrice in Central Marseille), 1863. Albumen
print from a glass negative. 15 13/16 x 14 1/4 in. (40.2 x
36.2 cm) ②

Félix Teynard French, 1817–1892
Amadah — vue générale des ruines (Amadah — General
View of the Ruins), from the album *Égypte et Nubie:*

Sites et monuments les plus intéressants pour l'étude de l'art et de l'histoire (Egypt and Nubia: The Most Interesting Sites and Monuments for the Study of Art and History), ca. 1851–52, printed ca. 1853–54. Salt print from a paper negative. 9 1/2 x 12 1/8 in. (24.1 x 30.8 cm) ①

Esneh—dattiers, sycomore et café sur le bord du Nîl (Esneh—Date Palms, a Sycamore Tree, and a Café on the Bank of the Nile), from the album *Égypte et Nubie: Sites et monuments les plus intéressants pour l'étude de l'art et de l'histoire* (Egypt and Nubia: The Most Interesting Sites and Monuments for the Study of Art and History), ca. 1851–52, printed ca. 1853–54. Salt print from a paper negative. 9 3/8 x 12 1/8 in. (23.8 x 30.8 cm) ①

Karnak (Thèbes)—premier pylône—ruines de la porte et des colosses, vues du point E (Karnak [Thebes]—First Pylon—Ruins of the Gate and the Colossi Seen from Point E), from the album *Égypte et Nubie: Sites et monuments les plus intéressants pour l'étude de l'art et de l'histoire* (Egypt and Nubia: The Most Interesting Sites and Monuments for the Study of Art and History), ca. 1851–52, printed ca. 1853–54. Salt print from a paper negative. 9 5/8 x 12 1/8 in. (24.4 x 30.8 cm). *Plate 74* ①

Félix Thiollier French, 1842–1914
Untitled [Emile Noiret, Painting by a Stream], 1880s. Gelatin silver print. 11 1/2 x 15 3/4 in. (29.2 x 40 cm). *Plate 6* ①

John Thomson Scottish, 1837–1921
Public Disinfectors, ca. 1877–78. Woodburytype. 4 5/8 x 3 5/8 in. (11.7 x 9.2 cm). *Plate 110* ①

Workers on the "Silent Highway," ca. 1877–78. Woodburytype. 4 1/2 x 3 1/2 in. (11.4 x 8.9 cm). *Plate 109* ①

Linnaeus Tripe British, 1822–1902
Madura. Blackburn Testimonial, 1858. Salt print from a paper negative. 10 3/8 x 13 9/16 in. (26.4 x 34.4 cm). *Plate 61* ③

Benjamin Brecknell Turner British, 1815–1894
Ludlow, ca. 1852–54. Paper negative. 11 3/4 x 15 3/4 in. (29.8 x 40 cm). *Plate 25* ②

Ludlow, ca. 1852–54. Albumen print from a paper negative. 11 1/4 x 14 1/2 in. (28.6 x 36.8 cm) ②

Umbo (Otto Umbehr) German, 1902–1980
Potsdamer Platz, Berlin, 1935. Gelatin silver print. 8 15/16 x 8 15/16 in. (22.7 x 22.7 cm). *Plate 176* ②

Ob's reicht? (Will It Be Enough?), 1940s. Gelatin silver print. 11 3/4 x 8 1/8 in. (29.8 x 20.6 cm). *Plate 32* ①

Unknown Artists American
Untitled [Ambrotype Studio], ca. 1840. Ambrotype. 3 1/2 x 4 3/4 in. (8.9 x 12.1 cm). *Plate 81* ①

Untitled [Man and Horse], ca. 1850. Ambrotype. 2 1/8 x 2 5/8 in. (5.4 x 6.7 cm). *Plate 83* ①

Untitled [American Farm Landscape], 1850s. Daguerreotype. 5 1/4 x 7 1/4 in. (13.3 x 18.4 cm). *Plate 80* ①

Untitled [Crystal Palace, Main Gallery], 1850s. Stereo daguerreotype. 2 11/16 x 2 5/16 in. (6.8 x 5.9 cm). *Plate 36* ①

Untitled [African American Woman with Two White Children], ca. 1860. Ambrotype. 2 1/2 x 3 1/2 in. (6.4 x 8.9 cm). *Plate 82* ①

Untitled [Family in Front of a Farmhouse], ca. 1870. Tintype. 6 7/8 x 9 in. (17.5 x 22.9 cm). *Plate 91* ②

Untitled [Two Men Posing in Front of Niagara Falls, View of the Canadian Side], ca. 1870. Ambrotype. 6 1/2 x 8 1/2 in. (16.5 x 21.6 cm). *Plate 90* ②

Untitled [Woman Dressing], ca. 1900. Gelatin silver print. 3 3/4 x 4 1/2 in. (9.5 x 11.4 cm). *Plate 118* ①

Unknown Artist British
Muddin Mahal, Jubulpur, ca. 1870. Albumen print from a glass negative. 9 1/16 x 11 5/16 in. (23 x 28.7 cm). *Plate 78* ②

Unknown Artists French
Untitled [Château de Goulaine], ca. 1840. Daguerreotype. 5 1/2 x 6 in. (14 x 15.2 cm). *Plate 34* ①

Untitled [Nantes, View of the Place de la Petite Hollande], ca. 1840. Daguerreotype. 6 1/2 x 8 in. (16.5 x 20.3 cm) ①

Roman Vishniac American, born Russia, 1897–1990
Entrance to the Old Ghetto, Kraków, 1937. Gelatin silver print. 9 15/16 x 7 11/16 in. (25.2 x 19.5 cm). *Plate 187* ②

Adam Clark Vroman American, 1856–1916
Hopi Mesa, ca. 1897. Gelatin silver print. 5 1/4 x 7 5/8 in. (13.3 x 19.4 cm). *Plate 102* ②

Hopi Woman Grinding Corn, ca. 1897. Gelatin silver print. 4 9/16 x 6 9/16 in. (11.6 x 16.7 cm). *Plate 104* ②

Carleton E. Watkins American, 1829–1916
The Golden Gate from Telegraph Hill, ca. 1868. Mammoth-plate albumen print. 15 3/4 x 20 5/8 in. (40 x 52.4 cm) ②

New Tacoma, Washington, Puget Sound, 1882. Mammoth-plate albumen print. 14 7/8 x 20 15/16 in. (37.8 x 53.2 cm) ②

Spokane Falls, 1882. Mammoth-plate albumen print. 14 5/8 x 21 1/16 in. (37.1 x 53.5 cm). *Plate 95* ②

Weegee (Arthur H. Fellig) American, born Poland, 1899–1968
Woman, New Jersey Nudist Camp, ca. 1960. Gelatin silver negative print. 8 7/8 x 7 1/4 in. (22.5 x 18.4 cm). *Plate 210* ①

Dan Weiner American, 1919–1959
Teenage Party, Greenville, South Carolina, 1957. Gelatin silver print. 9 1/8 x 13 1/2 in. (23.2 x 34.3 cm). *Plate 200* ②

Jack Warren Welpott American, born 1923
The Farmer Twins, Stinesville, Indiana, 1959. Gelatin silver print. 7 5/8 x 9 3/8 in. (19.4 x 23.8 cm). *Plate 199* ①

Henry Wessel Jr. American, born 1942
Buena Vista, Colorado, 1973. Gelatin silver print. 10 x 14 7/8 in. (25.4 x 37.8 cm). *Plate 211* ②

Edward Weston American, 1886–1958
Legs in Hammock, Laguna, 1937. Gelatin silver print. 7 5/8 x 9 5/8 in. (19.4 x 24.4 cm). *Plate 22* ①

Clarence H. White American, 1871–1925
Stella and Homer Hobson, Ringling Brothers Circus, ca. 1905. Platinum print. 9 1/2 x 7 5/8 in. (24.1 x 19.4 cm) ①

Nude and Baby, 1912. Platinum print. 7 5/8 x 9 9/16 in. (19.4 x 24.3 cm). *Plate 119* ①

Henry White British, 1819–1903
Untitled [Country Cottage with Couple], 1856. Albumenized salt print from a glass negative. 7 13/16 x 9 3/4 in. (19.8 x 24.8 cm). *Plate 50* ②

Minor White American, 1908–1976
Vicinity of Dansville, New York, 1955. Gelatin silver print. 7 3/8 x 9 3/8 in. (18.7 x 23.8 cm). *Plate 12* ②

Garry Winogrand American, 1928–1984
Park Avenue, New York, 1959. Gelatin silver print. 13 1/8 x 8 3/4 in. (33.3 x 22.2 cm) ②

Marion Post Wolcott American, 1910–1990
Woman Packing-House Worker from Tennessee with Three of Her Four Children, Eating Supper of Fried Potatoes and Corn Bread, Canned Milk, Belle Glade, Florida, 1939. Gelatin silver print. 7 7/8 x 7 11/16 in. (20 x 19.5 cm) ②

Willard E. Worden American, 1868–1946
San Francisco Skyline at Night, 1905. Gelatin silver print. 5 3/16 x 9 5/8 in. (13.2 x 24.5 cm) ①